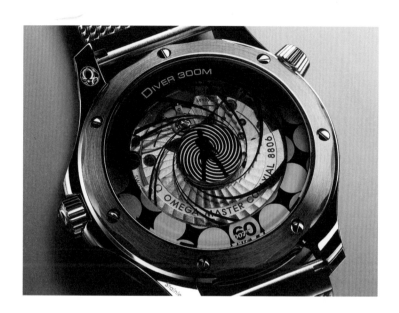

A TRIBUTE TO JAMES BOND

On a mission to honour the world's favourite spy, OMEGA presents a brand new Seamaster Diver 300M infused with 007 details. While the wavy blue dial is inspired by James Bond's first OMEGA watch in *GoldenEye*, the mesh bracelet is the very same style worn in *No Time To Die*. Turn the timepiece over and the action continues through an animated caseback that recreates the iconic opening title sequence. For fans of this legendary film franchise, there's no better way to bring secret agent storytelling and innovative watchmaking to life.

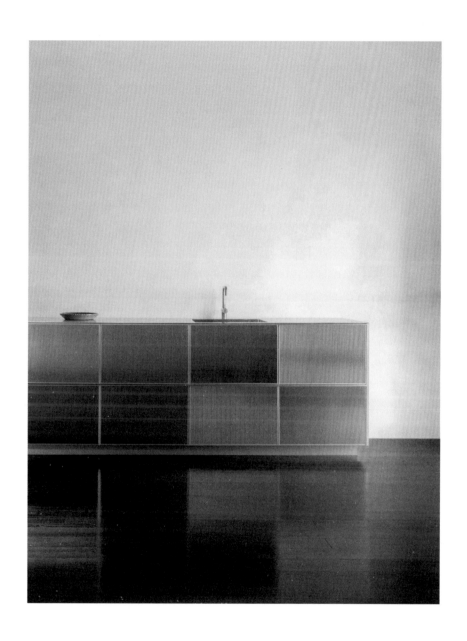

Reform

REFLECT by Jean Nouvel

Hydrate

KINFOLK

MAGAZINE
—

EDITOR IN CHIEF	John Burns
EDITOR	Harriet Fitch Little
ART DIRECTOR	Christian Møller Andersen
DESIGN DIRECTOR	Alex Hunting
COPY EDITOR	Rachel Holzman

STUDIO
—

PUBLISHING DIRECTOR	Edward Mannering
STUDIO & PROJECT MANAGER	Susanne Buch Petersen
DESIGNER & ART DIRECTOR	Staffan Sundström
DIGITAL MANAGER	Cecilie Jegsen

—

CROSSWORD	Mark Halpin
PUBLICATION DESIGN	Alex Hunting Studio
COVER PHOTOGRAPH	Michael Oliver Love

The views expressed in *Kinfolk* magazine are those of the respective contributors and are not necessarily shared by the company or its staff. *Kinfolk* (ISSN 2596-6154) is published quarterly by Ouur ApS, Amagertorv 14B, 2, 1160 Copenhagen, Denmark. Printed by Park Communications Ltd in London, United Kingdom. Color reproduction by Park Communications Ltd in London, United Kingdom. All rights reserved. No part of this publication may be reproduced, distributed or transmitted in any form or by any means, including photocopying or other electronic or mechanical methods, without prior written permission of the editor in chief, except in the case of brief quotations embodied in critical reviews and certain other noncommercial uses permitted by copyright law. The US annual subscription price is $80 USD. Airfreight and mailing in the USA by WN Shipping USA, 156-15, 146th Avenue, 2nd Floor, Jamaica, NY 11434, USA. Application to mail at periodicals postage prices is pending at Jamaica NY 11431. US Postmaster: Send address changes to *Kinfolk*, WN Shipping USA, 156-15, 146th Avenue, 2nd Floor, Jamaica, NY 11434, USA. Subscription records are maintained at Ouur ApS, Amagertorv 14B, 2, 1160 Copenhagen, Denmark. SUBSCRIBE: *Kinfolk* is published four times a year. To subscribe, visit www.kinfolk.com/subscribe or email us at info@kinfolk.com. CONTACT US: If you have questions or comments, please write to us at info@kinfolk.com. For advertising and partnership inquiries, get in touch at advertising@kinfolk.com.

WORDS

Precious Adesina
Allyssia Alleyne
Alex Anderson
Annabel Bai Jackson
Louise Benson
William Cobbing
Ed Cumming
Marah Eakin
Jade Forrest Marks
Laura Hall
Robert Ito
Rosalind Jana
Rebecca Liu
Nathan Ma
Jenna Mahale
Justin Myers
Okechukwu Nzelu
Sala Elise Patterson
Manju Sara Rajan
Laura Rysman
George Upton
Alice Vincent
Annick Weber
Tom Whyman

STYLING, SET DESIGN, HAIR & MAKEUP
—

Monica Alvarez
Michelle-Lee Collins
Liz Daxauer
Jade Forrest Marks
Magdalena Major
Dmitry Maximov
Jèss Monterde
Sally Morris Clark
David Nolan
Nadia Pizzimenti
Sarah Pritchard
Kristi Vlok

ARTWORK & PHOTOGRAPHY

Enrique Alvarez
Lauren Bamford
Maya Beano
Ted Belton
Fernando Bengoechea
Jonas Bjerre-Poulsen
Henny Boogert
Luc Braquet
Clara Colonna
Pelle Crépin
Marina Denisova
Daniel Eatock
Richard Gaston
Chris Gloag
John Hall
Todd Hido
Tilman Hornig
Javarman
Elena Khrupina
Carl Kleiner
Jae-An Lee
Bernhard Leitner
Estelle Loiseau
Michael Oliver Love
Andy Massaccesi
Chou Mo
Christian Møller Andersen
Garrett Naccarato
Eric Piasecki
Gabriele Picco
Reto Schmid
Fritz von der Schulenburg
David Schulze
Yana Sheptovetskaya
Tonje Thilesen
Marsý Hild Þórsdóttir
Emma Trim
Ville Varumo

PUBLISHER
—

Chul-Joon Park

marset
Taking care of light

WELCOME
The Water Issue

"The best way to care for something is to fall in love with it," says Cyrill Gutsch, the designer turned advocate intent on getting more people to care about the health of the world's blue spaces. "Bringing people into nature, exposing them to the beauty and the magic of the sea is, of course, the ideal way of doing it."

Consider this issue your invitation to fall in love with water through the stories of people who have built their lives around it. For adventurers Ross and Hugo Turner, that feeling of awe came at the moment when, while rowing across an ocean at night, the stars were reflected in water so still that it appeared they were "rowing in a sphere." For deep-sea explorer (and former astronaut) Kathryn Sullivan, it was traveling to the deepest known point on the earth's seascape—and realizing that it looks just like the moon's surface. For figure skater Mirai Nagasu, the moment came on ice, when years of grueling training paid off and she landed a triple axel at the Winter Olympic Games in 2018. And if all this seems a bit far out of reach, don't worry; we also have a photo shoot celebrating the many pleasures of a water source you will almost certainly have access to—the kitchen sink.

What unites many of the stories in Issue Forty-Eight is that they feature people who have decided to step off the path expected by their industry. Artist Jordan Casteel is a particularly striking example of this trend. Having built an acclaimed career as a New York City–based portrait artist, she has moved upstate and shifted her focus to the natural world. Her explanation? She knew "the expectations around my growing name and career would need the grounding that the land could offer." Elsewhere, we speak to Rose Chalalai Singh about her decision to swap the security of a restaurant kitchen for the unpredictable thrill of catering for the Parisian art and fashion set, and architect Anupama Kundoo outlines her extraordinary vision for Auroville, an experimental township where everything is done differently—even the "tower blocks" are horizontal.

Of course, given the season, there are plenty of lighthearted top notes to this issue to help you slip into a summertime frame of mind. On page 104 we're featuring alcohol-free thirst-quenching cocktails, and on page 150, we explore the design history of a boat Alvar Aalto built for travel to and from his island holiday home. There are also short essays on the perfect length for a vacation, the curse of packing light and—most importantly—the etiquette of a summer crush.

WORDS
JOHN BURNS
HARRIET FITCH LITTLE

The Bone Chair

Finn Juhl | 1944

HFJ

finnjuhl.com

STARTERS
Crushes, feng shui and the Iceman.

FEATURES
American homes and Indian communes.

"You have to eradicate all traces of trends or fashion from your mind." (Patrizio Gola – P. 68)

Photo: Pelle Crépin

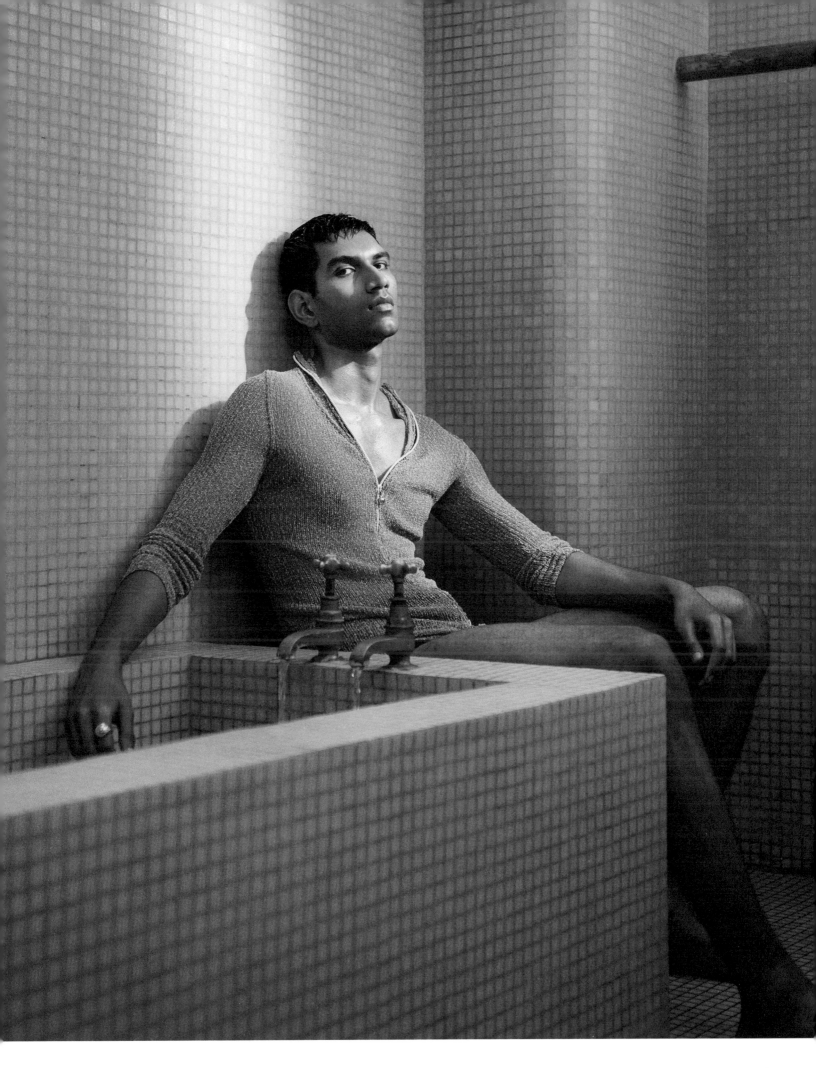

CONTENTS

Photo: Michael Oliver Love

vipp

STARTERS:

THE SWEET SPOT
How long is the perfect vacation

There is no better feeling than knowing that a dream vacation you have spent months planning is just around the corner. What gets your heart racing will depend on who you are and where you're going, but how long you get away for could maximize the benefits of that break.

A report published in the *Journal of Happiness Studies* found that our general level of satisfaction dramatically increases from the moment a holiday starts but peaks roughly on the eighth day. "It takes some time to wind down after a stressful work period and acclimatise to vacation," the researchers concluded. They also noted that after the eighth day, our contentment slowly fades away, plateauing around the eleventh.

But it isn't that simple. One potential flaw with this popular study is that only people with at least two weeks off participated in it. Their day-eight high may have been because, just over a week in, they still had some time to go before the end of their trip. By the same token, the day-eleven plateau might reflect back-to-work pessimism rather than holiday ennui. The study also showed that the joy felt on longer trips fades fairly quickly after the return to work.

If there's no long-term benefit to be gained from extended holidays, then perhaps frequent quick breaks are the answer. Research published in the *International Journal of Environmental Research and Public Health* in 2018 showed that short-term getaways can positively affect well-being even up to 45 days later. The pleasure from longer trips dissipating faster "may be due to returning to a massive pile of work," the researchers proposed. "A shorter vacation might prolong the long-term effectiveness by not having to return to a comparably high workload but still being away long enough to fully recover from daily work-related stressors." One way to counteract the dreaded post-holiday workload could be if everyone adopted the Swedish approach to time off. There, a large portion of the population takes four consecutive weeks of leave in July.[1] If no one else is working, there's no mountain of work to return to.

The novelty of the trip also plays a part in the benefits a holiday has. Speaking to the BBC, professor of neuroscience Peter Vuust explained that exploring a new environment increases dopamine levels because it pushes us to adapt to a new culture and routine. Participating in a range of activities is also essential. "If the experience is one-dimensional, you get tired of it very quickly," Vuust says. "But if it's varied and challenging, it will keep on being interesting."

Of course, there are many ways to improve well-being by taking time off. The common thread in these studies is that the vacationer enjoys it. According to Ondrej Mitas, an emotion researcher at Breda University, most people misjudge what satisfies them when it comes to holidays: "It will take deep reflection, trial and error to know what makes [you] happy and for how long."

WORDS
PRECIOUS ADESINA
PHOTO
CLARA COLONNA

(1) According to *The Economist*, the explanation may be partly pragmatic in that it is easier for manufacturing companies to take time off all at once to avoid disrupting the production line. It was once common for factories to holiday as a group, with the company arranging transportation.

17

Zippy Chippy, the American thoroughbred, came from a long line of champion racehorses but ended his career winless after 100 tries, largely because he had a sour disposition and didn't much like to run at all. Florence Foster Jenkins, the American socialite, was such a poor vocalist that audiences would flock to performances just for the sheer wonder of hearing "the world's worst operatic singer."

Despite their shortcomings (and in many ways, because of them), both attained an odd sort of fame, and even fandom. Zippy Chippy, a beast so ornery he once bit a fellow competitor on the ear in the middle of a race, was the subject of a 2016 biography and a beloved children's picture book. Jenkins' singing career, such as it was, inspired several plays and a 2016 biopic starring Meryl Streep.

Why do some people (or, sometimes, horses) become celebrated for being lousy at what they do? The idea seems to go against human nature. People tend to love winners and hate losers; we applaud excellence and deplore ineptitude. But a select few souls rise above their shortcomings to attract an outsized level of affection. The Chicago Cubs and the Boston Red Sox, for instance, whose records are said to have been blighted by long-running curses, have some of the most devoted sports fans on the planet.[1] The martial artist Chuck Norris, widely considered one of the world's most limited actors, has retained a loyal fan base for decades, appearing in dozens of films and TV shows.

If there's one common factor among these lovable incompetents, it's that their lack of ability doesn't hurt others, not really. Nobody loves inept heart surgeons, for instance, or poorly performing nuclear plant inspectors. But otherwise, famously bad stars come in all sorts of types and professions, which is part of their allure. Among the latest trends in reality TV is the "horrible cook" competition, which includes shows like *Nailed It!* (about poor bakers) and *Worst Cooks in America*.

One of the reasons we love underperformers is because, when it's done right, underperforming is so much fun to watch. On any given night, one can see a good sports team win, but there's often a certain sameness and ease to it, particularly with really great teams. But bad squads and truly poor players? To tweak Tolstoy, every untalented team is untalented in its own way, and there's a certain delicious pleasure in watching folks consistently and creatively flail.

(1) The Curse of the Billy Goat, placed on the Cubs in 1945, was the supposed reason behind the team's World Series drought from 1945 to 2016. The Curse of the Bambino, tied to the sale of Babe Ruth from the Red Sox to the New York Yankees in 1920, ran from 1918 to 2004.

WORDS
ROBERT ITO
PHOTO
CARL KLEINER

TERRIBLY GOOD
The fun of an epic fail.

Postcards, cocktail stirrers, stickers and sugar packets: These are the incidental objects that punctuate our lives. Momentarily useful and quickly forgotten, their designs are rooted fundamentally in the present; they are mass produced for brief use before being replaced with the new and the next.

It is little surprise that collectors find the very idea of this impermanence appealing. The richly textured variations of these cheap and disposable ephemera offer an honest insight into the whims and fancies of a specific time and conjure a shadowy image of previous owners. It follows that even the most ordinary objects can become charged with new meaning if a famous artist or writer —someone who has spent their life creating their own mythology—once possessed them.

Take the widely reported house clearance of Joan Didion last year, in which assorted knickknacks, writing accoutrements such as pens and blank notebooks, and even a group of seashells and beach pebbles picked up by the author were auctioned off at more than 10 times their estimate. The clue to their appeal? The picture they painted of the revered Didion herself.

Does a shell collected by an artist who we feel a bond with take on more significance than one picked up by a stranger from the past? The art world is built on such speculative systems of near-mystical belief. But even objects that have no such provenance retain the power to reveal the many ways in which we collect, memorialize and find connection. Consider a teenager cherishing their ticket stubs from memorable concerts, back when they were still printed, or our reluctance to part with coins from a foreign vacation. Like the lingering scent of a once-loved perfume, the throwaway always has the capacity to become anything but.

WORDS
LOUISE BENSON
PHOTO
DANIEL EATOCK

MONEY FOR NOTHING
On collecting ephemera.

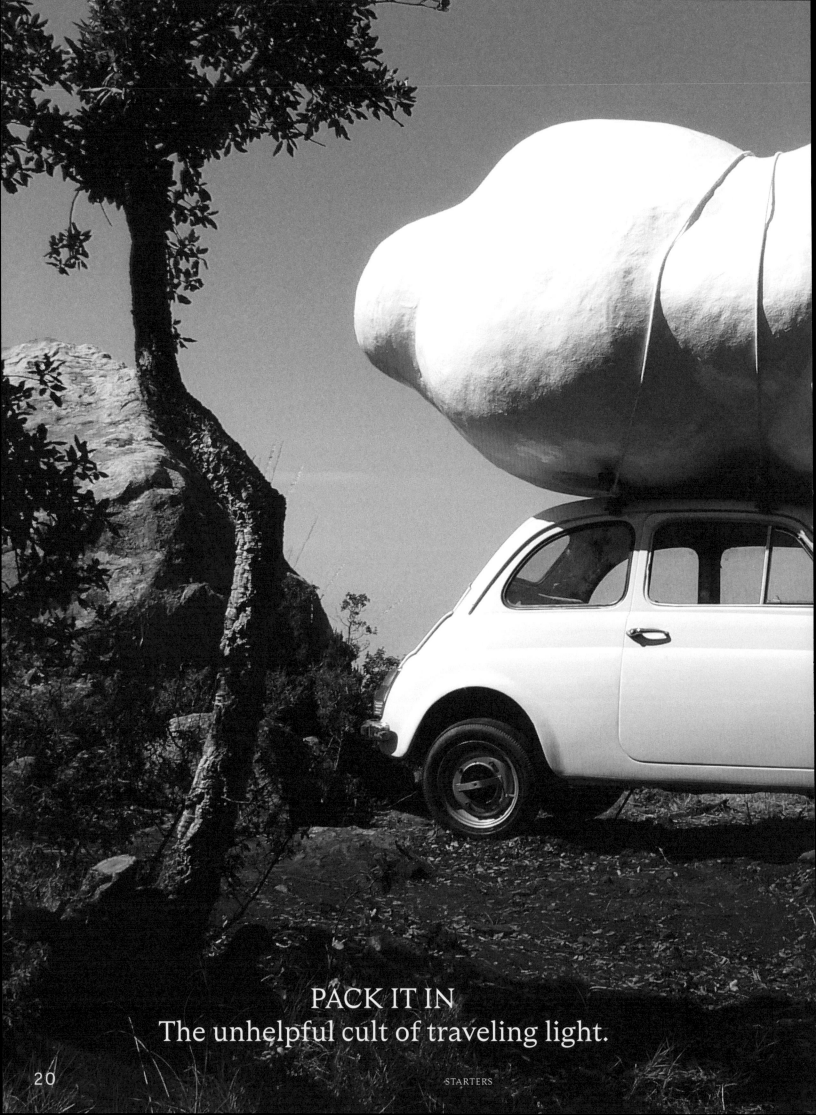

PACK IT IN
The unhelpful cult of traveling light.

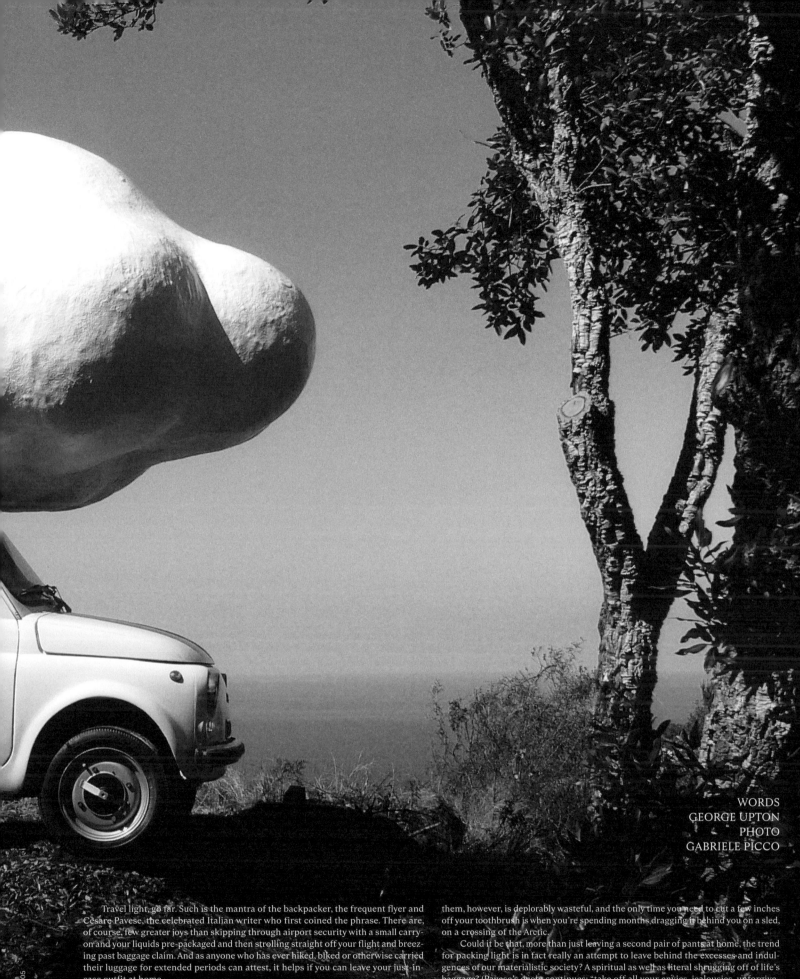

Artwork: Nuvola, 2005

WORDS
GEORGE UPTON
PHOTO
GABRIELE PICCO

Travel light, go far. Such is the mantra of the backpacker, the frequent flyer and Cesare Pavese, the celebrated Italian writer who first coined the phrase. There are, of course, few greater joys than skipping through airport security with a small carry-on and your liquids pre-packaged and then strolling straight off your flight and breezing past baggage claim. And as anyone who has ever hiked, biked or otherwise carried their luggage for extended periods can attest, it helps if you can leave your just-in-case outfit at home.

Yet as liberating as it can be, the trend of packing light—as popularized by travel influencers and "ultra-light" packing guides—has perhaps gone a little too far in its own way. Neglecting to take the right clothes for the climate or, for that matter, enough underwear, is one thing—you'll be uncomfortable, but you can always buy more. Throwing clothes away when they're dirty, rather than traveling home with

them, however, is deplorably wasteful, and the only time you need to cut a few inches off your toothbrush is when you're spending months dragging it behind you on a sled, on a crossing of the Arctic.

Could it be that, more than just leaving a second pair of pants at home, the trend for packing light is in fact really an attempt to leave behind the excesses and indulgences of our materialistic society? A spiritual as well as literal shrugging off of life's baggage? (Pavese's quote continues: "take off all your envies, jealousies, unforgiveness, selfishness and fears.") After all, what's really the harm in carrying a few extra pounds—especially if it means you can take your slippers? Checking your luggage at the beginning of a journey, or unloading the car at the end of another, might mean it will take a little longer to get to when you're going, but at least you'll be comfortable when you get there.

WIM HOF

WORDS
JENNA MAHALE
PHOTOS
HENNY BOOGERT

An audience with the Iceman.

At 63 years old, Wim Hof, the Dutch motivational speaker known as the Iceman—for his Guinness World Records–famous feats of cold-related human endurance—has been thinking about warmer pastures, having recently mooted over the purchase of 10 hectares of Australian rain forest on the border of Queensland and New South Wales. "I love the cold," says Hof. "I don't like it, *I love it*. Because it is such a powerful tool. But I'm a sucker for botanical gardens."

Dressed in a zany floral-print shirt and bright blue, thigh-skimming board shorts, Hof bellows about the benefits of his Wim Hof Method (WHM), a combination of deep-breathing techniques, cold exposure and ice baths. "Your body becomes stronger inside to oppose the stress from the outside," he says. "That's why I never get sick. Because I make my body work." Hof's charisma is undeniable, but he occasionally veers into a kind of ableist health exceptionalism that has arguably come to define the wellness guru archetype.

While there is some scientific evidence to support his claims of WHM as an anti-inflammatory health panacea, a number of researchers have challenged them. In a 2017 journal article, for example, Maastricht University's Wouter van Marken Lichtenbelt called Hof's scientific vocabulary "galimatias" [nonsense], adding that studies into his method are "often presented with a biased view."

Here, Hof discusses the psychology behind his method, his deepest fears (having overcome that of death), poetry, painting and more.

JENNA MAHALE: You've lived in the Netherlands for almost your entire life. What's something you think people should know about living there?

WIM HOF: The winters are dark, foggy and misty. But you can make a summer of your winter: that way, it will not get to you. Look at me, I wear shorts and a T-shirt all winter long. When people get dressed up, they close themselves up, they disappear. In the winter, you're just a little face and hands—if you're not wearing gloves. And the rest is totally covered. It's like we are imprisoning ourselves: We are caged; we are disconnected from nature. People disconnect from stimuli outside, and do anything that makes them comfortable and feels convenient. This is not strengthening their bodies, or stimulating their innate capacities to deal with stress. And then when stress comes—like a virus or a divorce, or getting the sack—then suddenly you fall into a depression. You are weak, and you will be further weakened.

JM: Can you explain the psychological mechanism behind the Wim Hof Method?

WH: When you go into the cold, because the cold is dangerous, a neural signal is sent. Deprivation of oxygen is also very dangerous. But with exercises, we can control our breathing, rather than forcing it. That way, psychologically, you learn to connect

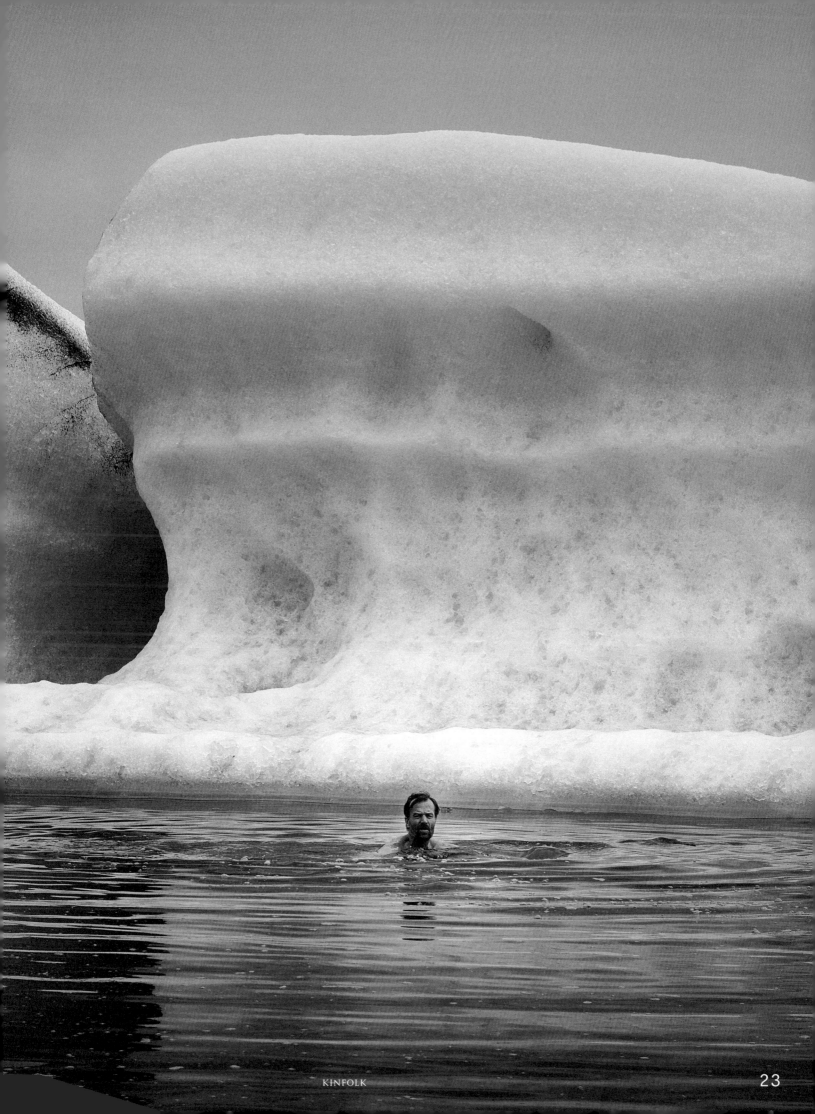

with the deep brain, which you need in case of outside stressors. What that does is create a deep, calm confidence. You become confident because you know in your subconscious what is going to happen in the future, with mathematical precision. Like intuition and instinct, those things have got nothing to do with your thinking brain. You are able to be without fear. There's no fear [in you] anymore, because it comes as a signal from the deep physiology of the brain, which you can train and control.

JM: You've spoken before about an experience that led you to "conquer the fear of death." But surely a measure of fear is important in life sometimes?

WH: Fear is a great messenger, and we cannot mess with the messenger. If you're walking next to an abyss, you'd better count your steps. But if fear is not needed, then it should not be there. Learning to be in the cold is learning exactly what your body is capable of. Eventually, you can sense it. But it also illustrates that the distance between you and your fear is a big area—that danger is a big area—and you are able to go into that area freely. Fear is good, but you have rational and irrational fears.

JM: Tell me about your rational fears.

WH: I have six children, and I just want them to be happy. My daughter had a baby, five weeks old, and it fell off the bed. They went to the hospital for observation, and nothing was wrong, but they were worried. And at that moment, I felt worried too. I called, and said, "Just love the kid, because it happens. Just give it all you've got." That's what I do with my rational fears, my fears for the children—I just give it all I've got. I think life is too short to live in fear. So, I just want to change the world.

JM: What do you like to do outside of being the Iceman?

WH: I'm a sucker for botanical gardens! I love animals. I love the jungle, I love the exuberance of the natural beauty, of the lush vegetation coming out—red and blue! And then comes a green parrot, and there is a lizard—you dive under the water and see thousands of fishes in all kinds of colors! I get high off that. It blows my mind. I'm writing a book of poetry right now. And I just made a new music album—I'm going to perform for a full hour in front of 55,000 people in September. I play the guitar and sing, along with some very good guitarists. Together we made an album, like Pink Floyd. It's 47 minutes of old stories, from all these tribes—it's music with a message. And then I paint, too: the African savanna, mountains, rocks, little lizards, lions and elephants. The cover of our LP is going to be one of my paintings.

JM: I'm curious as to your policy on alcohol. Do you ever drink?

WH: Alcohol. *Al-kuhl*. It means "bad spirit."[1] The thing is, I used to love it. There was a time I loved [beer] so much, I called it yellow water. And I drank lots of it. At first, I did my work during the day, and then I would think, "It's time for celebration," and I would drink beers one after the other—up to eight, maybe sometimes nine. That was my quota. But there were certain moments I had to ask myself: Who is the boss, me or the beer? So three and a half years ago I thought, "Let's check it out; I'm not going to drink anymore." And boom, from then on, I didn't. Remember what I said earlier? I am going to change the world. Does that involve alcohol? No, so I'm not drinking. I don't need to drink, I'm drunk anyway, every day. Because it doesn't matter where I go: People recognize me, and when they look into my eyes and say "You changed my life" or "You saved my life"— do you know what kind of a drug that is? It is amazing. So, I'm drunk on life.

(1) This etymology is generally believed to be false. It is more likely that "alcohol" comes from the Arabic *al-kuhl*, which refers to the cosmetic kohl. The process of creating kohl resembles that of distillation.

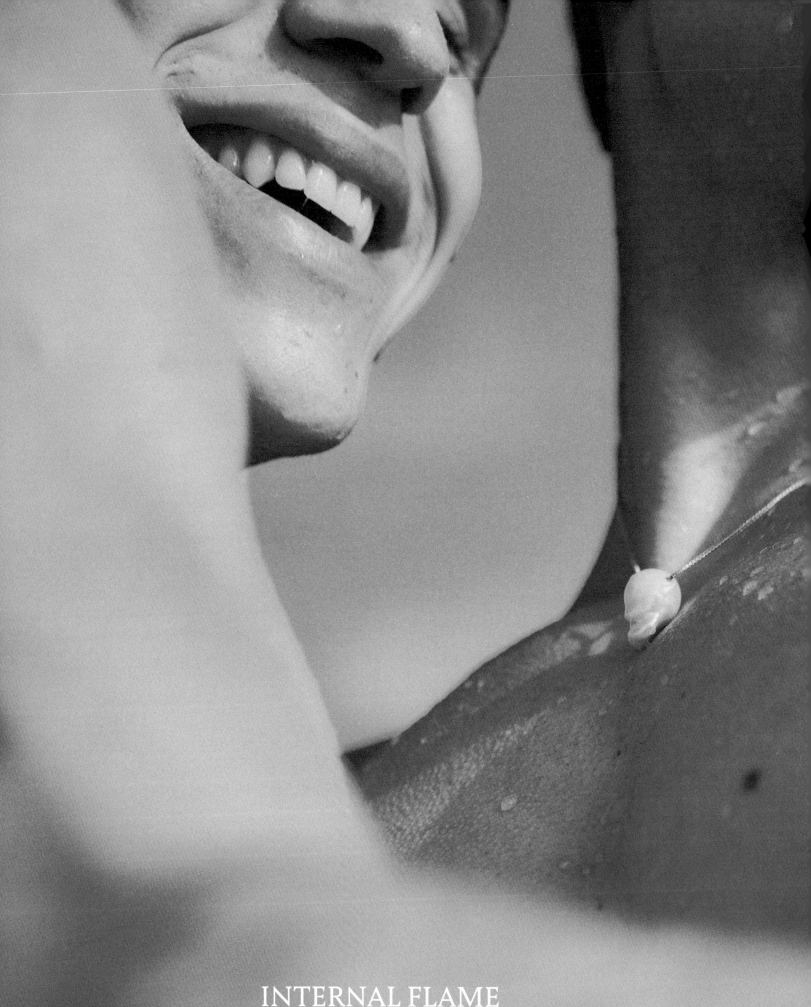

INTERNAL FLAME
The etiquette of a crush.

Models: Tristan Cardinal & Zachary Courchesne

Feeling attracted to someone is often the first step toward a larger entanglement; a spark that, with the help of certain accelerants, will grow into the inferno of a romantic or sexual liaison.

But where does this leave the humble crush? They have a bad reputation: angsty, unrequited fixations that can squeeze the life out of us and grind our hearts into dust. These are sparks that will never know the fullness of flame. Yet there can be something life-affirming about a secret, distant fascination that keeps your mind alive. The hot co-worker who brings coffee without asking; the stranger on your regular commute who smiles every morning; your partner's oldest friend, whose jokes land perfectly. You might never act on the desire, but that doesn't mean it's a waste of time.

A crush can be a decent way of checking in with yourself. It's an early warning system, alerting you to the areas of your life needing attention. What are you actually looking for? And what will you do about it? As intense as it might feel in the moment, most crushes are destined to be cringed at and laughed over later in life, much like teenage paramours and long-forgotten wardrobe crimes. In time, you'll wonder what on earth you were thinking, and future you will appreciate these clues to the state of your general psyche while you were gripped by this benign passion.

Accepting a crush is to recognize it can never be real and that it has an expiration date. Eventually you will run out of fantasy scenarios that could—dramatic license allowing—throw you together, and your brain will incorporate the object of your affection back into reality. Paradise is an intangible concept best imagined; similarly, the real-life version of your crush within a relationship's confines would likely be much less alluring.

Enjoy the high, appreciate the distance from reality, and be supercharged by its energy. If anything, a crush's role is either to make you thankful for what you've already got, or ensure you seek something more fulfilling than stolen glances or illusory flirtations. Sometimes the thrill of forbidden fruit is in the wanting, not the tasting.

WORDS
JUSTIN MYERS
PHOTO
GARRETT NACCARATO

28

ALL THE BESTIES
How to make work friendships work.

WORDS
MARAH EAKIN
PHOTO
RETO SCHMID

According to a recent Gallup poll, about a quarter of employed adults in the US say they have a "work best friend." That number has gone down a few points since the start of the pandemic—it's hard to make lasting connections with colleagues you may have never actually met in person—but it's an interesting metric all the same. People with work besties are more likely to say they're happy at work and to recommend their workplace to others.

But having a best friend at work can be a tricky tightrope act. Those who chat too much can be dubbed gossips and run the risk of seeming cliquey to others. And what about when your good-time best friend becomes your boss, or vice versa? You may find it difficult to receive harsh feedback from someone you once saw fall out of an Uber at 3 a.m.

Navigating the nuances of forming friendships at work is simpler when you're new to the working world: Typically, everyone you bond with is young and in a similar boat in terms of responsibilities, pay and stakes. As we age and advance in our careers and our friendships, though, we have to learn to parse the boundaries. It can be challenging to walk back a die-hard friend relationship when it needs to transition into something a little more businesslike.

Most experts—including Roxane Gay, who writes the "Work Friend" column for *The New York Times*—say that it's best to hold firm when it comes to setting a line between your business life and your personal life. Avoid oversharing and make it clear (subtly) that you're in your job for professional enrichment and advancement, not to round up a new group of pickleball pals.

It might seem a little harsh—we all want to be liked, after all—but there's a fine line between getting along with co-workers and regretting all those hair-raising nights out a few years later when you're battling it out with your bestie for a promotion and a pay raise.

It's not impossible to make a work friend and keep them forever. Most baby boomers say that they've made the majority of their friends at work, after all.[1] But those friendships may also have come with trade-offs, be they personal or professional. For instance, the same recent Gallup poll said that people with work friends are less likely to leave their current place of employment, lest they risk losing their buds. That's terrific for companies—less turnover equals more productivity—but it can cut both ways for employees. It's great to work with people you like, but it's also good to know that, if some promising new job opportunity comes up, you won't second-guess it and end up holding yourself back professionally.

(1) One 2020 survey by online retailer Hampers found that over half of employees considered their co-workers to be their best friends. Tellingly, when asked why they felt this way, 63% said it was because of how much time they spent together, and only 23% said it was because they thought their colleagues truly cared about them.

THE ART OF FASHION

WORDS
ROSALIND JANA
PHOTO
ESTELLE LOISEAU

On what artists' clothes communicate.

Fashion and art critic Charlie Porter's *What Artists Wear* (2021) is not just another glossy book full of photos. There are photos, yes, but they meander through the text: Lee Krasner's paint-spattered slippers, Martine Syms' bootleg designer sneakers, Louise Bourgeois in Helmut Lang. Porter is interested in what an artist's clothes say and do. Who are they defying? Or trying to impress? How do they rise to the physical demands of making? In asking these questions, Porter's odyssey through the artist's wardrobe becomes an illuminating examination of power, play and the lived intimacy of garments worn for years on end.

ROSALIND JANA: Why is it interesting to think about what artists wear?

CHARLIE PORTER: It's a way in. By approaching artists through their clothes, that opens your eyes to so much else. It's about how they live, where they live, why they live, the conditions under which they live, what they want to change in their life, and what is restricting their life.

RJ: When we consider dress, we often look toward the most flamboyant dressers—those who we see as breaking some kind of norm, often through spectacle. But you argue that functionality can be just as subversive.

CP: Functionality can be a radical act, because it can be about functioning as a human beyond the parameters that are set. This book was never about showing off as a way of gaining celebrity. Although there are famous people within it who did engage with celebrity, like Warhol, [there's also] someone like the artist Phyllida Barlow, who is absolutely crucial. In the book, she's in a Barbour in the freezing cold, wearing layers and layers and layers of clothing in her studio, dipping her hand in gunk to make some kind of sculpture: the absolute, deep physicality of it.

RJ: So much of this book is about artists questioning or undermining the status quo. Is this something you consciously embedded on a narrative level by who you chose to focus on?

CP: At the beginning, I set myself one clear rule, which was that Picasso would be in the book, and Picasso gets one line. There's no hierarchy. So there can be no *Oh you are an artist of this stature, therefore you get more attention.* One of the longest sections is on [installation artist] Anthea Hamilton. The ideas that she's discussing are so important and strong, that's the length it deserves. It was very purposeful, because as soon as you start talking about clothes, you have to engage with patriarchy, you have to engage in [layers of] messaging. The art [world] is a very, very conservative industry that gets away with this conservatism because it allegedly allows for radicalism or freedom of thinking.

RJ: Speaking of radicalism, your next book is on the Bloomsbury Group and fashion. In the past couple of years, there's been a huge surge in interest in this group of British artists, writers and thinkers. Why do they continue to exert such a hold on us?

CP: They were radical humans at a time of radical change. It's that [shift] from Victorian to modern. The thing with them, particularly Virginia Woolf and Vanessa Bell, is about breaking this fashion industry assumption that the fashion industry drives fashion—like [claiming] corsets disappeared because of Paul Poiret. Actually, it's an act of refusal from young women, absolutely refusing to wear their stays. And this refusal combines with engagement with politics, writing, philosophy, sex. For me, it's a critical moment in time to understand the garments we wear today.

—

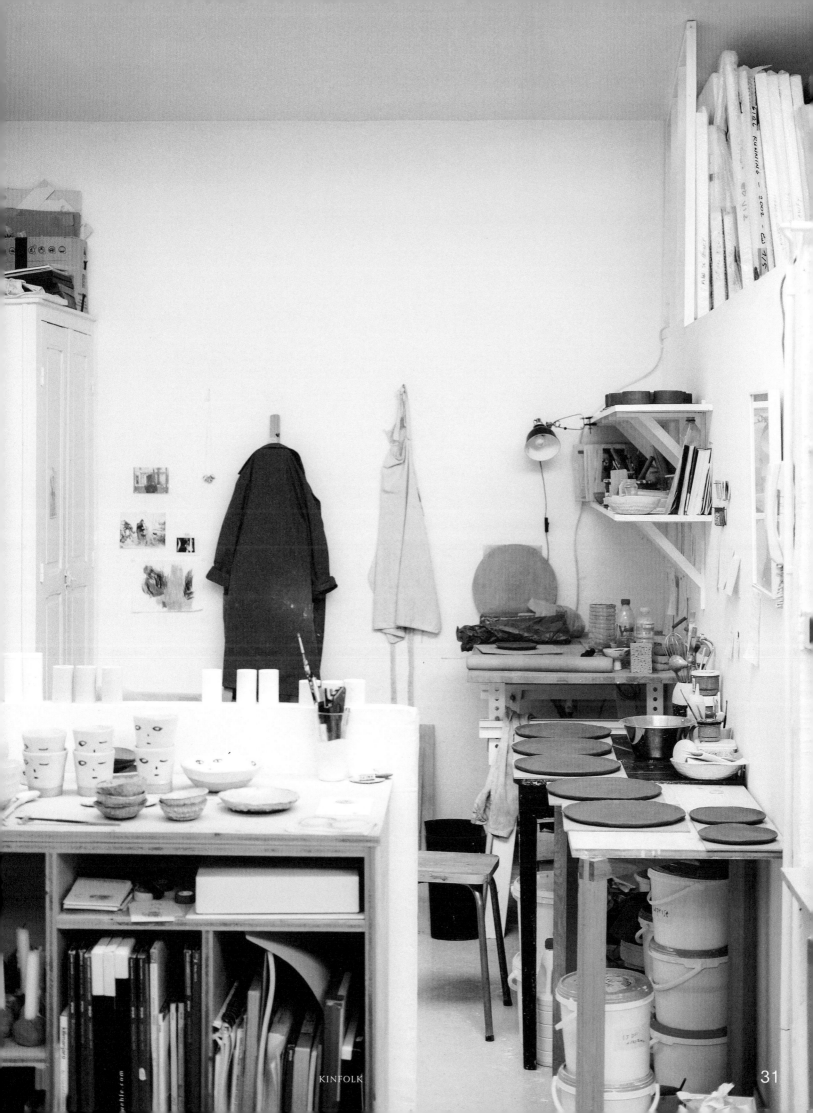

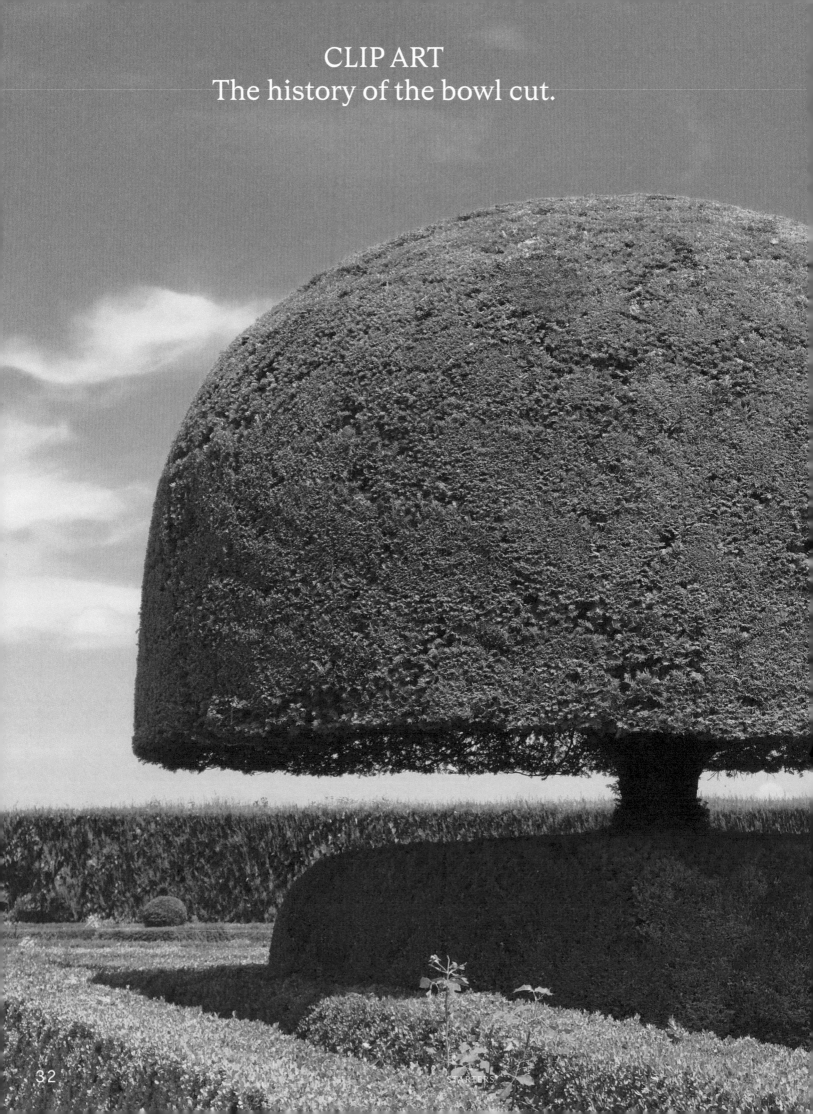

CLIP ART
The history of the bowl cut.

In hindsight, it's surprising that the bowl cut didn't make a triumphant return during the pandemic. If there was ever a moment for the archetypal do-it-yourself trim—staple of time-poor parents the world over, reviled by the children who had to sport them—it was when we were prohibited from visiting the hairdresser. Even the mullet made a comeback. Perhaps this is because, more than any other hairdo, the bowl cut associates the wearer with a particular set of characteristics: a foolishness and imbecility exemplified by Moe Howard of *Three Stooges* fame and renewed for a new generation by Jim Carrey in *Dumb and Dumber*. Then there's the hairstyle's more recent association with the far right, after the bowl cut of the perpetrator of a mass shooting in 2015 became a neo-Nazi meme. It has since been added to the Anti-Defamation League's list of hate symbols.

It is a pity that one of the few haircuts that can be reliably done at home, using equipment you can find in the kitchen, has been so maligned. For, contrary to the carefully coiffed bowls that illustrate the occasional half-hearted predictions of trend forecasters, a true bowl cut is one crafted by someone with little or no experience of cutting hair, hacking roughly around the edge of a mixing bowl with scissors. This would therefore discount the salon-styled bowl cuts of such style icons as the mop-top-era Beatles, Mr. Spock, Agnès Varda and, probably, Henry V of England.

Sure, some things are best left to the professionals, but you can't knock someone for trying themselves. At least the first time.

—

—

WORDS
GEORGE UPTON
PHOTO
JAVARMAN

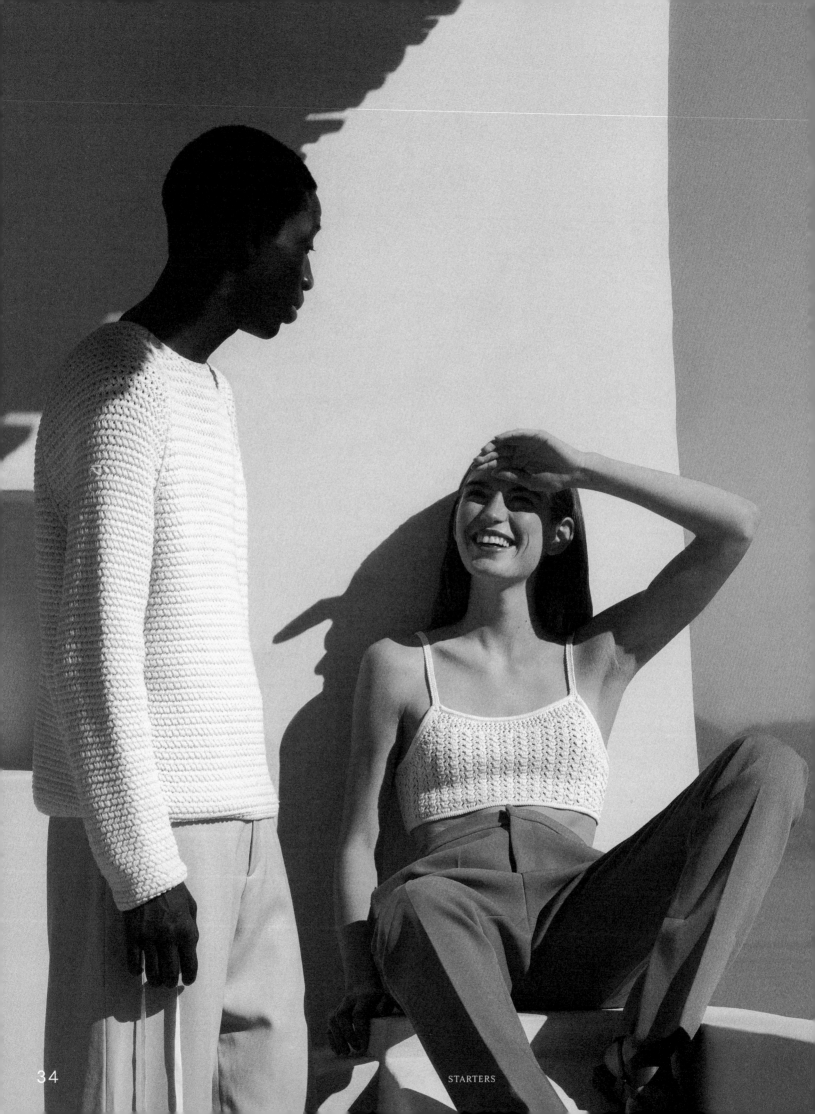

SWEET NOTHING

WORDS
NATHAN MA
PHOTO
CHRISTIAN MØLLER ANDERSEN

On the virtues of hanging out.

Some people try to program productivity into their downtime, engineering their social lives for constant stimulation. But in *Hanging Out: The Radical Power of Killing Time*, literary scholar Sheila Liming argues that we can gain so much more from just, well, hanging out.

In Liming's eyes, hanging out happens when we refuse to be productive in any economic sense. It's about making both the space and the time to bask in this nothingness. With references ranging from the work of philosopher Walter Benjamin to the Industrial Workers of the World to the Food Network, Liming seeks to understand when exactly we gave up our downtime and what we lost in doing so.

NATHAN MA: What first got you thinking about hanging out as a phenomenon worthy of serious study?

SHEILA LIMING: My entry point was thinking about hanging out on reality television. It was the first chapter of the book I wrote: I was reflecting on the uncanny experience of being part of my friend's reality television show, and how reality TV has become a major enterprise in our culture, and one of the primary ways that we engage with TV. Mostly, it's us eavesdropping on other people's social lives. It's us just watching people hang out. What do we see as the entertainment value in that? And why do we want to stare at other people? We might be doing that because we feel like something's missing in our own lives.

NM: You write that "what we can't agree to share has to be bought." For example, remote workers might visit a coworking space that offers both desks and a sense of "community." Is hanging out now a product?

SL: Anytime you notice that you're being sold something, that's an indication that it's becoming a pretty rarified commodity. It makes it something that we might actually want to buy.

NM: Is all hanging out created equal?

SL: Highly mediated forms of hanging out sometimes yield a different quality of interaction with others; when we're hanging out with friends online via direct message or text message, there's a different flow to the conversation. At times, there are also different expectations about what the conversation is supposed to do, or where it's supposed to go. If you're keeping a friend company over text messages while they're in line at the grocery store, you know exactly what your role in that scenario is. This is different from when we hang out in person—when we have unstructured time to spend in someone else's company. The more mediated the format of the hanging out is, the more constrained it can sometimes be in terms of what we're actually able to do, say or experience.

NM: What do people get wrong about hanging out?

SL: Our interactions on social media lead us to think of relationships as having this burden of permanence. The friends you have on Facebook could be people you've known for decades. There's a sense that you can't ever say "no" to these relationships. Hanging out becomes easier when we recognize that it doesn't have to be that way. Not everything has to last, nor does it have to be significant or meaningful. It can be fleeting, and that's fine too.

It's one of the more divisive habits among bibliophiles: to write in the margins of a book, or not? Is the act more subversive for being done in pen rather than pencil, or in the pages of a freshly printed hardback, rather than a secondhand paperback? Marginalia, the grand-sounding name for what is often a juvenile activity, can both delight and enrage, depending on who has created it and where.

As long as books have had margins, there has been marginalia. The scholars behind medieval textbooks littered the edges of their curlicued text with drawings of everything from disgruntled unicorns to monkeys playing the bagpipes. Noteworthy examples of more recent jottings: Vladimir Nabokov neatly going through *55 Short Stories from The New Yorker, 1940-1950* in pencil and grading each story. (He gave his own, "Colette," an A+.) Nelson Mandela, while imprisoned in 1977, writing his own name next to a passage from *Julius Caesar*—in a copy of Shakespeare passed around by his fellow inmates—that read: "Cowards die many times before their deaths." Examples of less impressive commentary: teenage notes screaming "SYMBOLISM!" next to storm depictions in 19th-century gothic novels.

Marginalia has always been one of the appeals of browsing in secondhand bookshops. The rise of the e-book over the past couple of decades had fans worried about its demise: How to preserve the grumblings of the Mark Twains of the future (the American writer has landed far lesser books than his own in important collections, simply because he wrote in them) if they only exist digitally? But few anticipated that the internet would ignite a new, broader appreciation for marginalia. Designers may be creating book covers with Instagram flatlays in mind, but Instagram stories and TikTok are filled with the pages themselves as users underline passages and show off Post-it notes of favorite pages. Will these insights stand the test of time? In some ways, yes. TikTok videos last for mere seconds, but once-beloved books will still wind up in a secondhand bookstore somewhere.

WORDS
ALICE VINCENT
PHOTO
CHRISTIAN MØLLER ANDERSEN

MARGINAL GAINS
On the joy of secondhand scribbles.

WORDS
ANNABEL BAI JACKSON
PHOTO
TILMAN HORNIG

There's a website that algorithmically recommends books to its users. I input my desired genre, pace and page length, and a whole roster of precisely tagged and well-endorsed options load onto the screen. It turns an old-fashioned conversation with a librarian into a high-speed search. But when standing in a bookshop later the same day, not one of the suggested titles springs to mind. The search begins all over again.

This is "digital amnesia"—the phenomenon of people forgetting stuff that's instantly, technologically available to them. It's why we defer to Google Maps in cities we've lived in for years, and can't string together a sentence in Spanish despite our unbroken Duolingo streak. There's a flavor of absurdism to this micro memory loss, like forgetting lines onstage as they're fed through an earpiece. Information is more available than ever before, and yet can sometimes feel more elusive.

Humans have always relied on external devices to keep hold of information (pen and paper were, once, a data-storage solution), but now the smartphone is the almanac, the expert and the archive all rolled into one. And while the zip line from acquiring to forgetting information can free up brain space for meaningful memories, instead of weekly shopping lists and facts from Wikipedia, it can also be corrosive. Some psychologists fear that when our synapses are asked to do only cursory, superficial work—to hold details for only a moment—our ability to form memory traces will wane, with our long-term recall as collateral damage.

Luckily, we can still restore our own hard drives. There are solutions beyond a nostalgic devotion to printed encyclopedias. Combining the brilliant stuff tucked away in our phones with active, tactile involvement could strengthen our ability to recall, synthesizing instant information with real-world impressions; studies have shown that "haptic perception" is key to durable memories. If an app describes the evening's constellation—go and look at it. If a website recommends an interesting movie—go and watch it. In this way, we can recover knowledge from fleeting, present-tense encounters and turn it into a reservoir for our own keeping—if only we can hold onto it long enough.

DELAYED GRATIFICATION
The long history of a new classic—the PK4 chair.

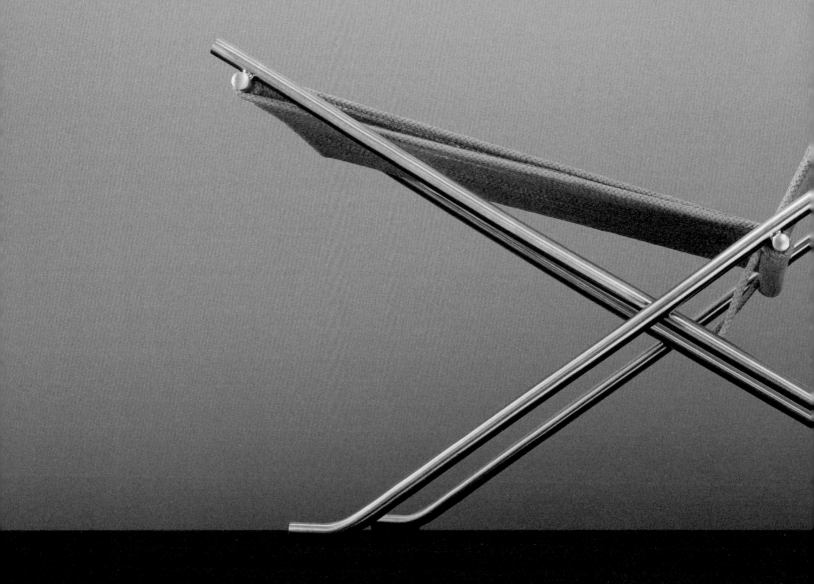

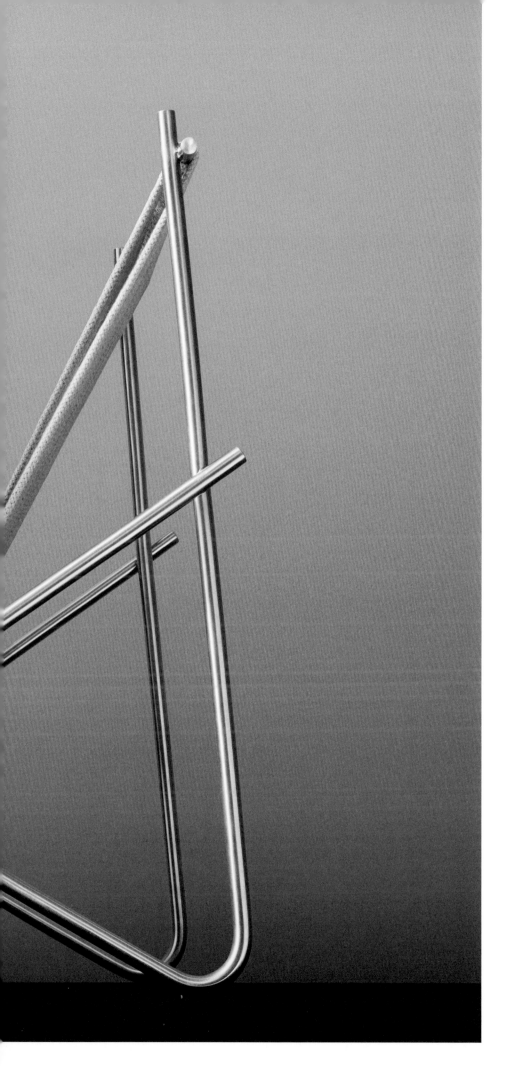

Design schools are much more than just a place to learn a trade. For young designers, particularly those coming of age at times of great change, they are often the site of bold innovations that will go on to define a new generation's aesthetic tastes.

For Danish designer Poul Kjærholm, the three years he spent at the School of Arts and Crafts in Copenhagen were transformative. By the end of 1952—the year he graduated—he had already designed four pieces that marked him out as one of Denmark's most important mid-century designers, despite being only in his early 20s. One of these—the PK4 chair—has recently been reissued by the Danish design house Fritz Hansen.

Developed as a simplified version of Kjærholm's graduation project, the PK4 demonstrates the idiosyncratic approach to form and materials that he developed as a student. While most of his contemporaries were working with natural materials, Kjærholm designed the PK4 from sections of tubular steel and a length of halyard rope, woven back and forth to form the seat and back of the chair.

Kjærholm's use of industrial materials goes beyond their practicality. "I consider steel a material with the same artistic merit as wood and leather," he once said. "The refraction of light on its surface is an important part of my artistic work."

Only a few PK4s were initially made, the frames manufactured by the father of Knud Holscher, another celebrated designer whom Kjærholm had met at school, and the halyard woven by Kjærholm and his wife, Hanne. The reissued Fritz Hansen PK4, developed in collaboration with the Kjærholm archive, is faithful to his straightforward design, with just one concession to make the chair even more comfortable.

"The slim-profile, circular pillow adds to the graphic appearance of the chair itself, and the materials borrow from Kjærholm's tradition of working with canvas and leather," says Marie-Louise Høstbo, creative design director at Fritz Hansen. "When you add to a historic design, it must be done respectfully, and with this loose pillow, the chair's profile remains defined."

WORDS
GEORGE UPTON
PHOTO
VILLE VARUMO

WORD: KALOPROSOPIA
A word that celebrates the masks we wear.

Etymology: The word *kaloprosopia* refers to the practice of living your life as a work of art. Rooted in the Greek words for "beautiful" (*kallos*) and "face" (*prósopon*), the term was devised by the fin de siècle French writer and occultist Joséphin Péladan who was dismayed at the rapid ascendancy of capitalism and mass production in late 19th-century Paris.[1] Péladan, an eccentric man with a taste for long robes and strong ideas, saw kaloprosopia as a counter to this new age of consumer culture: a way of consciously fashioning a personality that would stand in opposition to the mainstream.

Meaning: As Oscar Wilde once famously wrote, "give [a man] a mask and he'll tell you the truth." Kaloprosopia has been used to describe famous figures as varied as Marlene Dietrich and David Bowie, who understood the power of not just adopting a memorable persona, but of using it (or in Bowie's case, them) to shape a whole life. A mask is often seen as something synthetic—a veiling of reality, or even a form of trickery. But through the lens of kaloprosopia, a mask can lead to genuine transformation. Rather than a form of surface deception, it is a tool—just like clothing, physical appearance, interiors, mannerisms, accents, skills and so on—that offers infinite adaptability. By this measure, anyone can turn their life into a beautiful work of art. You just need to know what kind of character you wish to cultivate and then be bold enough to execute it.

Ironically, given Péladan's distaste for the world of consumerism and mass culture, kaloprosopia's most natural home today is likely on social media. The online world is a welcome habitat for those who wish to develop a beguiling picture of themselves, no matter how contrived. From bon mots on Twitter to the aesthetic choices made on Instagram, it's never been easier to shape exactly who you want to be. Perhaps we should embrace the showmanship of it, thinking of these sites with their ever-rolling updates as the modern-day equivalent of a Parisian boulevard: a place to see and be seen, full of unending possibilities for reinvention. But, so often, the performance happening there seems to be less of a repudiation of the world as it is than a chance to closely mirror its ideals.

(1) Péladan, both a Catholic and a mystic, was interested in magic symbols and beliefs. He became an influential Parisian salon host and convinced many Symbolists working at the time to embrace occult imagery. As befits a man who coined "kaloprosopia," he was generally considered pompous; literary critic Mario Praz described him as heroic in intention and comic in results.

WORDS
ROSALIND JANA
PHOTO
TONJE THILESEN

SLAYING IT
On the building blocks of horror.

A century ago, moviegoers experienced horror in the dark. Furtive, crazed villains in ominous, dank rooms set audiences on edge. The architectural backdrops of these horror films were dismal and unbalanced. In flickering black and white, German silent movies of the early 1920s established the convention. The sets of *The Cabinet of Doctor Caligari* were strangely twisted. The hard angles, slashes of light and shadow, and unaccountably distorted walls and windows unsettled audiences as much as the insane Caligari himself. *Nosferatu*, a lurid vampire story set in Transylvania, horrified audiences two years later. It established Gothic architecture as the essential counterpart to the sinister and occult themes of early horror films. Untended, overgrown and gloomy old buildings soon became standard backdrops to the devilry unfolding on-screen. Remote and mysterious, the disturbing strangeness of these settings gave the audience some distance from the fear. People might have been haunted in the dark of the movie theater, but when the lights went up they could return home and smile as they recalled their dread.

As the horror genre evolved, it moved into more mundane settings, which made the films all the more frightening. *Halloween* (and its 12 sequels) and *A Nightmare on Elm Street* brought gore and violence into the suburbs. The deranged villains in these movies grew up in these environs and returned to terrorize them. This kind of horror came into homes in more ways than one. With VHS and home theaters, viewers shivered as they watched in their own cozy living rooms, and afterward they lay fearfully awake in darkened bedrooms, alert for sounds of intruders. The relentless violence and jump scares in films from the 1970s and '80s disrupted the apparent normalcy and the security of life on tree-lined suburban streets and in modest, well-cared-for houses. Architecturally, their sets were nothing special, and that was the point. Nowhere was safe anymore.

Horror films have recently found more stylish venues to unnerve their audiences, as modernist architecture has taken over the genre. The austerity of sleek concrete and steel buildings has set life out of balance in films since the early 1970s, when dystopian futures played out against Brutalist structures in Stanley Kubrick's *A Clockwork Orange* and in the bunker-world of George Lucas' *THX 1138*.[1] In the past decade, modernist film sets have taken a more sinister turn. In thrillers such as *Ex Machina* and *Parasite*, dark themes play out against the hard edges, obsessive cleanliness and unforgiving openness of modernist houses. While seeming to reveal all, their brilliant, airy living spaces veil ominous hidden realms, which mirror the bleak inhumanity of their owners.

Whereas the antagonists of suburban slasher movies returned home to torment their victims with violence, the rich, narcissistic villains in these modernist houses play more cerebral games, relentlessly drawing their victims into their magnificent homes and cheerless lives. In *Ex Machina*, the house of an unfathomably rich tech CEO becomes an instrument of surveillance and control. In *Parasite*, an affluent family's modernist home obscures huge disparities of wealth and poverty, setting up an inevitable, violent clash. The cryptic themes of horror films born in the darkness a century ago have become more complex and deeply disturbing as they develop in the brightness and clarity of modern architecture.

WORDS
ALEX ANDERSON
PHOTO
TODD HIDO

(1) A 2022 exhibition at Ikon Gallery in Birmingham, UK, called *Horror in the Modernist Block*, looked at how postwar high-rise construction has become intertwined with tragedy in the popular imagination. Artworks on show included reference to the 2017 Grenfell Tower fire in London, which killed 72 people, and to the many workers who have died in high-rise construction projects around the world.

43

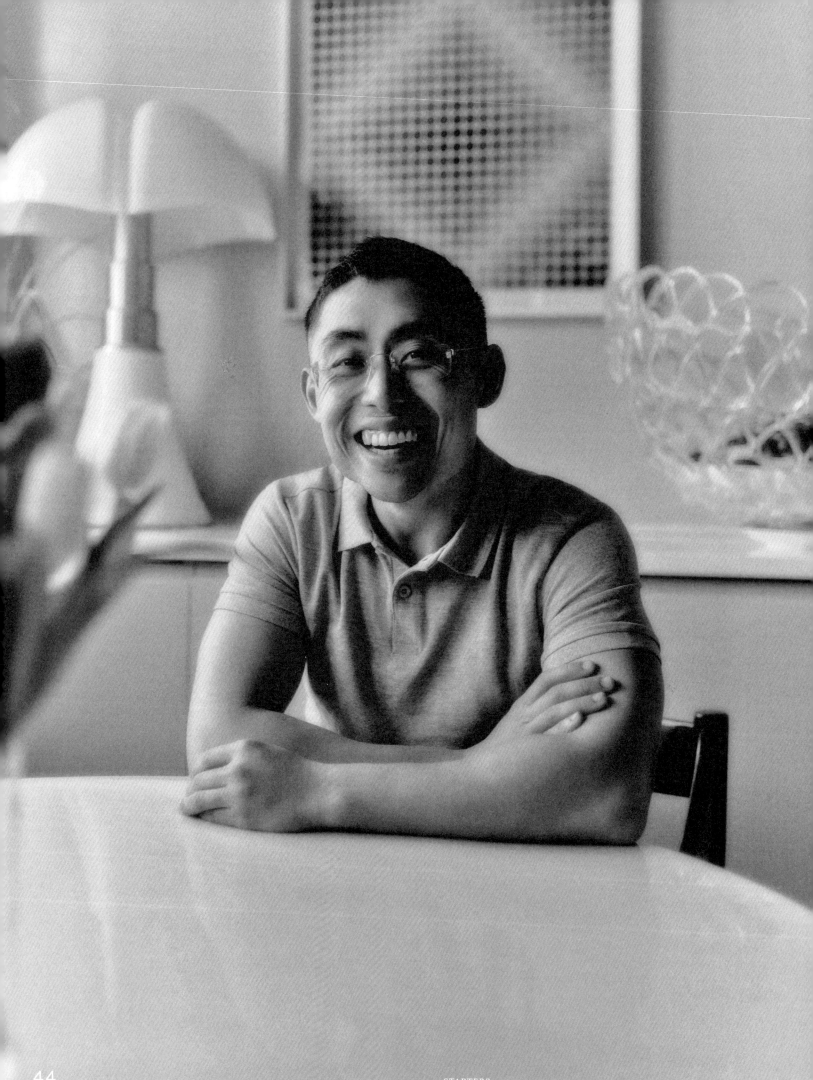

CLIFF TAN

WORDS
JENNA MAHALE
PHOTO
MARSÝ HILD ÞÓRSDÓTTIR

Four questions for a feng shui guru.

Seconds after we meet over a video call, Cliff Tan has diagnosed my living room: The space is in desperate need of a roller blind. "It will filter the light, give you some privacy and remove all that cutting energy," says the 35-year-old architect and TikTok phenomenon. He explains that the stripy shadows from the wooden slats over the window create tension, "like in the interrogation room in the movies."

With humor and candor, Tan uses the teachings of feng shui to give his two and a half million followers practical advice for transforming their living spaces. The ancient Chinese art form applies a range of concepts to optimize energy flow and create balance between important elements in rooms and buildings. "Feng shui is about finding the best place to be," he explains. "Not just crafting the right environment, but inhabiting the best spot within it."

JENNA MAHALE: How did you come to learn about feng shui?

CLIFF TAN: I'm from Singapore, where it's part and parcel of life. In East Asia there's a great focus on it in everything that we do. Growing up, my granddad happened to be a feng shui master, but I've always just been interested in buildings and architecture. I moved to London to study them and started my own practice not long after. Whether I tell my clients or not, I apply the principles of feng shui in all my designs because it's second nature to me.

JM: Why do you think there was such a huge Western craze around feng shui in the 1990s? It seems to have fallen out of fashion since.

CT: Feng shui is a bit like yoga: discussing energies, how to achieve balance. I think they were both quite fresh back then. During the communist era in China, feng shui was associated with spirituality and religion, which they wanted to stamp out. So you had this great wave of migration from the East—all these Cantonese people going to America and England and taking their culture with them. I don't know if it ever fell out of fashion. I know many people are skeptical about feng shui because the way it's presented can seem a bit too "woo-woo." I don't blame them, because people only rarely explain the rationale behind the way things are done in feng shui. But that's what my TikTok channel is really about.

JM: When it comes to home design, what's a common mistake you see?

CT: In terms of layouts: when people don't acknowledge the command position. This is basically the idea that you need to feel as secure and protected as possible in whatever you do. For example, you don't want to sit at your desk with your back facing the door—if someone comes in, you'll be startled. You want some distance between yourself and any kind of change.

JM: Any tips for making a new home feel more balanced?

CT: Try to ensure the color palette works together. Keeping everything in a room within one shade of each other will help the space feel more calming and reduce visual noise.

—

—

WORDS
ALLYSSIA ALLEYNE
PHOTO
CHOU MO

If you don't have a smart speaker in your home now, there's a high chance you will soon. In the United States alone, penetration rose from 0.5% of households in 2014 to 60% in 2022. But won't someone think of the children? In an opinion piece published in the *Archives of Disease in Childhood* journal last year, academics posited that voice-controlled smart devices could have "long-term consequences on empathy, compassion and critical thinking among children," in part because AI assistants don't require children to ask politely for what they want. No one wants a generation of tyrants who are rude to those who are close to them (and even worse to those who aren't), and tech firms have already taken note. In 2018, Google updated its Assistant with a "Pretty Please" mode that praises kids for saying please and thank you, and Amazon's kid-friendly Echo Dot offers similar incentives for polite chat, the way a teacher—or indeed a parent—might be expected to.

On the surface, it's progress. But it's also a bit rich, not least because, according to a 2019 Pew Research Center report, nearly half of adults, likely raised on human interaction, forgo the "please" when speaking to voice assistants. As adults we understand that, even when given a voice and a name, mechanical devices aren't people and, as such, do not have feelings to be appealed to. We should trust that children will understand that too.

Forcing a child to say please to machines may help drill the words into their heads through rote repetition. But these interactions won't teach them that people can turn you down no matter how nicely you ask, and that life is full of thankless tasks. With the gesture separated from the spectrum of outcomes, manners become nothing more than a means to an end.

If being courteous to an algorithm makes you feel good about yourself, or assuages some misplaced malaise, by all means do it. Ditto if you do so by force of habit. But there's no moral obligation to show manners to a machine that is incapable of appreciating them.

HOW TO TALK TO AI
Can you be rude to a robot?

FEATURES:

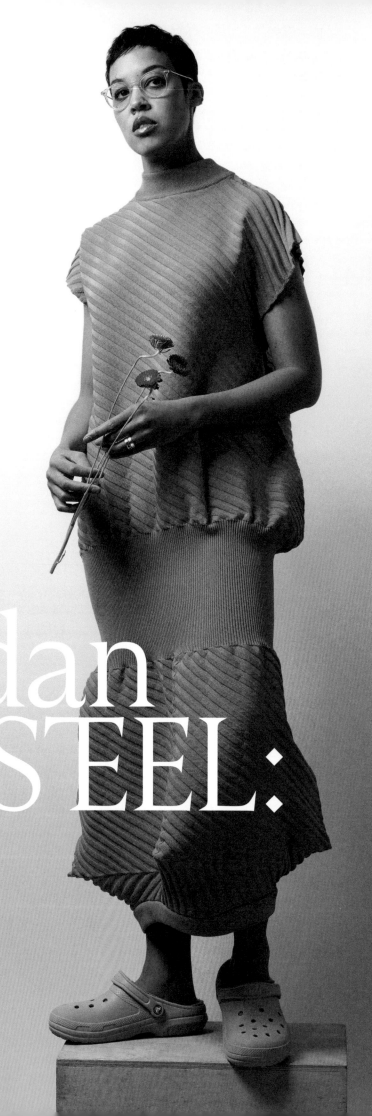

Jordan
CASTEEL:

Words
SALA ELISE
PATTERSON

TE ACCLAIMED PAINTER OF PEOPLE— AND NOW PLANTS.

Stylist
JÈSS MONTERDE

Photography
DAVID SCHULZE

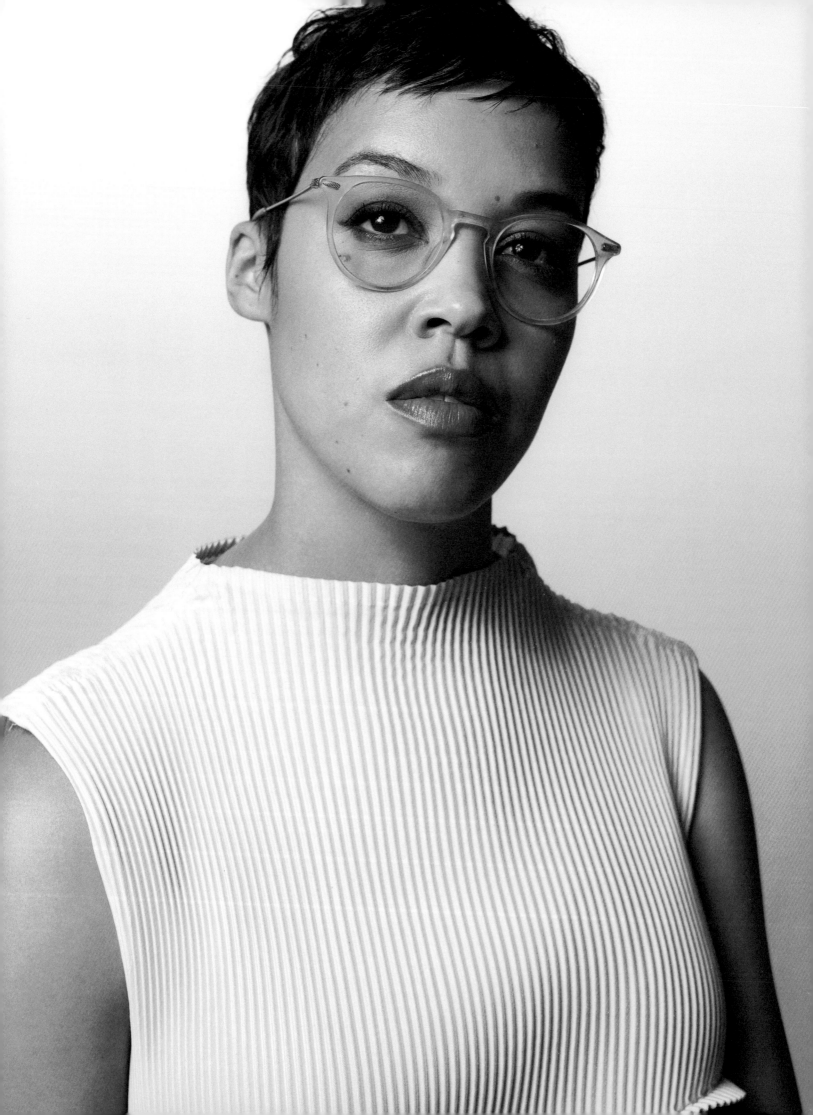

JORDAN CASTEEL shot to fame painting portraits of her New York neighbors. So why did she move upstate and start painting flowers?

Set Designer: Sally Morris Clark. Hair & Makeup: Magdalena Major

A reproduction of David Hammons' "African-American Flag" stands guard over painter Jordan Casteel's sweet, one-story home in the Catskill Mountains of New York. A reinterpretation of the American original in the Pan-African red, black and green, the flag can be read many ways: affirmation, art history lesson, political statement.

For Casteel—a recent transplant from Harlem—it is a sort of placemaker. She became a headline name in New York City's contemporary art scene, and the flag conjures the Black and brown community she left behind and summons a version of it that she hopes to build upstate. It's the same flag that appears on the facade of the Studio Museum in Harlem, where she was an artist-in-residence in its career-making studio program between 2015 and 2016.

Casteel and her husband, photographer David Schulze, bought this property in 2020. Shortly after, they added a freestanding studio building (she's upstairs, he's down) and decided to call this place home. Casteel welcomes me at the door of the studio on a bright winter's day in February wearing a multicolored patchwork sweater and a smile. "One of the first things I did when we got here was put up the flag," she tells me, sitting at the kitchen table on the first floor of the studio. "If this is a home that I'm going to be a part of, like the Studio Museum, what this flag is and represents, all of these things are true to the identity of what this house is going to be."

The interior of the building has an industrial feel with its high ceilings and hard angles, but it's softened by white walls, unfinished wood on the stairs and hallways and lighting over Casteel's workspace that is specially engineered to imitate natural light. It's a peaceful, domestic setup. Her studio manager is tapping away upstairs. Schulze pops in to get carryout lunch requests.

How Casteel came to live high on a grassy hill 100 miles from the city is a study in being and becoming: being an artist and becoming a public figure, with all the demands that come with it. The inflection points of her meteoric rise are well-documented: Her first major solo exhibition, *Visible Man*, in 2014 (the same year she finished an MFA at Yale); the Studio Museum residency in 2015 which led to increasingly impressive showings at galleries, museums and on "One-to-Watch" lists; a portrait of her mother selling at Christie's in 2020 for $666,734, more than twice the high estimate, setting an auction record for Casteel. Days later, her first major solo show opened at the New Museum, exactly one decade after she took her first oil painting class while studying abroad in Italy as an undergraduate. Next came an event that cemented Casteel's status as an art world phenomenon. In 2021, she received the prestigious MacArthur Foundation

(previous) Casteel wears a dress by ISSEY MIYAKE and shoes by CROCS.
(opposite) She wears a top by ISSEY MIYAKE.

"Genius Grant," an unrestricted $625,000 award given to "extraordinarily talented and creative individuals as an investment in their potential." She was 32 at the time.

"I remember finding out about the MacArthur, and actually the first thing I felt wasn't excitement but a sort of fear of what it meant to have something that big at this point in my career," Casteel says. "Of course, it's amazing. But the pressure of [the award] got me first. And I felt that as the pressure was growing, I was losing sight of the thing that got me here in the first place."

The "thing" that got Casteel here—aside from her extraordinary talent with a paintbrush—is her community. Casteel's people—her subjects—are the ones right in front of her: family, her students at Rutgers University–Newark where she taught from 2016—2021, other grad students at Yale and, after graduation, the New Yorkers who were fixtures of her every day—in the subway car, or milling about under her window at the Studio Museum.

She explains her thought process at the time. "I wanted to highlight people and make paintings that [brought] them into this museum that I've come to know and love, to find a way of bringing the street that was so pronounced to me into the space," she says. There is something very full and true about the lives on display in a Casteel portrait. These are whole people and whole worlds. Calling herself a "referential painter," she works from multiple photographs that she takes of her subject, collaging them together to forge one rich painting that encapsulates the totality of her experiences with the person. From many images emerges another more true than the sum of its parts. In Casteel's paintings, you feel the heat

emanating off a charged body or from the pavement on a summer day. You hear the whine of a restless child, sense the love between a hand-holding couple or the unbreakable pride of a man sitting spine-straight. Thelma Golden, director of the Studio Museum described it as Casteel's

(above)
Casteel wears a dress by MARA HOFFMAN.

ability "to capture a sense of spirit, a sense of self, a sense of soul."

Not surprisingly, Casteel tries to build intimate relationships with her subjects. At a minimum, that engagement involves sharing a signed print of the finished painting, keeping the subject abreast of whose collection it joins and where it shows. She insists on that. But some people are open to going all in. Like James, a man she has painted three times since meeting him in 2015 in front of

the famed soul food restaurant Sylvia's— once on his own, then with his wife, and again since his wife has passed. When asked about the community she has left behind in New York, James is among the first people she mentions.

Casteel describes herself as an introvert, but the desire to know and paint her community draws her out and keeps her going. "Although I perform a certain extroversion, my soul is soothed by time alone," she says. "I could be inclined to be quiet and go off in the woods and completely disappear." So, the move to the Catskills. Although Casteel says there was some trepidation about leaving the city and its rich diversity, it appealed to the part of her that craves seclusion—as well as to her inner "Colorado girl."

The plan, however, is not to disappear. "I thrive on intimate relationships, and painting has become a way for me to interrogate that and secure it in my life," she says. "When I do meet people and I am building relationships and I am sitting with someone and I'm hearing their story and I'm sharing mine, then something real happens. It's like magic." In fact, she and Schulze chose the Catskill region because of the number of people of color they saw around town, and therefore the prospect of being able to feel at home. A lot has been made of the fact that Casteel paints African Americans (especially men) and immigrants. To a certain extent it's true. She has talked about how painting people of color is nonnegotiable for her as a Black artist. But she has also lamented that this is an idea that gets glommed onto and twisted (not to mention that the same observation would never be made of white figurative artists whose subjects are all white). For example, one erroneous version

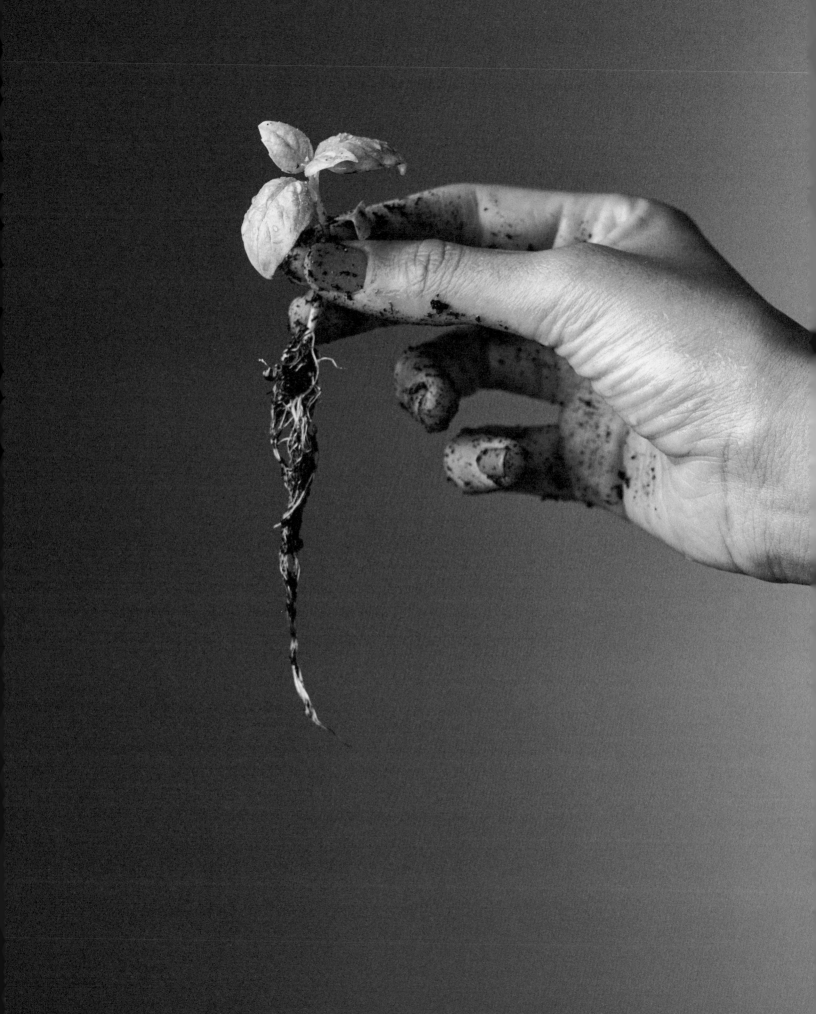

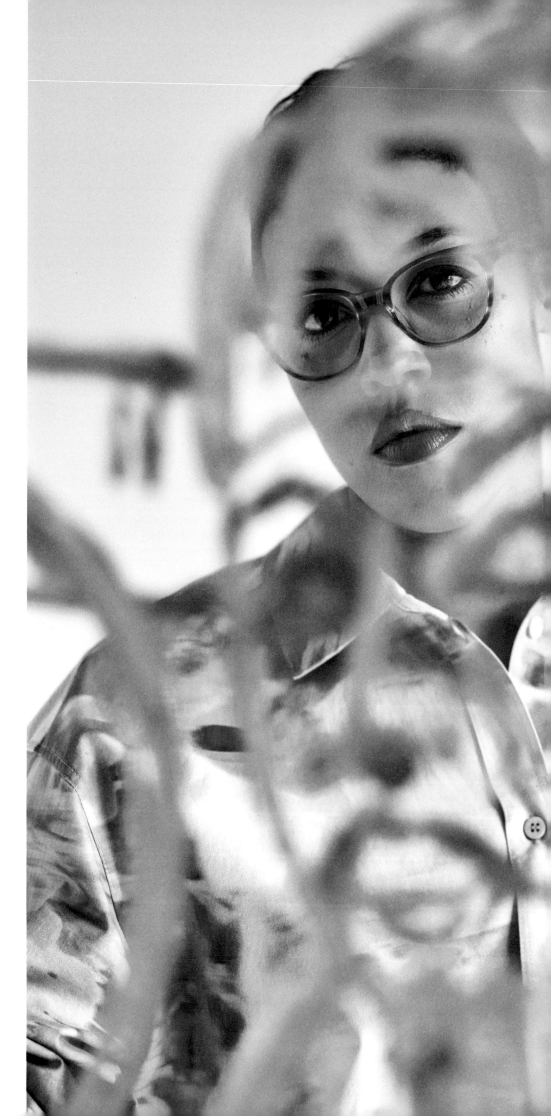

of things says she started painting Black people after Trayvon Martin was murdered.

The problem is that stopping at the race of her subjects is reductive and obfuscates her motivation—which is more complex and quite beautiful. Yes, she has chosen to feature people, who like her, have traditionally not been seen as worthy of being on museum walls. But also, and before all else, she wants to do what she loves (painting) to honor what she loves. She has been exasperated by the mishandling of her story: "People's capacity to understand the intention behind the work and my commitment to it and my commitment as a practitioner first, is so hard. All of the language becomes so important, in helping —as one of 'the onlys' in the space—to define other people's relationship to it," she says.

 Case in point: Living upstate, Casteel has been drawn to the earth. Once she moved there full time, she found herself choosing time in the garden over the studio. Like the street vendors and neighbors who had enthralled her when she was working in Harlem, the landscape and her plot in their seasonal machinations became the focus of her loving attention. But, she didn't think to paint them, she says, because the story that had been constructed around her (and by extension her newfound success), associated her with the figure, especially the Black one. And while she resents a narrative that "shrinks the breadth of the work that I do," as she puts it, the voices in her head also made her question whether the value people placed on her as a painter might diminish if she ventured out to new subjects. "The whole narrative of what it means to be a painter and what people value as it relates to me as a painter in this moment was superseding the thing that I just wanted to paint."

Ultimately, and with her husband's encouragement, she said *screw it* and the result was liberating. "I'm now starting to paint landscapes and still lifes, leaning into the questions of light and space and form within the context of a still life or my immediate surroundings as they are changing," she says. A few of those pieces debuted in *Jordan Casteel: In Bloom* at Casey Kaplan

> " I have seen
> enough examples
> of institutions
> using, abusing and
> cycling through
> a person like me
> with no recourse."

gallery last fall to great acclaim.[1] Casteel says landscapes and still lifes feel like self-portraits because the flowers she paints either have significance in her personal history or because they were coaxed to life by her own hand. Take the painting from which the show gets it title: In the foreground is a beautiful riot of zinnias in her garden. The flower was a favorite of her beloved grandmother and "nods to what's important to me," she says. "I see my own labor in it. It's not about observing the things that are most true for *you* in this moment. It's about observing the things that were most true for *me*."

The branching out was so pivotal that she held on to the first painting in the series, *Woven*. It hangs in her home and reminds her, essentially, to stay free. "The practice has to be willing to stretch and grow. I don't want people to define me. I need the practice not to be defined," she emphasizes. The move upstate has been a catalyst for this process. "I just knew that I could potentially have more balance and sense of self, that the art world and the expectations around my growing name and career would need the grounding that the land could offer," she says.

Casteel's love of the city and her world there is still alive; she still owns a home in Harlem and was in the city last week for an exhibition opening. But she thrives on the life she leads between those visits, filled with time in the garden, "keeping my hands

moving in other ways than just the studio." And she is slowly beginning to find her people here. She mentions a local writer friend and a family that owns a local restaurant who she plans to paint. She trusts that others will follow. "Now that I've been here full time, I'm finding that as soon as you sit somewhere for a period of time, people appear. It might take me a little longer to find them here. But there's a whole world of people that can open up through one person's introduction. And it's already beginning to happen," she says.

The need for a pared down life is born of a lot of success packed into a small number of years and at a young age. Add to that the tax of being a Black woman and the whiplash of being touted by institutions that have historically excluded people who look like you. It requires a lot of tightrope walking, triple guessing and holding up of the weight that has been placed on your shoulders—no matter how grateful you are to be chosen to carry it. Casteel is aware of the hazards. "I have seen historically enough examples of institutions using, abusing and cycling through a person like me with no recourse. There is real potential for that in my mind, regardless of the amount of accolades that I've had."

For Casteel, the only way to be immune to that is to focus on the work and its meaning. At this point, that looks like tending to the cycles of life, be it a person or a blossom, or her own evolution. "That's where the practice derived itself: from being in the world and being curious and discovering people and things," she says. "I don't want to burn out. I want to do this for a very long time."

(1) The exhibition was name-checked by *Time* magazine when it featured Casteel on the Time 100 Next list in 2022. Her entry read: "In expanding her repertoire to the natural world, Casteel makes yet another inextricable connection, between people and the ecosystems they occupy."

(opposite) Casteel wears a shirt by STINE GOYA.

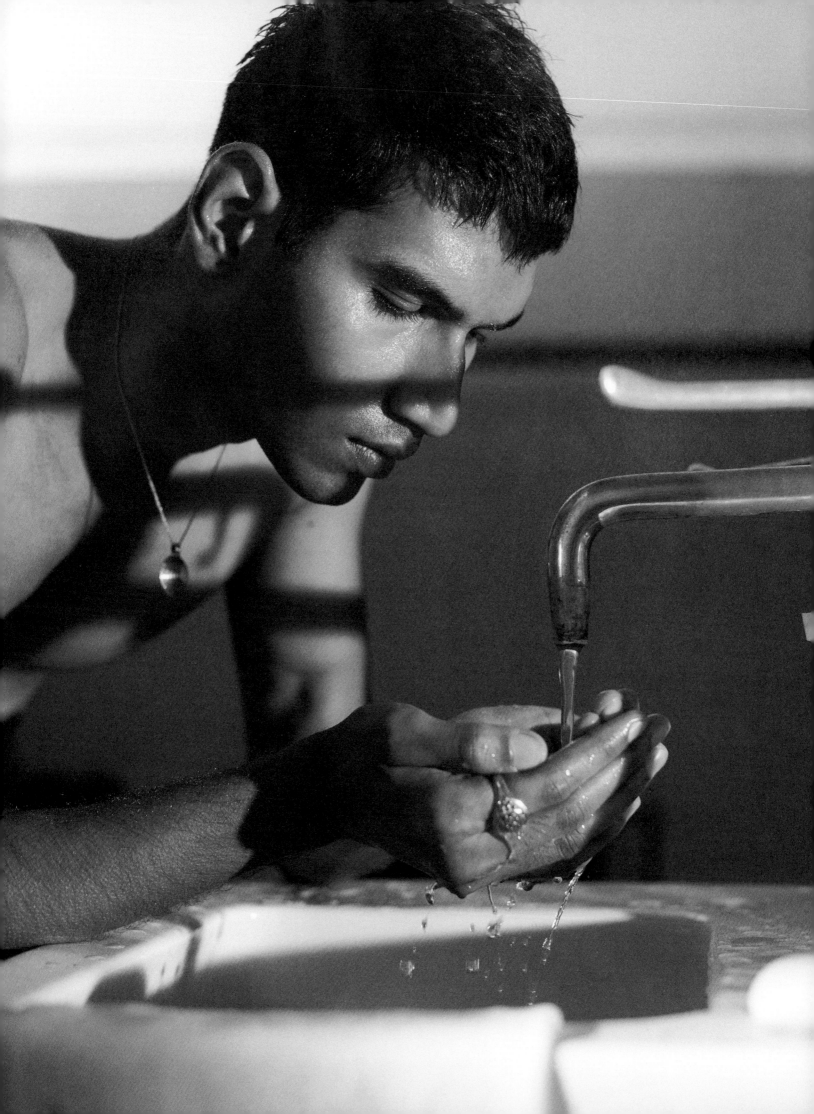

The healing powers
of a long, hot soak.

59 MINERAL CONTENT

Photography
PELLE CRÉPIN
Styling
DAVID NOLAN

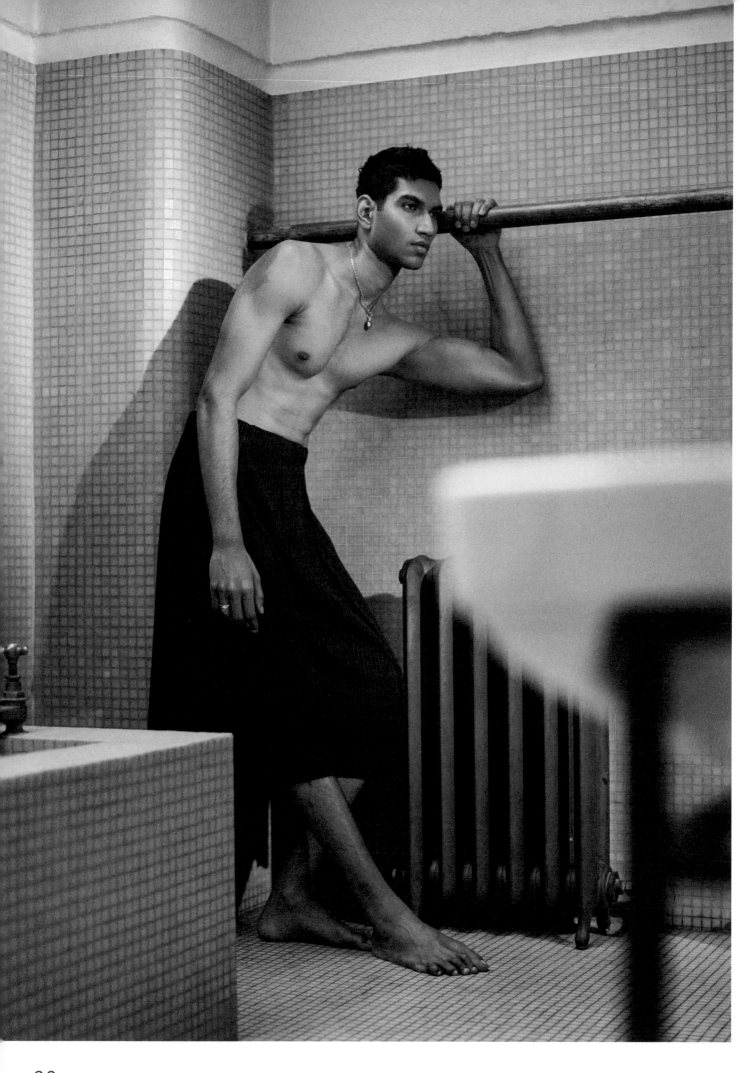

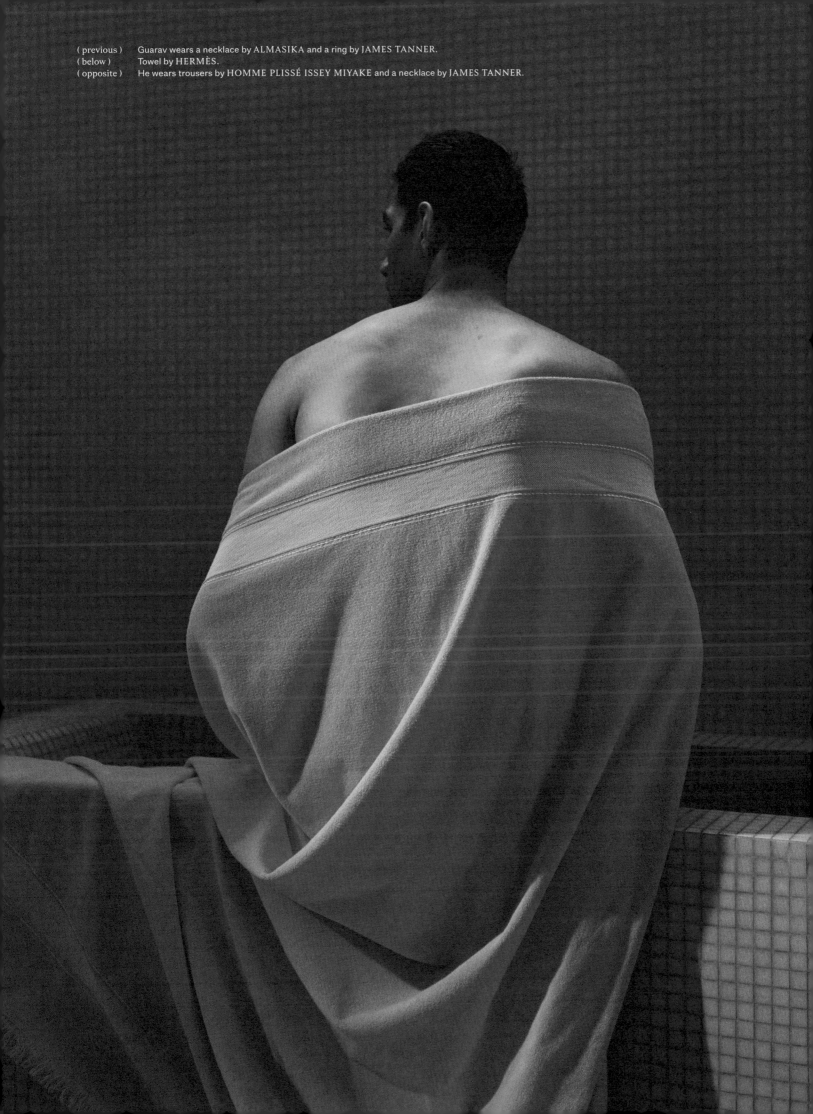

(previous) Guarav wears a necklace by ALMASIKA and a ring by JAMES TANNER.
(below) Towel by HERMÈS.
(opposite) He wears trousers by HOMME PLISSÉ ISSEY MIYAKE and a necklace by JAMES TANNER.

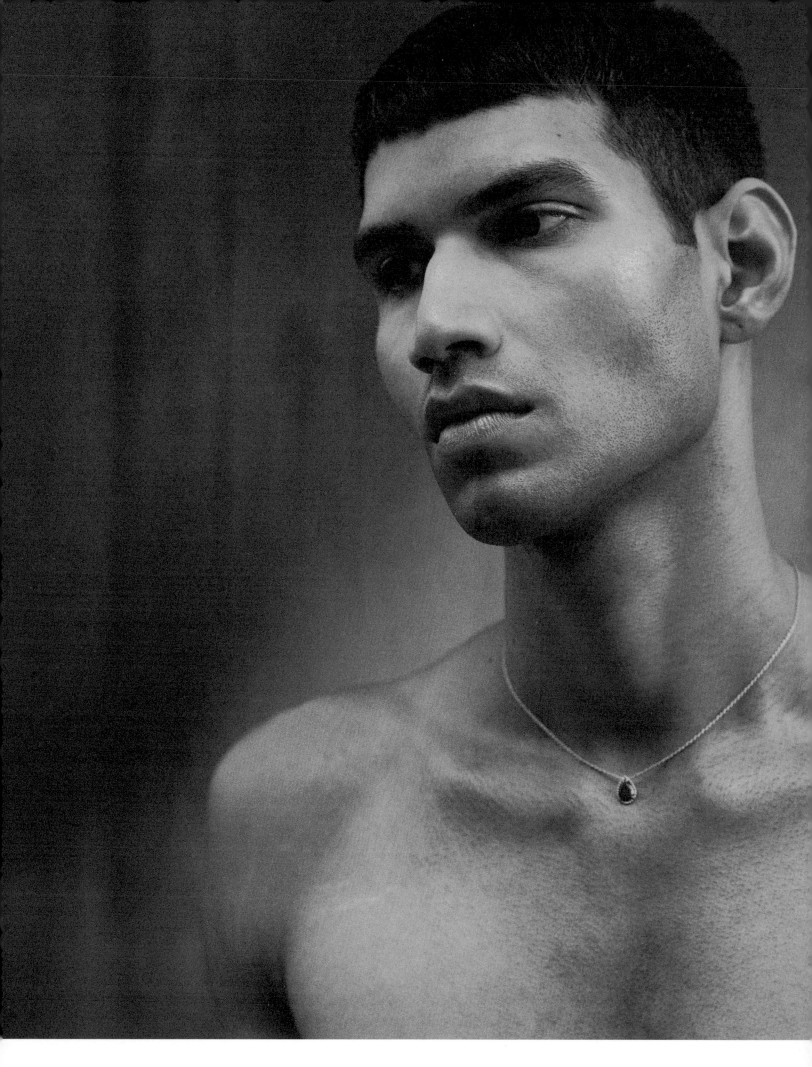

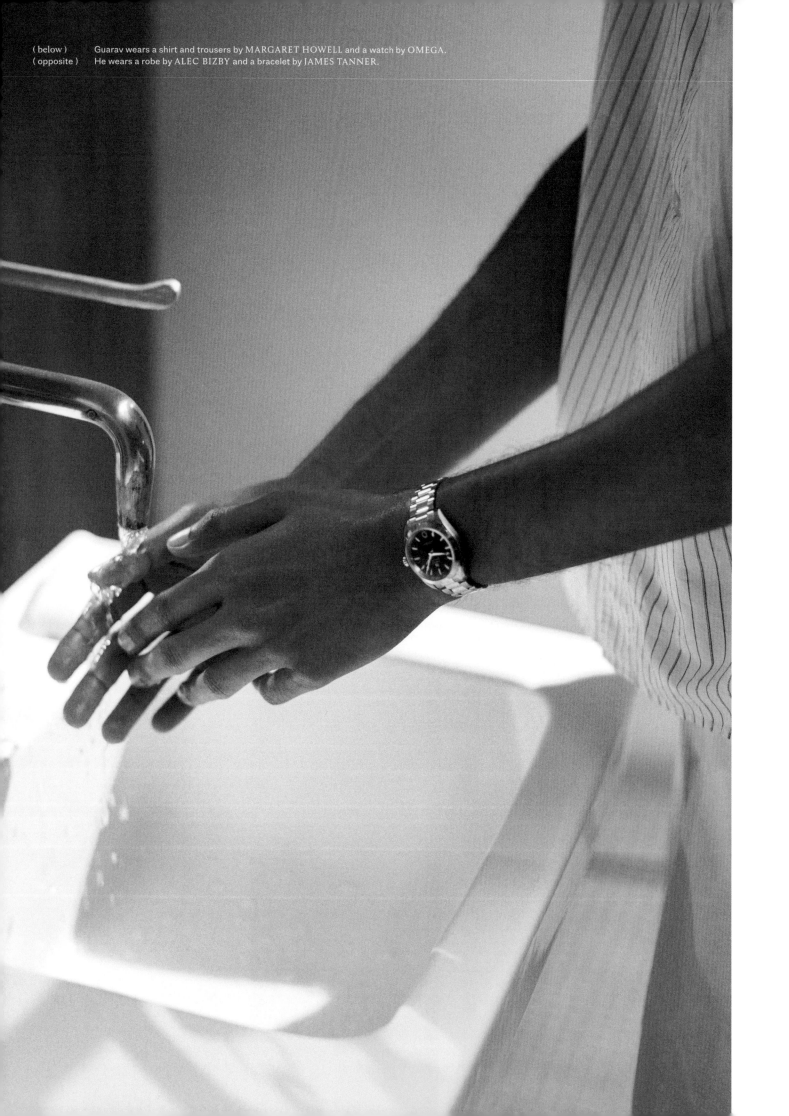

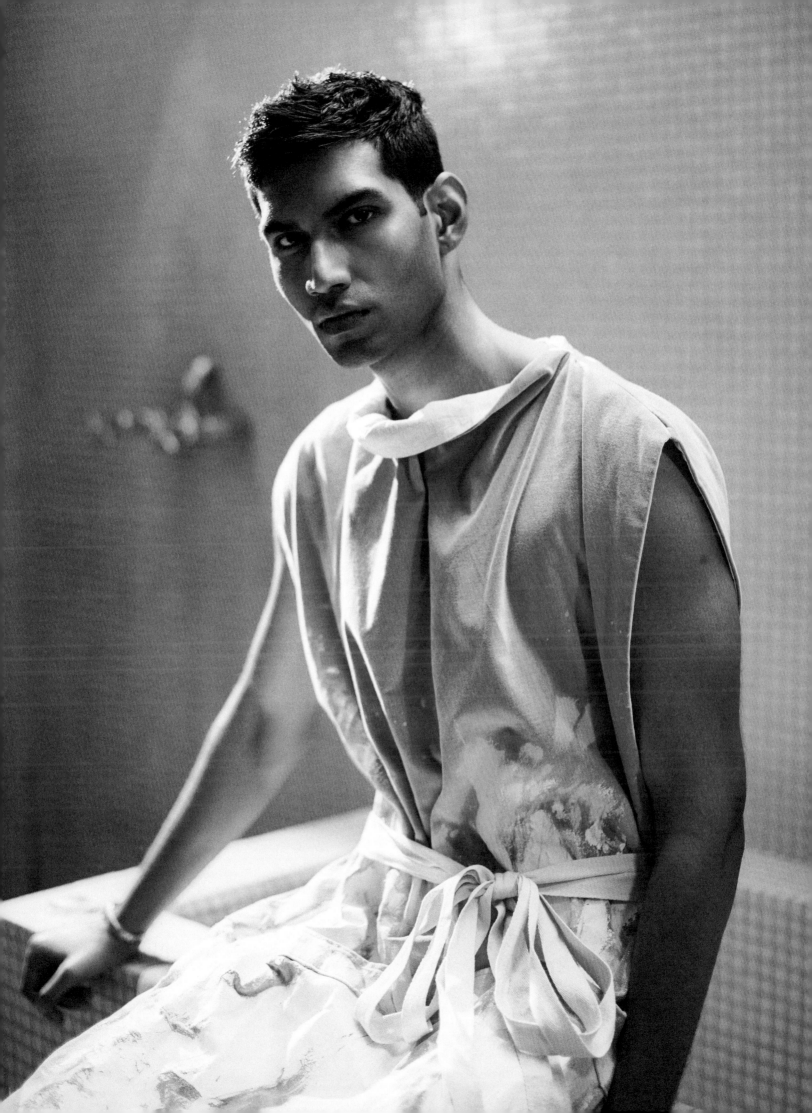

Photos ANDY MASSACCESI

At Work With: STUDIO UTTE

A visit to the small, sophisticated Milanese studio of Patrizio Gola & Guglielmo Giagnotti.

Words LAURA RYSMAN

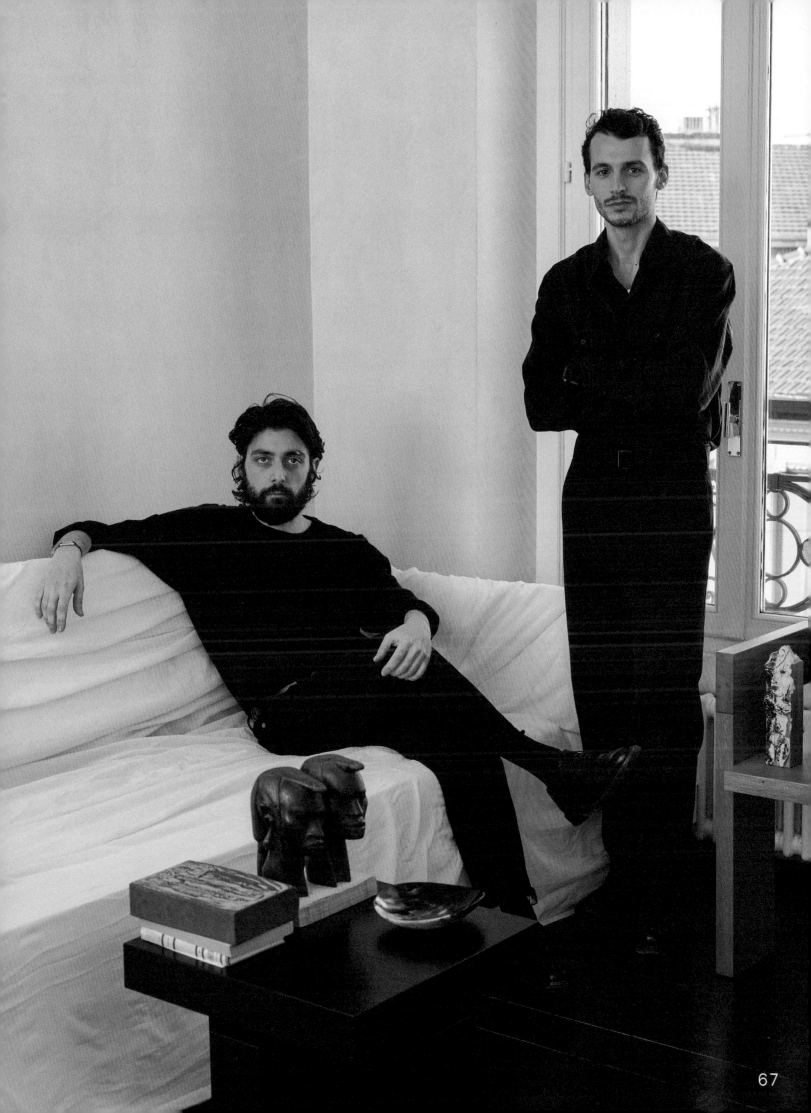

In just three short years, STUDIO UTTE has perfected the time-consuming art of utter simplicity.

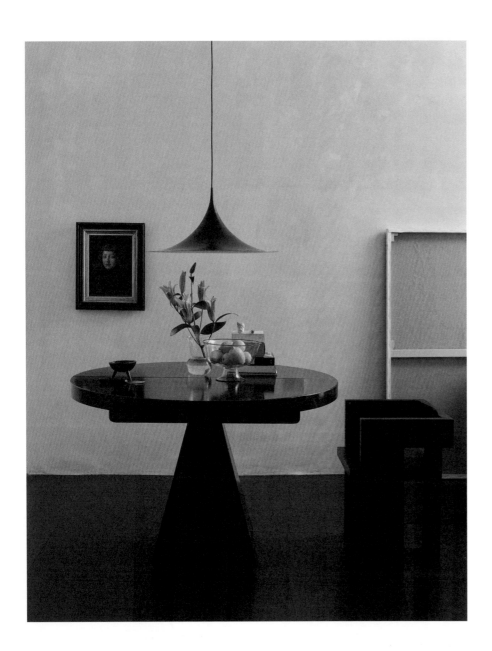

The Milan neighborhood surrounding the headquarters of Studio Utte is an exuberant jumble of 20th-century architecture. Just beyond the Central Station, with its fascist-era soaring halls and larger-than-life classical decorations, you'll find stately art nouveau and neo-Gothic residences standing beside eccentric 1970s apartment blocks built to fill bombed-out lots. Gio Ponti's green-tiled cubist Palazzo Montedoria is among them. Milan, considered ugly by Italian traditionalists, bears its own kind of splendor: a zany abandon unhindered by heritage and spurred on by the wealth and rapid building needs of the last hundred years.

It's the context in which Studio Utte was born, and from which it stands apart. On arrival, I leave the madcap experiments of the street outside and enter a domain restrained to the palette of a black-and-white photograph. Patrizio Gola (black crewneck, white button-down, white pants) flanks Guglielmo Giagnotti (black sweatshirt, black Levis), who holds open the door—it's his apartment, with the studio office upstairs. The walls are a foggy gray; the wood-beam floors are stained brown; a couch is cloaked in a white sheet. There's a monolithic dark wood table made by Vittorio Introini, and I am invited to sit in the ebonized oak version of Studio Utte's emblematic 001 Ert chair. Constructed with seven planks of wood, the box-shaped seat is both airy and majestic, zen and imposing—an exercise in absolute quietude.

"Simplification takes an incredibly long time," says Giagnotti. "There's an enormous complexity in the work of eliminating details." Gola adds, "You have to eradicate all traces of trends or fashion from your mind

to create something that, we like to think, is an object without a connection to any specific era."

Having founded their studio in 2020, the duo's first big project was the Munich concept shop Rootine, for which the designers conceived a meditative space of natural materials and custom furnishings. There's a discreet wall lamp shielded by a sleeve of steel, a heroic-sized oak table, plus stools, chairs and the other needs of the lifestyle brand—a big undertaking for a fledgling operation. "We weren't scared," says Giagnotti. "At the beginning, there was nothing but enthusiasm," says Gola. "Then came reality," adds his partner.

But Studio Utte (from the German *hütte*: a hut, small cabana, wooden cabin, or shelter. "The origin of architecture is the protection of mankind," explains Giagnotti) is making its own reality, today designing a handful of homes and launching limited-edition furniture as the pair adhere carefully to the rules they've set out for themselves—spareness, timelessness, pure form that speaks to the quintessential. They're happy to keep the studio small. The designers both previously worked at Dimore-studio, though in different departments, when the fast-growing firm was in the process of leaving behind its original lush but uncluttered aesthetic in favor of more flash.

"We like everything possible to be done in-house," says Gola, as Giagnotti dashes up the iron spiral staircase to find the catalogs they've produced. The oversized books contain the stark photos of objects they shot with a manual 1970s camera, alongside the messy charcoal sketches that begat them. "We love everything analog," says Giagnotti. Their Giano vase, shown in the catalog, also sits in physical form on the floor—a chalk-colored bulb of terra-cotta blooming atop a tapered base, whose perfect and austere geometry is softened by irregular handmade facets. "All of our designs begin from sketches," says Giagnotti, "but our ceramics remain closer to the original imperfectness of hand-drawings." These terra-cotta pieces, "small architectures," says Gola, create a "warm minimalism: not perfectly orthogonal, not industrial, but manual and expressive."

Their design process begins with piles of books and references covering the table, then drawings and discussion. A nascent form emerges to be repeatedly re-elaborated and pared down, and a final archetypal object is produced. Their studio space, a pocket-sized attic room with a sloped wood-beam ceiling and skylights over the desks, bears witness to their thought process with heaps of books—boldface spines celebrating Isamu Noguchi, Enzo Mari, Tadao Ando, Carlo Scarpa and other purists—plus "I spy" sketches, notes, photos, sample blocks of black wood, rattan seat backs in a range of dark finishes and much more: creative chaos in monochrome.

On the living room table there are three small handmade knives. I pick up one of them—a slim and artful curve of solid horn. "We're serial hoarders," admits Giagnotti. It's not what one might expect from the authors of such harmoniously essentialist designs, but the accumulations of objects have profound significance for the two. The knife, a gift from Gola to Giagnotti, was crafted specifically for caviar. "We don't have caviar yet, just the knife," jokes Giagnotti. It's also a symbol of an Italian legacy—of high craftsmanship and design applied to the quotidian details of life, of the depth and everyday beauty that has made Italy an aesthetic dream in the eyes of the world. The partners express an almost mystical belief in ascribing an animism to objects, but it's a faith derived from culture, and from reverence for the radical and experimental talents of architecture and design that helped illuminate a path for them.

They hail from opposite ends of Italy—Gola from Sondrio near the northern border with Switzerland, Giagnotti from Molfetta along the southernmost heel of Italy in Puglia. They venerate an Italianate design language in its most minimalist and modernist forms, with admiration for the concise styles

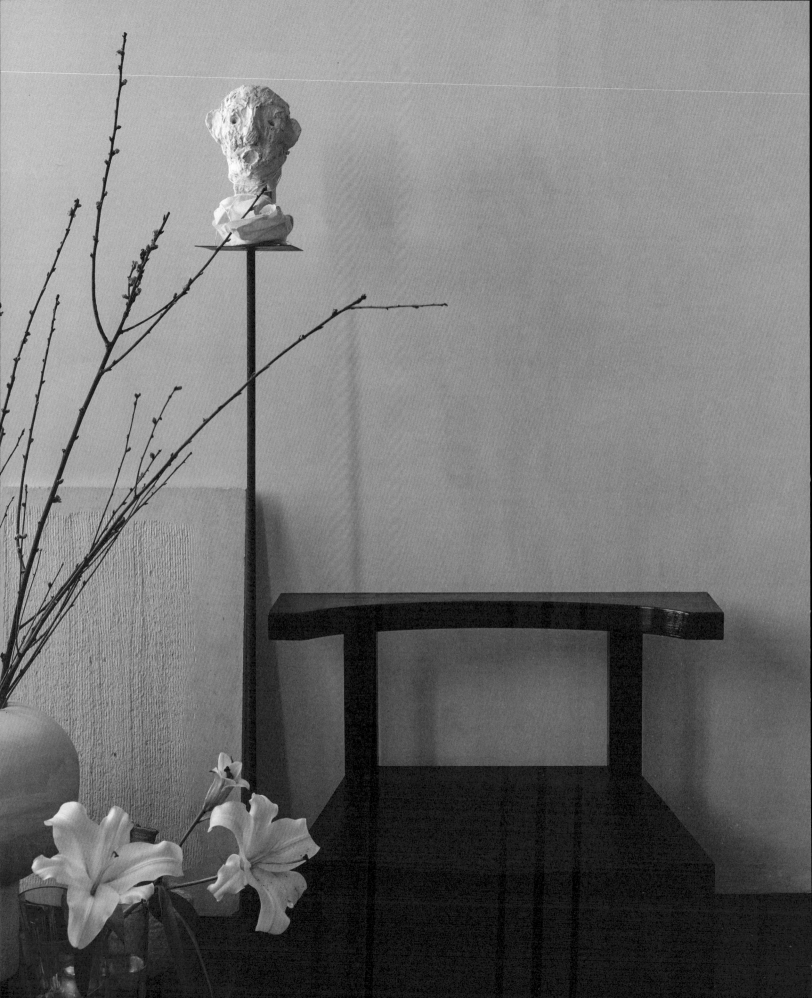

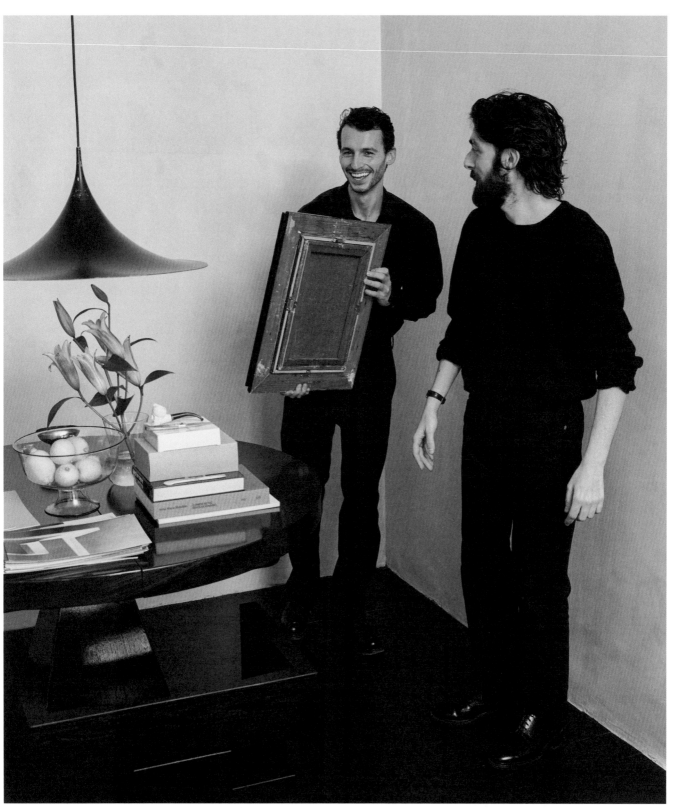

(above) Gola (left) and Giagnotti (right) have furnished the studio with pieces by other designers whose legacies
they admire. The central table is by mid-century designer Vittorio Introini.

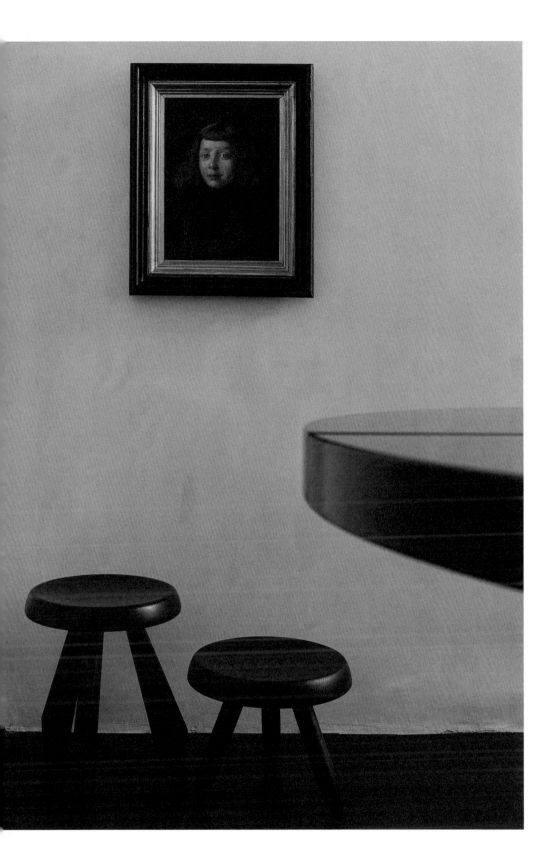

of Scandinavia, the Netherlands and Belgium, where Giagnotti worked for Vincent Van Duysen for three years. "What brought us together is minimalism—this finding of the canons of form—tinged by Italianism," he says. They point to the clean-lined exactitude of the 1920s, to Giuseppe Pagano, to Giovanni Muzzi, to Villa Necchi, to architecture that flourished during Mussolini's reign.

This is a difficult topic for Italy's design community. "Unfortunately, there was a politicization of architecture in Italy," says Gola. "The country attained this great simplicity and minimalism, but its connection with fascism ruined the aesthetic, and the result afterwards was a more baroque style." But today in Italy, people are largely so distanced from political life that the terror of the fascist years feels nearly as far away and impersonal as the reign of Julius Caesar. (Distant enough, even, to elect a prime minister with neo-fascist roots.) There hasn't been the same reckoning with the historical meaning of monuments and buildings that there has been in the US and elsewhere.

But Giagnotti and Gola also draw from a host of postwar architects as influences. They're encyclopedias of modern design, citing everyone from Aldo Rossi to Piero De Martini, Mario Bellini, and especially the great pragmatist Enzo Mari, an anti-capitalist firebrand who saw design as a tool to help overturn bourgeois society. For Studio Utte, their mission is instead to quiet things down. We live in a time when design has lost its links to ideologies, but has become a personal signifier, and for these two their designs are totems of a desired peace: hushed and clarified objects whose contemplative simplicity spreads a calm that surpasses the commotion of our time, odes to the eternal goal of serenity.

"We always say that there needs to be silence in architecture," says Giagnotti. The presence of "noise," or trends or extraneous details, says Gola, "wears out your interest, where silence is timeless."

Do they possess this tranquility inside them? "We're trying to arrive at silence," says Gola, his eyes shining more now from amusement at the idea. Their sense of design is "not a response to what we have inside of us," says Giagnotti. "It's an aspiration."

GIL SCHÆFER:

Words
ALEX ANDERSON

INSIDE THE ALL-AMERICAN FAMILY HOME.

Contemporary but classic; sophisticated but simple. Architect GIL SCHAFER on the 21st-century American aesthetic.

In conversation with Gil Schafer III, it's immediately evident that he has a deep, intuitive sense of what makes a home work, how it frames and adapts to people's lives, reflects its place in time, and how it can become integral to its surroundings. He has been designing houses for 30 years, more than 20 of those as principal of his own firm, which focuses exclusively on residential design. Each home the firm has built conveys a pervasive sense of comfort and an authentic but relaxed relationship with historical precedent. Whether a house in San Francisco or an apartment in Manhattan, each project reflects a uniquely American version of a familiar historical style.

The Greek Revival house Schafer built for his own family more than 20 years ago in rural New York embodies his profound understanding of home. It stands confidently on a rise among rolling green fields. Low stone walls and hedges expand the house into outdoor rooms, visible through high windows from the warmly furnished interiors.

ALEX ANDERSON: How did you come to work solely as a designer of houses?

GIL SCHAFER: My grandfather was an architect, and my parents were always building things, so I was around architecture and sensitized to it. I also had a stepmother who was a decorator. I was, I think, genetically wired to be interested in architecture. We also moved around a lot. We lived in different kinds of houses. I probably, in some deep

Freudian way, idealized home in my psyche. In architecture school, you're almost never given the problem of house design to solve. You do libraries,

(above)
The fireplace at Schafer's home in coastal Maine creates a sense of intimacy in an otherwise expansive, barnlike space.

museums—very lofty kinds of things. At Yale, I had really interesting studio critics; the last of these was [architect] Bernard Tschumi, who invited me to work for him after school. That was exciting, but it was sort of an extension of school. And the kinds of problems we were doing in the studio—including a hotel proposal for Euro Disney and a competition entry for the Kansai airport in Osaka, a mile-long building and

super interesting intellectually—didn't resonate in my soul. I realized that I just needed to switch gears completely. So, I went to work for a small firm that did residential work, and that somehow clicked for me. I felt like I could really plug into the user more directly than when designing an airport for hundreds of thousands of people.

AA: How would you characterize "home" in the work that you do?

GS: Well, the way I approach it is really thinking about what resonates for the homeowner. That has to do with memory and things that are familiar. For a lot of clients, these are not always right on the surface; you have to dig sometimes. Also, it's just creating places for people to live their lives and make their own memories, to create experiences for their families now. It's important that the "homeness" of the building allows for the evolution of a family, and the way a family lives. We've all, in the last three years, been through an amazing test in terms of how our homes can adapt to changes in our world, in our life.

AA: You called your 2012 book *The Great American House: Tradition for the Way We Live Now*. Is your work American in any particular way?

GS: I'm always looking at history as a place to be inspired. We're generally looking at American historical precedent, as opposed to European, so that's often where I start. Wherever we're building, I want to somehow connect to the place. You can go into American communities that have English Tudor

(opposite) Schafer's home in Brooklin, Maine, is set among acres of woodland and affords views over Blue Hill Bay toward Mount Desert Island.

and French Provençal [houses], all this kind of stuff.[1] But there's a certain inherent simplification that occurs, which is part of what makes it American, and part of what makes it appealing in a more democratic way. It's been reinterpreted, simplified, made less grandiose.

AA: Can you explain the distinction you make between your academic understanding of architecture and your own intuitive way of designing?

GS: We look at the style in order to understand it, because it's a language. We try to learn that language and be somewhat fluent in it, so we can adjust it without it being totally wrong. What's interesting is that a client almost never cares about the academic intellectual framework. If it's right, it just feels right. If it's wrong, it definitely feels wrong, but they won't know why. We make sure that we get it right. How we got there is less interesting to them than: Where is the family room going to be? How is the kitchen going to work? All of those things that are more about living life every day.

AA: How do you think about the house in relation to the landscape?

GS: The picture is incomplete if you can't think about the natural setting and how you engage with it—reaching out from the house and trying to connect with the things that are outside. Can you create something artful in the landscape that extends the ideas of the house beyond the four walls? Making rooms with hedges or walls has always been interesting to me, but it can also be the way you shape a view with natural elements to make a richer experience of living.

AA: How about the other direction, with the interiors?

GS: A lot of that grew out of recognizing that interior design is important. It's such an integral part of the way people want to live in their house. We started to get projects where there was no decorator, but there needed to be some thinking about that in order to complete the picture. I realized it was another part of things that really interested me, so we embraced it rather than ran from it.

AA: You do many renovations, but you incorporate older elements even in your new work. How does that work in your design process?

GS: Old materials, like old floors or hardware, right away, on a subliminal level, make a house have a sense of age. I love old things; I love patina, and a lot of our clients like that too. It feels comfortable; it ties into memory. My own house in Maine, which was built in 1992, had nothing historic about it, nothing that felt of a past time, so I had to embrace a slightly more contemporary language. As architects we love learning all the time and being challenged in a new way.

—

" There's a certain inherent simplification that occurs, which is part of what makes it American."

(1) Tudor architecture became fashionable in the United States in the mid-19th century and remained popular until World War II. Because it was an expensive construction style that required a lot of bricks, it became known as "Stockbroker's Tudors" for the owners who became wealthy during the market boom of the 1920s. French-style houses became popular after World War I, influenced by soldiers returning from Europe.

For a growing community of self-trackers, data holds the answer to life's biggest questions.

ESSAY:
THE QUANTIFIED SELF

Words
ANNABEL
BAI JACKSON

In my local subway station, a billboard advertising a private diagnostic service shouts a compelling slogan: "What if your body could tell you all its secrets?" According to this tagline, your body is covert and illegible, stubbornly foreign flesh. You might muddle through symptom and sensation to try and understand it, but the method is always guesswork and the result dubious. We take this logic with us when we can't decide whether to blame our morning fatigue on fractured circadian rhythms or late-night eating, or attribute a spike in menstrual pain to the catchall culprit of "hormones."

For the laypeople among us, our bodies resist interpretation. But a loose group of scientific researchers, enthused techies and amateur analysts believe they have the key to decoding them:

a way of life," explains Btihaj Ajana, professor of ethics and digital culture at King's College London and co-editor of *The Quantification of Bodies in Health* (2021). "It becomes so embedded in their daily routine, like brushing your teeth or eating your food." Regimen is key: One QS-er spent over a year tracing the relationship between her menstrual cycle and her creative "eureka" moments; another diabetic QS-er used self-tracking to run a series of marathons without any food, an "impossible" feat for a person with her condition.[3]

Adherents take a commonplace desire—to be in charge of our own bodies—to a place of passionate, mathematical preoccupation. Because why listen to your gut, when an app can tell you what it needs? Why guess, when you can know? "Most QS-ers are technological solutionists," says

> " It becomes so embedded in their daily routine, like brushing your teeth or eating your food."

data, collected by the individual through a process called "self-tracking." Connected to the Quantified Self (QS) movement, a phenomenon led by former *Wired* editors Gary Wolf and Kevin Kelly which advocates for "self-knowledge through numbers," self-tracking involves stringently recording an aspect of your physiology and parsing the resulting data.[1] Popular tags on the QS online forum include "ketosis," "productivity," "menstruation" and "cholesterol." Smart devices are typically used to amass data on heart rates, glucose levels and sleep phases.[2]

Since Wolf and Kelly coined the term "quantified self" in 2007, the ethos has trickled into mainstream culture: jabbing the dates of your period into apps like Flo, checking Fitbits for burned calories and chasing a 10,000-steps-a-day ideal. But for the 95,000-strong QS community, self-tracking is more than just a casual habit. "It becomes

Ajana. "They believe in the power of technology to fill the gap left by human agents: doctors, nurses and healthcare institutions." Indeed, swathes of self-trackers were provoked to join the QS community after growing dissatisfied with the medical establishment. If medical advice is predicated upon averages, standards and baselines, QS takes the idea of the individual ultra-seriously: As patient and doctor, analyst and analyzed, are rolled into one freestanding, self-reflexive unit, no specificity can be too specific.

(1) The four principles of any self-tracking project per the QS guidelines include questioning, observing, reasoning and consolidating insight.
(2) Most tracking devices are worn around your wrist. In 2015, however, Apple created patents for three different AirPod-style earbuds, each equipped with sensors capable of gathering health data such as blood oxygen levels, heart activity, stress levels and body temperature.

For QS-ers, this independence can be empowering. "I use [self-tracking] as a diary," says Jordan Clark, a self-described "data architect" working in the tech industry. In 2018, Clark presented a talk at a QS conference called "Quantifying the Effects of Microaggressions"—a creative and uniquely political approach to self-tracking, in which Clark consistently measured his heart rate variability after experiencing racial microaggressions on his college campus. "Ultimately, it's therapeutic," he says, explaining how the data could elucidate this much-dismissed form of stress in an evidence-based way. "Data doesn't lie: It tells a story."[4]

" Ultimately, it's therapeutic.
Data doesn't lie: It tells a story."

But Clark has continued to self-track for a multitude of other purposes.[5] He shows me the litany of devices he uses to turn his experience into the empirical: there's the Oura Ring, a $299 device that tracks an array of physiological signals; the Lumen, a sleek bar that calculates your metabolic rate when puffed upon; a smart water bottle that flashes red when Clark hasn't met his hydration goal. (His belief in the power of tracking extends beyond his own body; an electronic dog collar tells Clark's phone whether his pet has reached his exercise target.) Faced with this collection of gadgets, the thought of making decisions based on sensation alone does begin to look woefully archaic. But at what point does listening to the numbers mean we forget to listen to our actual bodies? "Yesterday, I woke up and the battery of my Oura Ring was dead," Clark says, regretting the lost data that would have quantified his "sleep score" for

(3) A similar project, the Zero Five 100 challenge, saw Dr. Ian Lake, who has Type 1 diabetes, run 100 miles over five days on zero calories to demonstrate how stored fat and ketones can be used as an alternative to traditional carbohydrate-based fueling.

(4) Self-tracking is often referred to as "personal science"—a term used in a 1991 paper by Brian Martin and Wytze Brouwer, who called for more narrative within science education on the basis that highly rational scientific principles are better learned by children when couched in a relatable story.

the evening. "In my eyes, it's as if I didn't go to sleep."[6] QS gestures toward a contradiction: People are at once desirous of control and eager to hand it over to devices; their "solutionism" is also a form of abdication. And while many QS-ers self-track precisely because it allows them to feel more embodied, there's always the risk of alienation—of treating your body as a petri dish.

While this might ring alarm bells for any non-self-trackers, implying a way of life entirely mediated by apps and algorithms, self-trackers genuinely believe in QS's ability to bring about a more informed society. As many self-trackers already work in tech or software engineering, they're buoyed by a DIY spirit, building devices and embracing the sense of being at a social and technological vanguard. Clark also represents this distinctive utopian streak in the movement: He hopes to blend the basic premise of self-tracking with VR technology, and ultimately develop a new system of financially compensating people for their data. "It gives me a sense of purpose to do this stuff," Clark says, "but I acknowledge that I'm very unique in that—right now."

Among the graphs, charts and conferences, what actually seems to be revealed in the process of self-tracking is the lively, dynamic tension between instinct and quantification—between the human desire to eat, exercise or train as much as the body wants, and the ring-fencing implicitly imposed by self-tracking. This negotiation is clearly stimulating and worthwhile for the majority of self-trackers. But, like all forms of self-regulation, it can become excessive. Alexandra Carmichael, who was once the director of the Quantified Self, wrote a poem in 2010 called "Why I Stopped Tracking":

Each day
My self-worth was tied to the data
One pound heavier this morning?
You're fat.
2g too much fat ingested?
You're out of control.

This is a reminder of a claim Ajana makes: that the way a self-tracker interprets data does not take place in a vacuum, but also bears "its own political and ethical dimensions." Why a self-tracker would seek to be one pound lighter, or ingest 2 grams less fat, is of course wrapped up in social mores. Carmichael's words expose one of the difficult frictions at the heart of QS: Despite being individualized and data-driven, it can't help but replicate the ideals of the social world beyond.

In 2004, the writer Mark Greif penned an amusingly prescient polemic against the quantification of our bodies called "Against Exercise," in which he observed the way an "individual's numbers" attain "talismanic status." The risk of data transforming into totems is always present in the QS community. It's what makes finding a balance so difficult: "We have to achieve that middle ground," says Ajana, "but that's always elusive."

(5) One benefit of tracking apps is the sense of community they can create. In 2021, *The New York Times* reported on how the app Whoop, which shares fitness data among friends, allowed men to develop support groups and check in with each other if, for example, they noticed a friend had not been sleeping well.

(6) In one recent study from Rush University Medical College and Northwestern University, researchers warned that sleep-tracking tech could provide inaccurate data and worsen insomnia by making people obsessed with perfect slumber, a condition they called orthosomnia.

Words ANNICK WEBER

Rose

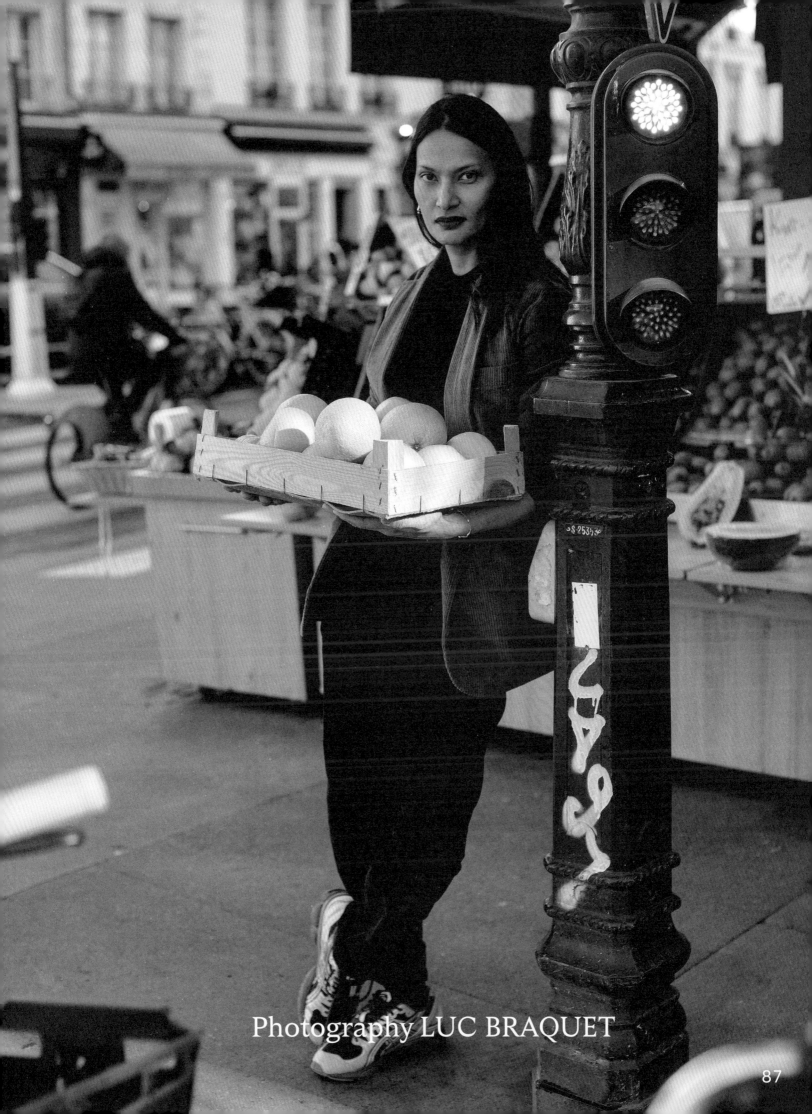

Photography LUC BRAQUET

ON COOKING FOR

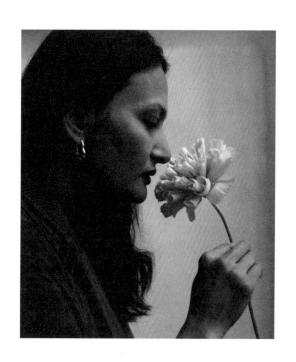

THE ART WORLD ELITE.

The first thing Rose Chalalai Singh does when hosting a dinner party—be it a 200-person affair for an art world client or a small, private event—is get the table ready. Only when that's out of the way will she be able to focus on the actual food. No wonder, perhaps, since much of the chef's childhood took place around a table that was always set for guests. Growing up, she lived in Bangkok with her grandmother, a mother of 11 children.[1] Singh would help cook up feasts for the constant stream of family members filling the house.

Today, Singh's cooking is still family-style, it's just the crowd eating it that has changed. Almost overnight, her two Parisian eateries—Ya Lamaï and the recently closed Rose Kitchen—became favorites among the city's art, design and fashion circles, helping her make a name for herself as their go-to chef for all kinds of events.[2] With Ya Lamaï now run by a trusted team of sous-chefs, Singh is free to dedicate all her energy to the catering side of things. Together with her business partner, Petra Lindbergh, she's worked with luxury conglomerate LVMH, gallerist Thaddaeus Ropac and the design agency Desselle Partners, and has befriended much of the cool set along the way. After all, can there be a better way to break the ice than with a bowl of steaming tom yum?

AW: What's your earliest food memory?

RCS: I will never forget my grandmother's fish sauce which she made from scratch. She would marinate the fish intestines for one year before filtering and boiling the mixture. You can only imagine how bad the smell was when she opened that pot after all those months. Everyone in my family would go to sleep at a hotel on that day.

AW: And how did it taste?

RCS: It was absolutely worth it. I love the way my grandmother did things; she was a great chef. She never cooked with gas, just with fire. She didn't even know how to do it the modern way. Still, she was very sophisticated in her ways of thinking and making.

AW: Did she pass on her recipes to you?

RCS: She never wrote down a recipe; they were all in her head. Everything I learned from her was by watching her and her daughters. I remember exactly how they sliced the fish for their curry, cutting it at an angle as if they were preparing Japanese sushi.

AW: Your restaurant, Ya Lamaï, is named after your grandmother. What would she make of what you do?

RCS: She would probably listen for the sounds of me making curry paste with the mortar and pestle and tell me which ingredients to add more of. That's what she used to do when I was helping her as a child. She didn't see well so she would judge me by the noise I was making as I was pounding the ingredients. She'd say, "Your movements are not constant enough; you will never find a man to marry."

(1) Singh worked in Thailand for a while after college. She modeled, ran the Bangkok showroom of interior designer Christian Liaigre and consulted on the design of a hotel in Phuket.

(2) Regulars at Ya Lamaï include fashion designers Riccardo Tisci, Haider Ackermann and Christophe Lemaire. Singh has also catered for galleries including Gagosian, Thaddaeus Ropac and Bruno Bischofberger.

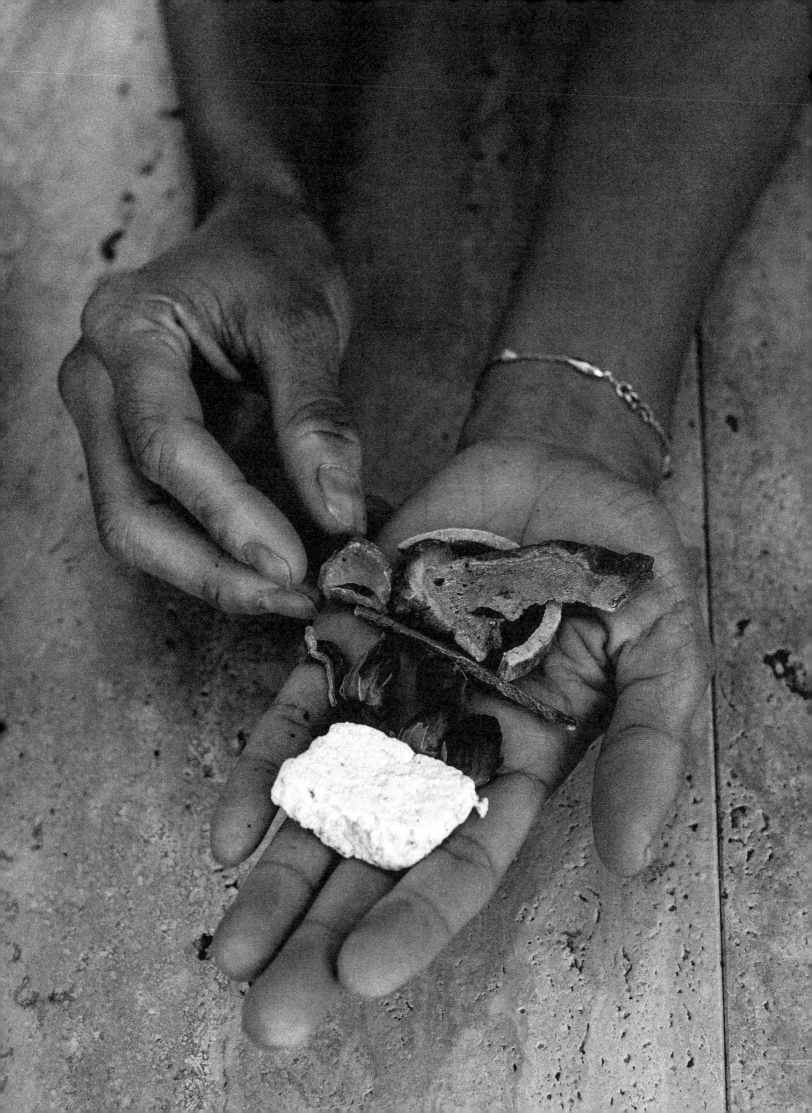

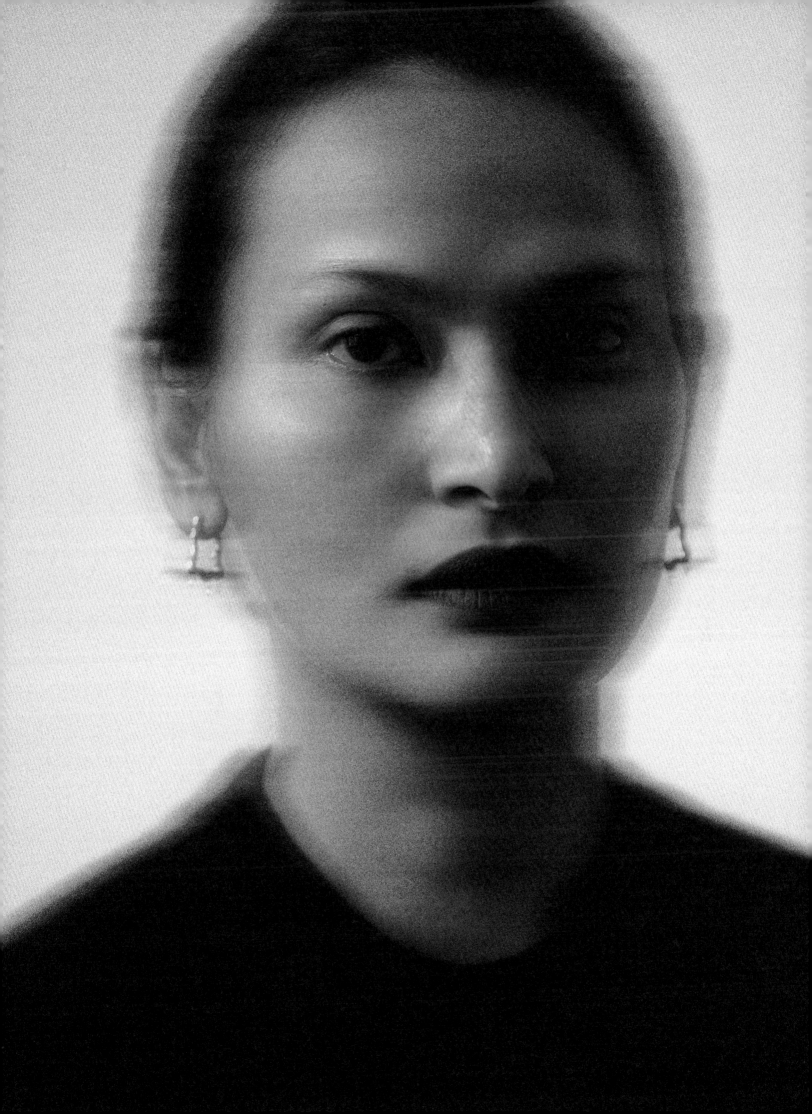

It would take hours until she was pleased. I hated it. When it came to choosing my career later, I started in interior design. It wasn't until I moved to Paris that I decided to go back to food.

AW: Why was that?

RCS: When I was pregnant with my son, Gabriel, I was hosting friends at home every day. I would go to Belleville to shop for ingredients and cook elaborate meals for them. I'm not someone who likes to be alone. I got this from my father, who has never eaten a meal by himself all his life. Sometimes there are 20 people—friends, friends of friends—that he's invited around his table. I realized that that's what I love doing too.

AW: What is it that you like about hosting?

RCS: I love listening to friends enjoying themselves as I cook. I get so much energy from it. Making them happy makes me happy too. It's as if I am feeding my soul by feeding them.

AW: In what way is cooking for customers different from cooking for friends?

RCS: For me, cooking for 10 friends or 200 strangers is the same thing. But what I do find stressful is cooking for two people. I'm not used to making small quantities and it doesn't go with my spirit—you lose the convivial sharing element.

AW: You've closed the doors of the Rose Kitchen restaurant in the Marais to focus on your catering activities. How come?

" Feeding theater people is a joy. They eat well, they drink, they sing. Fashion people don't eat so much."

RCS: I didn't necessarily find the restaurant kitchen environment to be too high-stress, it's just the non-freedom that was too hard for me. I want to be able to travel again—to Pantelleria and come back with jars of freshly made orange jam or to the mountains with my family. And I want to cook dinner for 200 people at the Palais de Tokyo without having to worry about my restaurant. Either you do catering or you run a restaurant; you lose your head doing both.

AW: How did you win a following in this highly competitive environment?

RCS: When I opened my first grocery store, nobody came in on the first day. We then started giving out food for free for people to try and became a small restaurant [the original Ya Lamaï, which later moved to larger premises]. Suddenly, from one day to the other, we

(3) Singh is primarily interested in catering for friends. In November 2022, *T Magazine* ran a story on a typical gathering she might cater: a small group of artists and other creatives meeting at the farm-turned-commune of the Berlin-based artist Danh Vo.

(4) Singh saw out lockdown with her family in the Majorcan countryside. The experience made her realize she wanted to focus more on growing and cooking her own produce.

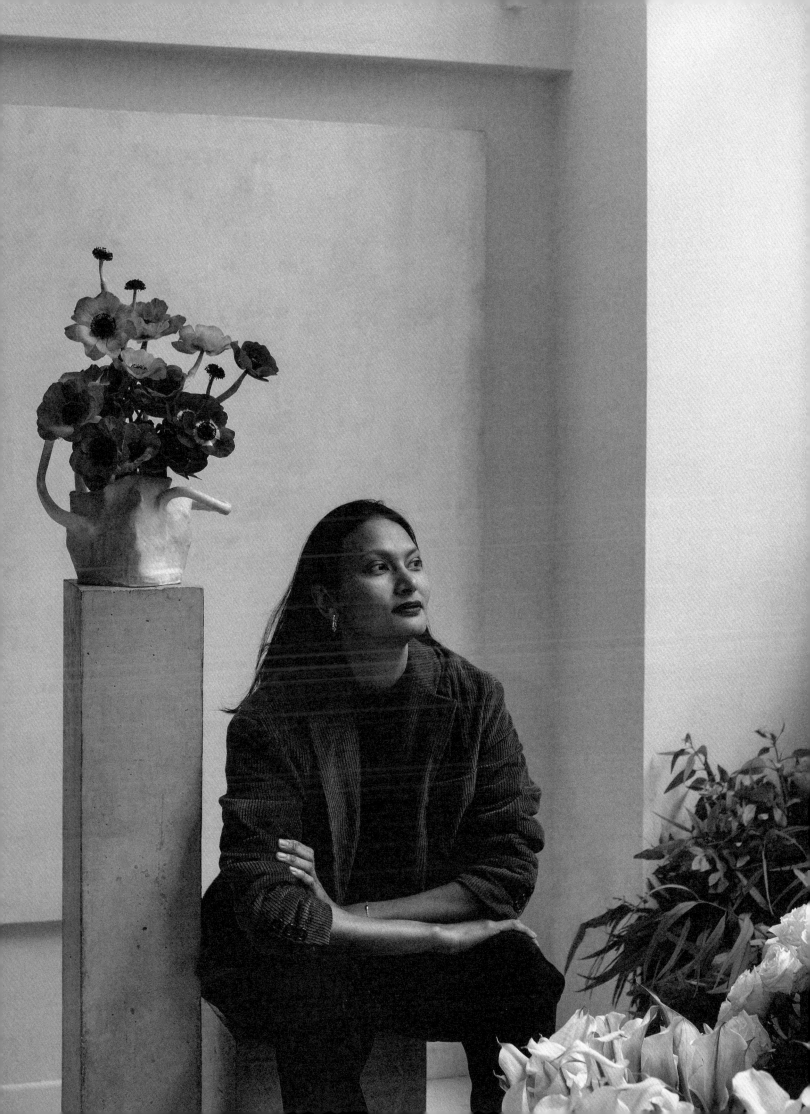

had lots of people, mainly from the fashion industry. They came and wanted to stay because they knew Rose was there. That's when we took on our first catering jobs for galleries and during fashion week.

AW: Who do you like cooking for the most?

RCS: Theater people. Feeding them is a joy: They eat well, they drink, they sing. Fashion people don't eat so much. Last year we cooked for all the actors, sound and costume people behind Thomas Ostermeier's *King Lear* at the Comédie Française. They give so much to the world on a tiny budget, so this is my way of giving them something back.

AW: The restaurant world has a lot of sexism. How do you and Petra handle that?

RCS: It's true that you get much more popular as a male chef, but that's not what we're after. We're not chasing Michelin stars. Our food isn't experimental, we just do what we like.[3] Everything we do is very personal, so we're not really affected by it.

AW: What are your plans for the future?

RCS: My dream is to have my own farm, where people could come for ateliers, like jam-making or mushroom-foraging.[4] We'd grow veg and be surrounded by fruit trees. Nature is so generous, we need to be more grateful for the things it gives us. I don't want to waste anything—neither my time, nor my ingredients.

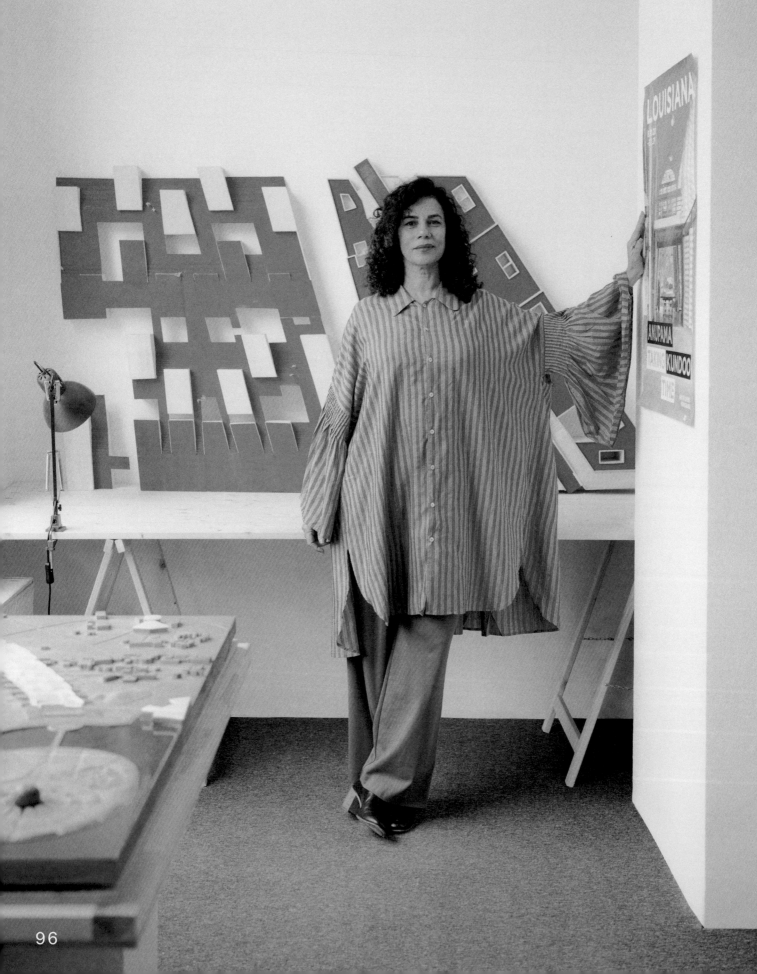

Studio Visit:
ANUPAMA KUNDOO

The Berlin-based architect knows what the city of the future should look like. *In fact,* she's already built it.

Words MANJU SARA RAJAN

Photos MARINA DENISOVA

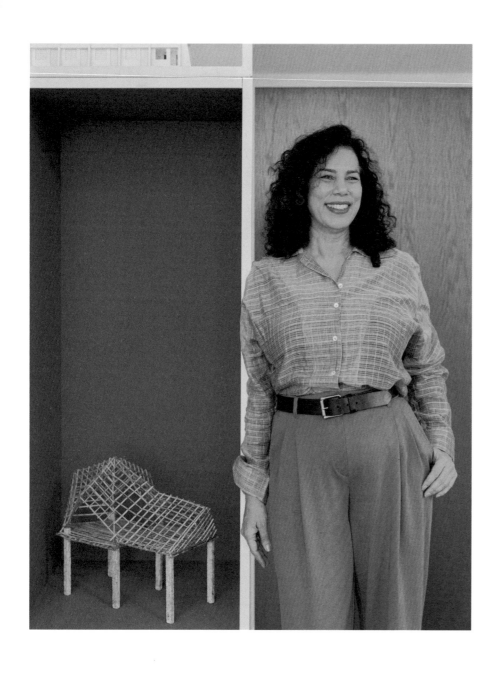

ANUPAMA KUNDOO works in service of her community. It just so happens that the community is an experimental township that wants to change the world.

Architect Anupama Kundoo began her practice in 1990 in Auroville, in the Indian state of Tamil Nadu, when she arrived in the experimental township as a fresh graduate. Founded by spiritual guru Mirra Alfassa (known as "the Mother") and designed by French architect Roger Anger, Auroville was developed as "a city of the future." The soul of the township is the meditation center, Matrimandir, and from it different zones radiate outward like the rings of a galaxy. Once the Mother passed away in 1973 there were disagreements among the residents about the next phase of development. This meant that, even though the construction began when it was founded in 1968, much remained unfinished by the time Anger died in 2008.

Kundoo worked for years with Anger, developing and detailing various elements of his plans at her own practice. Today, Auroville is the scene of many of her material experiments and the home of several of her exemplary structures. Although she lives and teaches in Berlin, where she is a professor at the Potsdam School of Architecture, Kundoo has just been appointed head of urban design for the township.

MANJU SARA RAJAN: Auroville was envisioned as a city with all nationalities, unified by a set of principles called the Auroville Charter. What is the role of architecture in such a place?

ANUPAMA KUNDOO: Sometimes when we design, we give too much importance to the client and not enough to the collective. Even if I build a house in a corner of a city, it is going to affect everybody, not only those who live in the house. The ownership model has led to a type of architecture where everything does not add up to a harmonious city fabric; we especially see this in Indian cities. There is this grave misunderstanding that Auroville is a utopia. It is not. Utopia is an idea that people think is unattainable, something you don't think is going to happen. Auroville is the opposite. It is grounded on physical land. For me, Auroville is a laboratory where you are not just allowed to experiment, you are obliged to. If you're building the same old thing, don't do it here, this is not your place.

MSR: What is being tested in this laboratory of a city?

AK: Roger Anger's plan from the 1960s is still relevant. [In Auroville] land cannot be individually owned; it belongs to the commons. The future ought to be like that, where considerations like inheritance become irrelevant. Also, it is a car-free city. That was a commitment made at a time when sustainability and environmental consciousness weren't usually considerations. Anger's plan

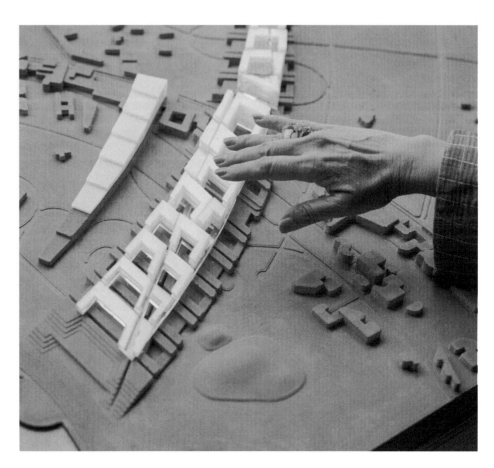

(above) The Line of Goodwill, modeled here, is the first high-density compact housing planned for Auroville. Anger envisaged housing blocks that would gradually grow higher, with the lowest level at the township's center so as not to impact the city visually.

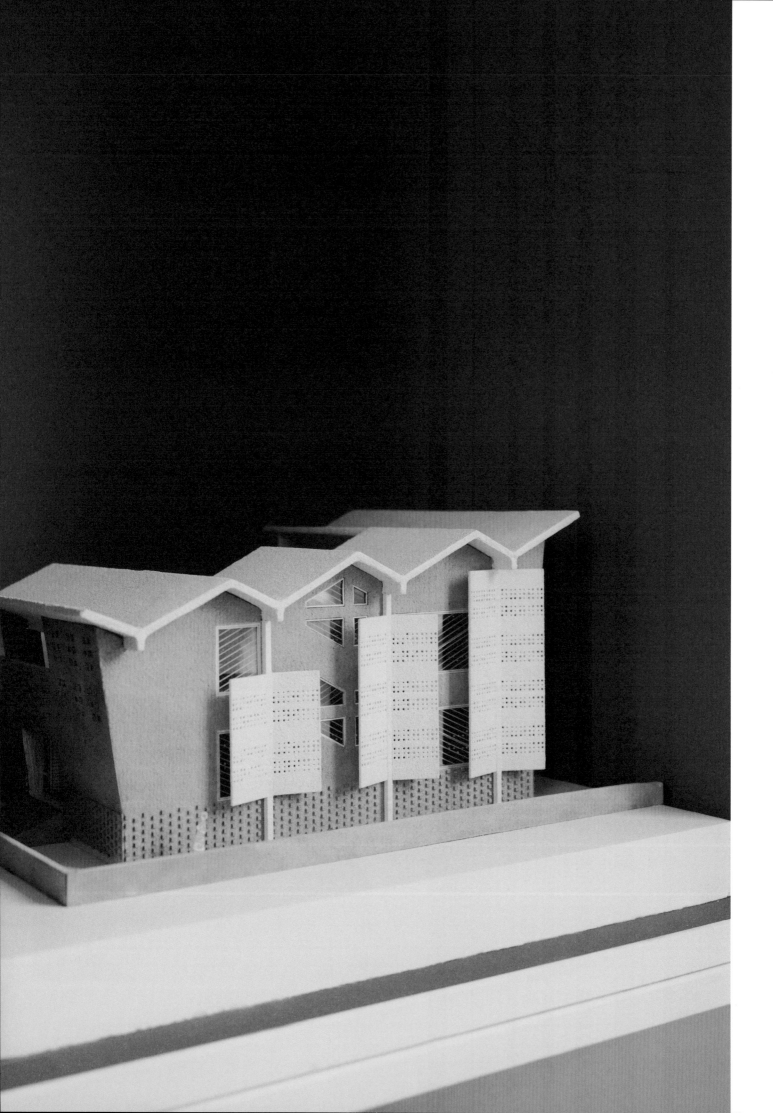

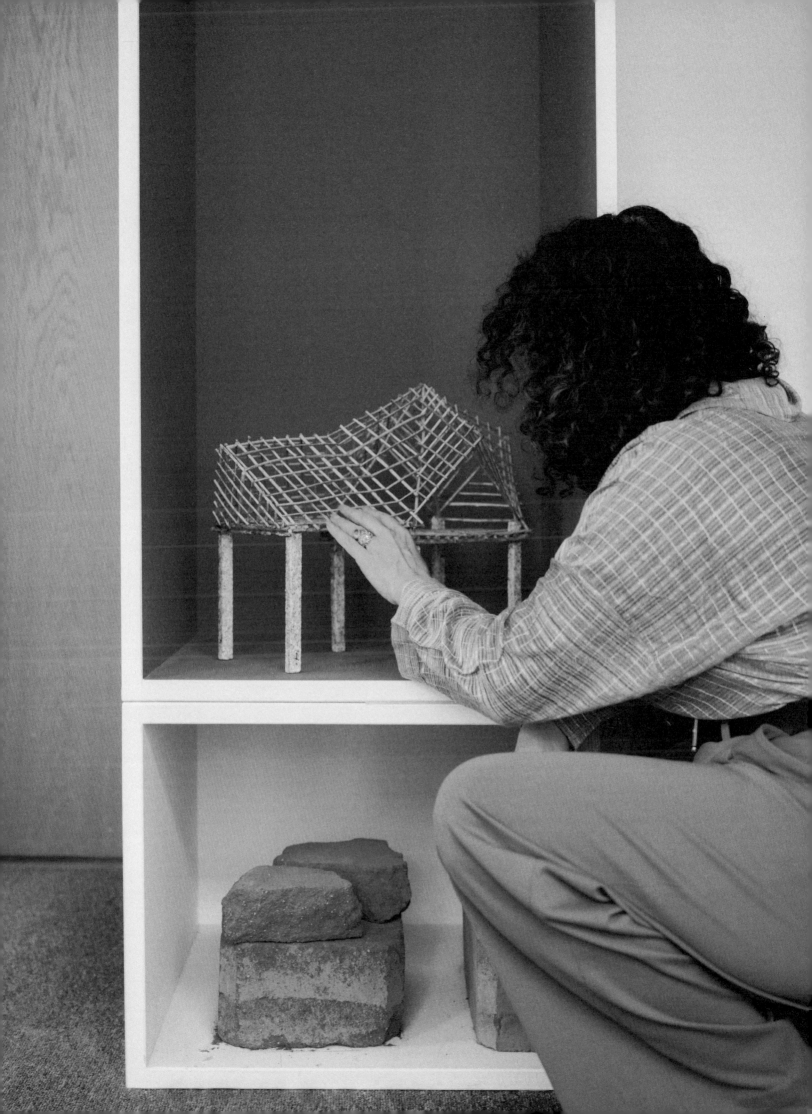

(opposite) Although Auroville was inaugurated in 1968 with plans approved by the Indian government to make it a city for 50,000 residents, much of the development remains in the planning stage, and only slightly over 3,000 people live there at present.

isn't a pompous, grandiose city plan where modernism comes with "motorism." Instead, he had detected that in the future if everyone has cars then our cities will get choked. The Mother's vision was of a place that would address the problem of human conflict, a place where you can work on humanity. Auroville must realize its true dharma, which is to become an example of how humans can live together. I always saw that ambitious dimension, but many people living there don't believe it. I think it can and will happen if we work for it.

MSR: What sorts of solutions are being proposed?

AK: In India, since the time I was born, the population has tripled. All over the world the solution to population density has been to build tall towers, instead of maintaining an urban fabric. These types of buildings are air-dropped randomly, and they don't have any horizontal connections to the street and its life. In Auroville, Anger proposed a type of tower which rises horizontally, slowly, and all the roofs—which are normally an element that is wasted—become roads. I am very excited by these solutions. I believe in them, and I feel there are so many things we could do differently but we cannot avoid big steps of change.

> " Utopia is an idea that people think is unattainable. Auroville is the opposite."

MSR: You work in these opposite environments—Europe and India. Do you find that your approach changes between the two?

AK: I am a "made in India" product and all my architecture came out of my upbringing and what I learned from my teachers, India and its values. [The world] is divided into mainstream industrialized countries and those that are not. The former are governed by strictures, and everything must fall neatly between these classifications and categories, whereas with the latter they are used to customization and making do with the resources they have. To me, to be Indian is to be holistic. I do not feel divided. I enjoy architecture projects in India and I enjoy research in the West. We have the conducive conditions for it in Germany because when I teach here, I don't feel that I must teach only about what is happening here. After all, we are facing global problems.

MSR: Your practice has always emphasized architecture as a form of collaboration. How does that play out in Auroville?

AK: I don't have anxiety that things must be my own—I am at peace with my irrelevance. I am taking Anger's plan further. I don't have the urge to redo everything. If I like his work, I don't mind that it's not my design. Architecture and city planning are highly collaborative. All our old cities have a natural harmony, like birds flying in a formation.

MSR: When it comes to your architectural work, what do you consider the mainstay of your designs?

AK: I'm very future driven, not nostalgia driven. It is easy to do what our ancestors did but our reality is different and so we cannot always choose classic solutions. Problems have evolved so we must evolve our response. Architecture's purpose is to provide health, happiness and well-being. It is not essential for it to be photogenic but if something is ugly then it will affect our well-being. Over the span of a 30-year career, if I merely repeated what I did before that would mean I had not taken note of everything that has changed. Today I should be able to work more efficiently—I must be able to build a roof with a bigger span with less materials. I am cleverer than when I began, my craftsmen are more skilled, so why can't I aim higher? I don't go looking for aesthetics, but if harmony has not been achieved during my design process, then the process is not complete. I must do more. Do better.

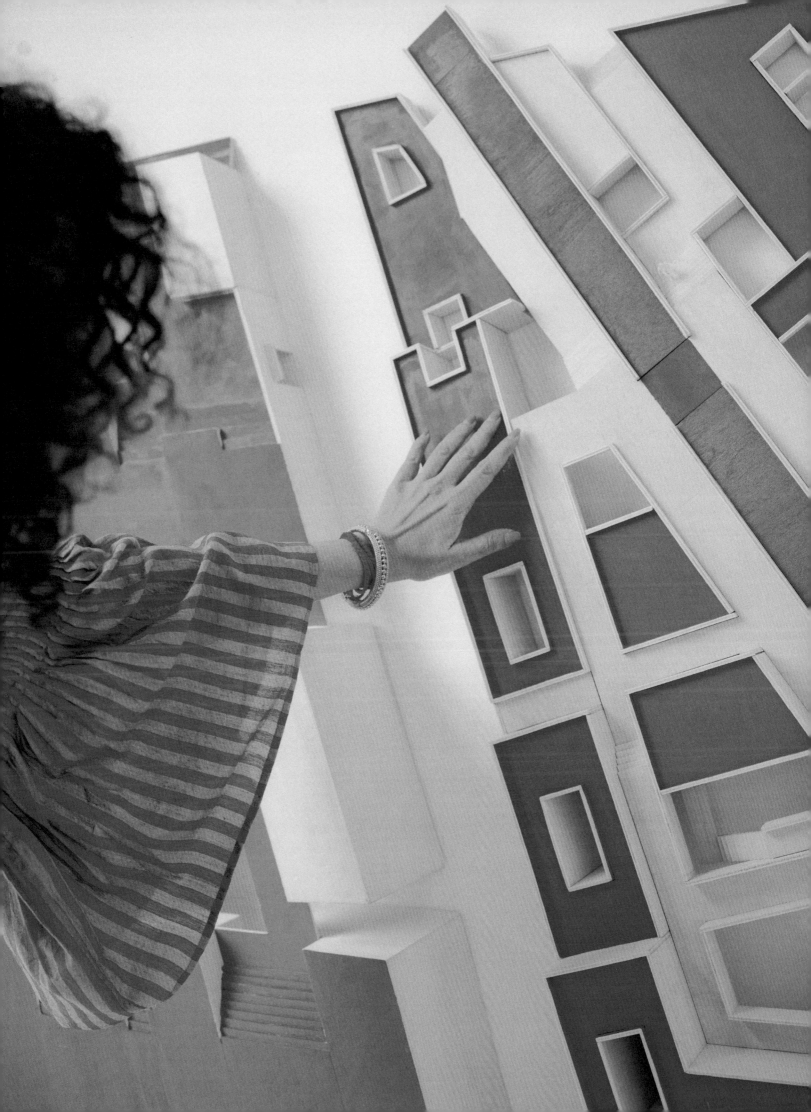

Thirst

Five alcohol-free cocktails for the summer.

Photography
YANA SHEPTOVETSKAYA
Recipes & Styling
JADE FORREST MARKS

Aid

SURLEY TEMPLE

Grenadine, once derived from pomegranate, is now most commonly made from artificial ingredients like corn syrup. This recipe uses the real juice with added elderberry for a fresh and antioxidant-rich alternative. *4 ounces unsweetened pomegranate juice, 4½ tablespoons raw sugar, Juice of 1 lime, 1 tablespoon elderberry syrup, 4 ounces ginger ale, Maraschino cherries for garnish.* To make the simple syrup, in a small saucepan, bring pomegranate juice and sugar to a boil. Reduce heat and simmer for 15 to 20 minutes, until thick. Remove from heat and stir in lime juice and elderberry syrup. Let cool. Fill glass with ice and the syrup mixture. Top with ginger ale. Garnish with cherries.

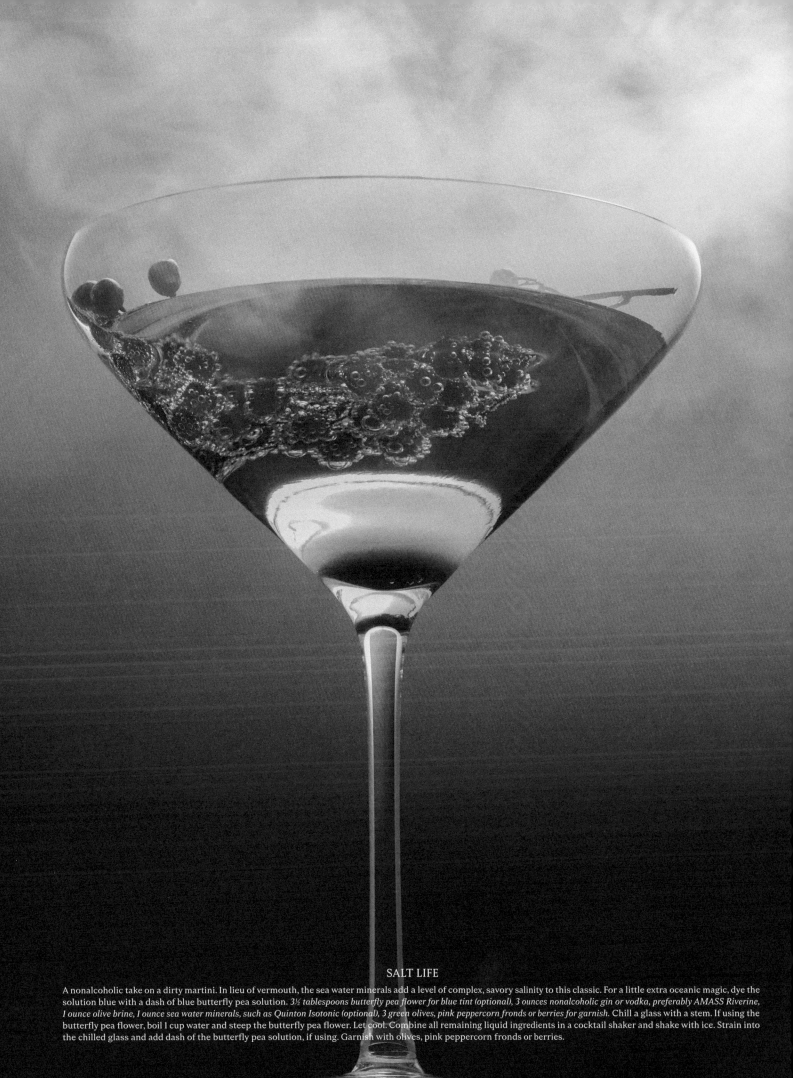

SALT LIFE

A nonalcoholic take on a dirty martini. In lieu of vermouth, the sea water minerals add a level of complex, savory salinity to this classic. For a little extra oceanic magic, dye the solution blue with a dash of blue butterfly pea solution. *3½ tablespoons butterfly pea flower for blue tint (optional), 3 ounces nonalcoholic gin or vodka, preferably AMASS Riverine, 1 ounce olive brine, 1 ounce sea water minerals, such as Quinton Isotonic (optional), 3 green olives, pink peppercorn fronds or berries for garnish.* Chill a glass with a stem. If using the butterfly pea flower, boil 1 cup water and steep the butterfly pea flower. Let cool. Combine all remaining liquid ingredients in a cocktail shaker and shake with ice. Strain into the chilled glass and add dash of the butterfly pea solution, if using. Garnish with olives, pink peppercorn fronds or berries.

GREENY COLADA

A green juice spin on a virgin piña colada. Use your green juice of choice. *2 ounces green juice, 1 ounce pineapple juice, 1 ounce coconut cream, ½ ounce lime juice, ½ ounce simple syrup, 1 slice yellow or red beet for garnish.* In a blender, blend all liquid ingredients with ice. Pour into a glass and garnish with a slice of beet for a pop of color.

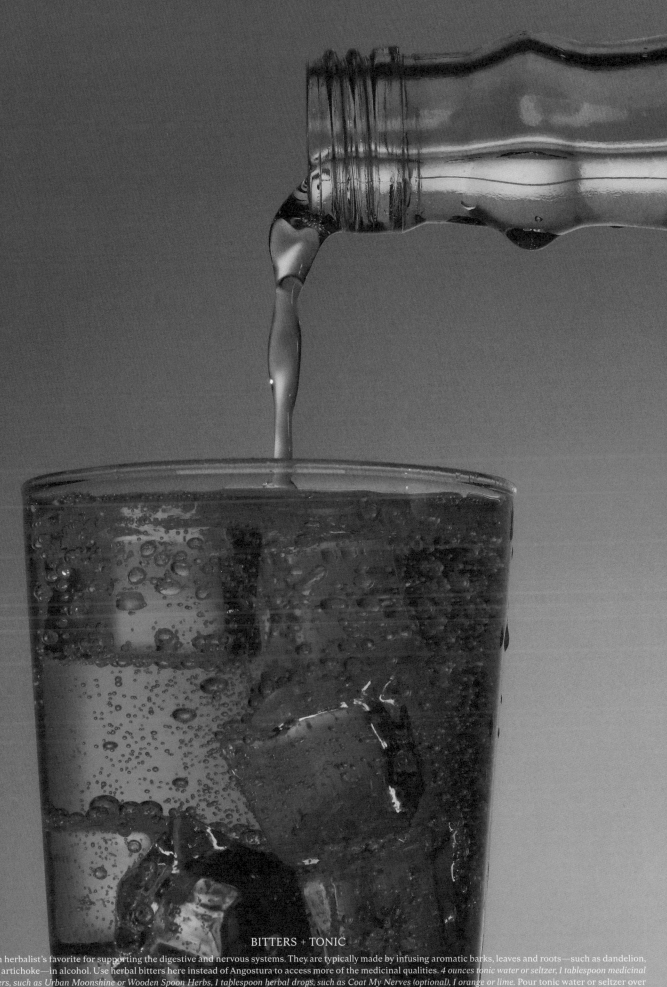

BITTERS + TONIC

Bitters are an herbalist's favorite for supporting the digestive and nervous systems. They are typically made by infusing aromatic barks, leaves and roots—such as dandelion, burdock and artichoke—in alcohol. Use herbal bitters here instead of Angostura to access more of the medicinal qualities. *4 ounces tonic water or seltzer, 1 tablespoon medicinal digestive bitters, such as Urban Moonshine or Wooden Spoon Herbs, 1 tablespoon herbal drops, such as Coat My Nerves (optional), 1 orange or lime.* Pour tonic water or seltzer over ice. Mix in the bitters and herbal drops, if using, and stir vigorously. Top with a squeeze of orange or lime and garnish with a slice of orange peel.

Q&A:
JADE FORREST MARKS
By Harriet Fitch Little

Q: What's different about developing a non-alcoholic recipe compared to an alcoholic one? A: Alcohol tends to overpower a lot of the more subtle flavors of plants, especially blowing out the most delicate ones like florals. Without using the blunt tool of alcohol, you also have to get more creative with ingredients. My friend Loren Kathe, who's a bartender at Lil Deb's Oasis in Hudson, reminded me that when making mocktails it's better not to try to "replace" the alcohol but rather to create something that has bite and complexity without it. I like to achieve that by using aromatics, like ginger or rosemary, an array of citrus and herb-infused vinegars and syrups.

Q: You also run the herbal drops company 69herbs. Why are drops taking off in popularity? A: For many of us, the empowering thing about herbalism is taking our healing and healthcare into our own hands. My hope is that people will continue to learn to make their own medicine and to look to our own ancestral traditions and local farms for sustainably grown herbs.

Q: What do herbs bring to drinks that would be lacking otherwise? A: Herbs bring a deeper level of complexity and freshness to food and drink. I especially love the bitter quality that herbs offer, which is really missing in our dominant culture's palette.

Q: What do you think will be the drink of summer 2023? A: I think the martini comeback is in full effect. I recently had the MSG martini at Bonnie's in New York City and it's unforgettable. I'm also really excited to taste the new non-alcoholic wine and beer options that are hitting the market. It's been a long time coming, and I think more people than ever are sober or sober-curious and looking for alternatives to traditional drinks.

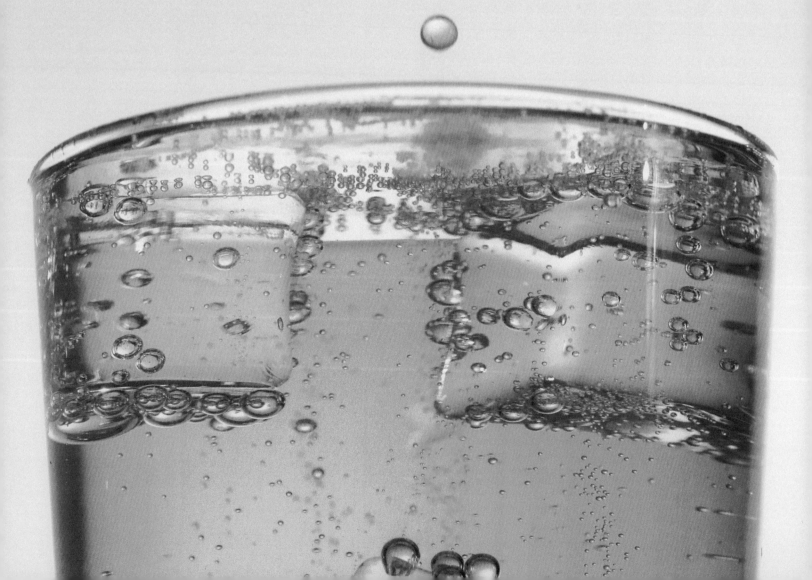

BLOOD ORANGE TAHINI COOLER

A savory-sweet refreshing drink that recalls the beach at golden hour. Blood orange brings it to the next level with a light pink color. *1 blood orange, 1 ounce lime juice, ½ ounce simple syrup, 1 tablespoon tahini.* Squeeze juice from the orange. In a cocktail shaker, combine all liquid ingredients and shake with ice. Strain into a glass and garnish with a slice of blood orange.

WATER:

FROM SEA TO SHINING SEA:

Words
ALICE VINCENT
Photography
RICHARD GASTON

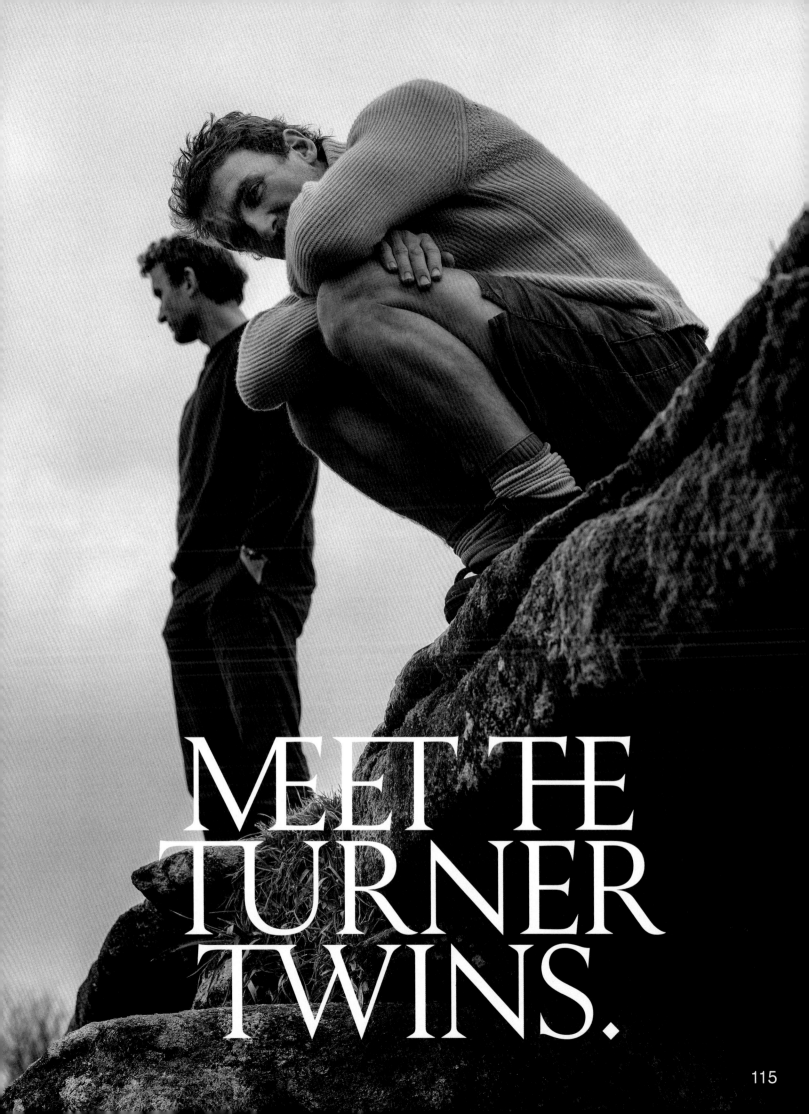

MEET TE TURNER TWINS.

For someone known for reaching Earth's most geographically inaccessible places, Ross Turner seems remarkably at home in the still, slightly trapped air of the Royal Geographical Society in London. The place is deserted but full of ghosts: Shackleton's Burberry helmet lurks in the collection and maps of a 17th-century world hang in the hallway. Alongside his identical twin, Hugo, who joins us on speakerphone from the Lake District, Turner is drawing on this legacy: The pair are professional adventurers, diving deep and roaming wide, rowing across the Atlantic and climbing Mt. Elbrus, Europe's tallest mountain.

The 34-year-old brothers—who have the old-fashioned manners expected, somehow, of explorers—have spent the past decade on death-defying missions with modern preoccupations: to do a survey of plastic quantities in the ocean, for instance. Their endeavors were motivated after Hugo broke his neck while diving at the age of 17. Having regained the ability to walk, he decided to live life to the fullest—alongside Ross, whose fledgling rugby career was ended by a broken leg—in some of the most treacherous environments on the planet. When it comes to water, the Turner twins understand its depths more than most, confronting it as ice, snow and ocean, while always ensuring they have enough of it to survive.

AV: What is the most dangerous situation someone can get into at sea?

RT: I would say shipping lanes.

HT: Shipping lanes are very dangerous. In the daytime it's fine because you can obviously see a ship and understand the angle at which you're viewing it, where it's heading and how fast it's going. But at night, all you're seeing is the boat's lights.

AV: What other things do you need to consider if you take to the water at night?

HT: It's very instrument-led, but you also have to understand what different boats' lights mean. Some might flash faster than others, some might flash in sets, others might be continuous flashes. Port and starboard are in red and green, and you have danger markers that are yellow, black and variations between them.

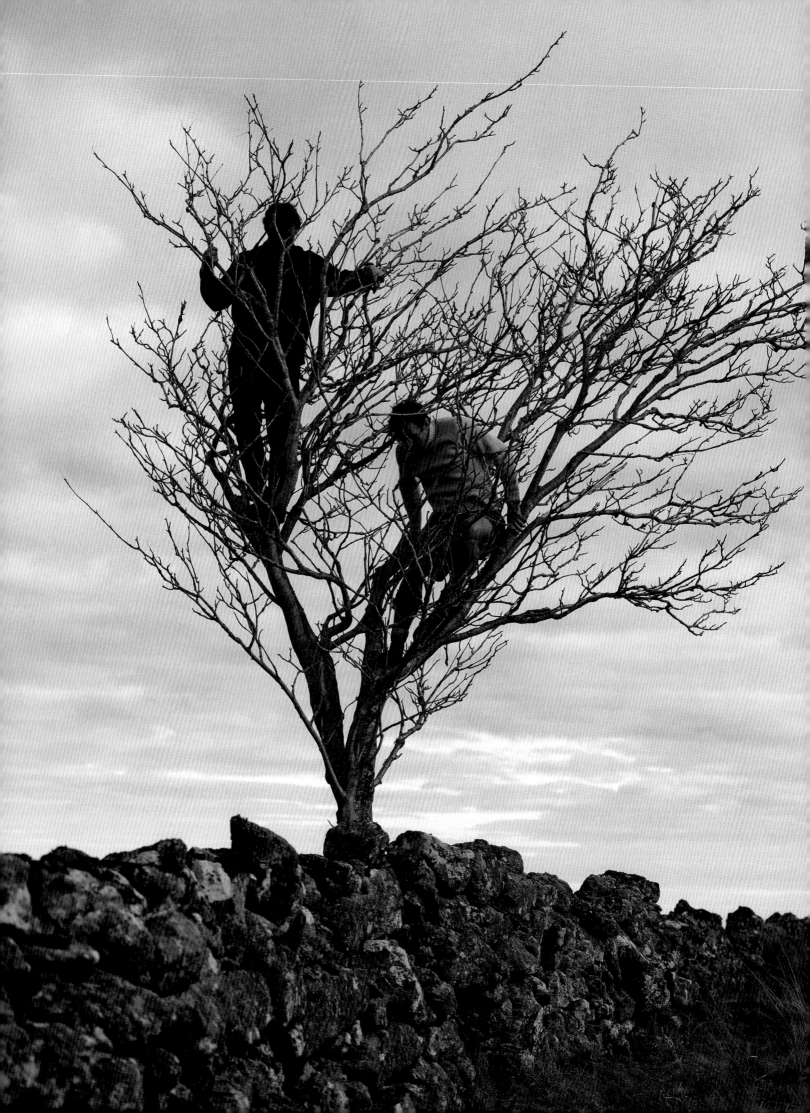

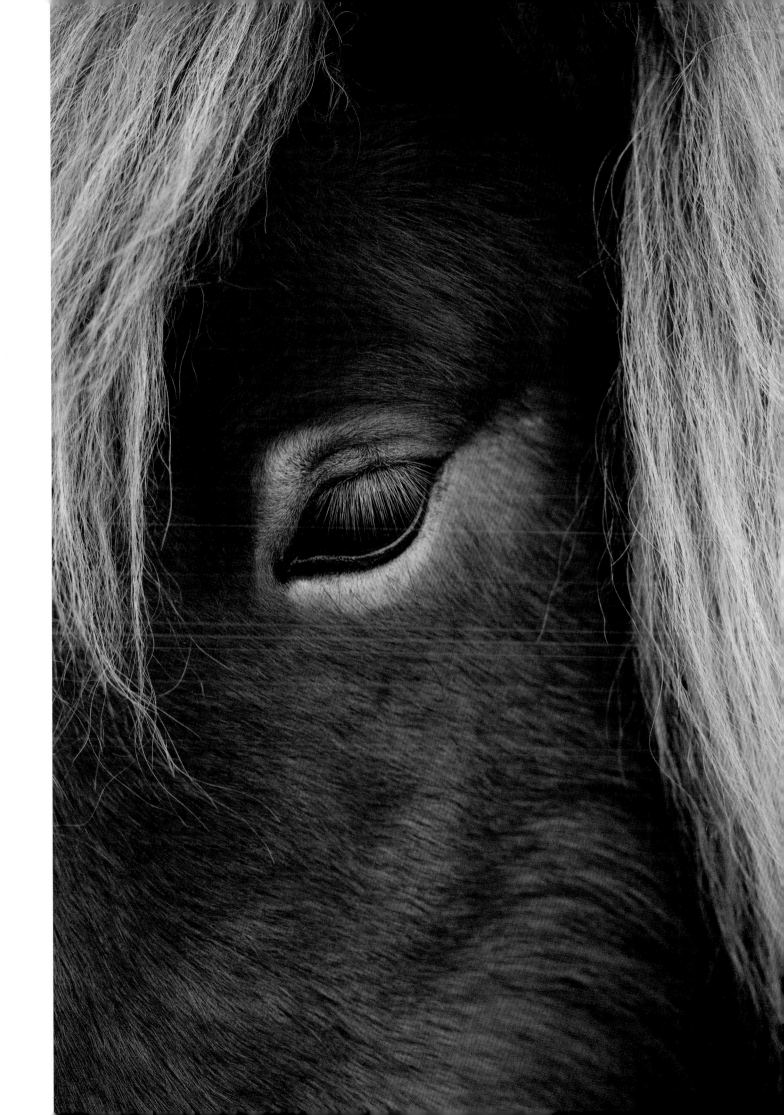

RT: Once you've got that, though, it's actually really simple. It's a lovely thing because you use more of your peripheral vision and your hearing as you're going along, particularly if you're under sail. If you can hear splashing, it usually means another boat doesn't have its lights on. Sound does travel pretty well on water.

AV: Have you ever witnessed bioluminescence—when light is generated by living creatures—in the water?

RT: The first time was when we rowed across the Atlantic, in 2011. Imagine rowing in total darkness, so dark that you can't see the horizon and there are stars all around you. The reflection of the stars in the water means you're rowing in a sphere. As we were rowing, our oars produced little whirlpools of bioluminescence. Then we noticed tuna chasing smaller fish under our boat; imagine the shape of a tuna, but somebody's put really small Christmas lights all over it.

HT: The other time was in Lyme Bay, in the English Channel. We had just completed a sailing project to the center point of the Atlantic to do a plastic survey and we were finishing off with a tour around the UK. We were sailing across Lyme Bay just before midnight and it was suddenly like we were in a Second World War movie: Straight off the beam of the boat were these underwater torpedoes . . . that were dolphins. The water was dark and they were disturbing the phosphorescence. That was one of the most incredible interactions I've had with water.

"At sea there's nothing—no human references other than a ship."

AV: Is it possible to make sense of the ocean's enormity when you're rowing across it?

HT: No, there's nothing—no human references, other than a ship. You can't reference the scale of anything; therefore, it's very disconnected. You don't really feel like you're on the planet.

AV: Does the water change?

RT: There are definitely different types of water. So the English Channel is a turquoise sea green. And then I think we must have sailed across this imaginary line, where this green coastal water that we find around the UK suddenly goes into what's called a Caribbean blue, that bright vivid blue. You can tell how far you are off land by the color of the water.

AV: How do you deal with a 40-foot wave?

RT: Forty feet might seem a lot on land but at sea the fetch—or the distance between the top of two waves—could be 200, 300 meters.

(opposite) Ross (left) and Hugo Turner (right) have gained a following for doing experiments well-suited to identical twins, including monitoring the effects of a vegan lifestyle and testing the best mountaineering equipment.

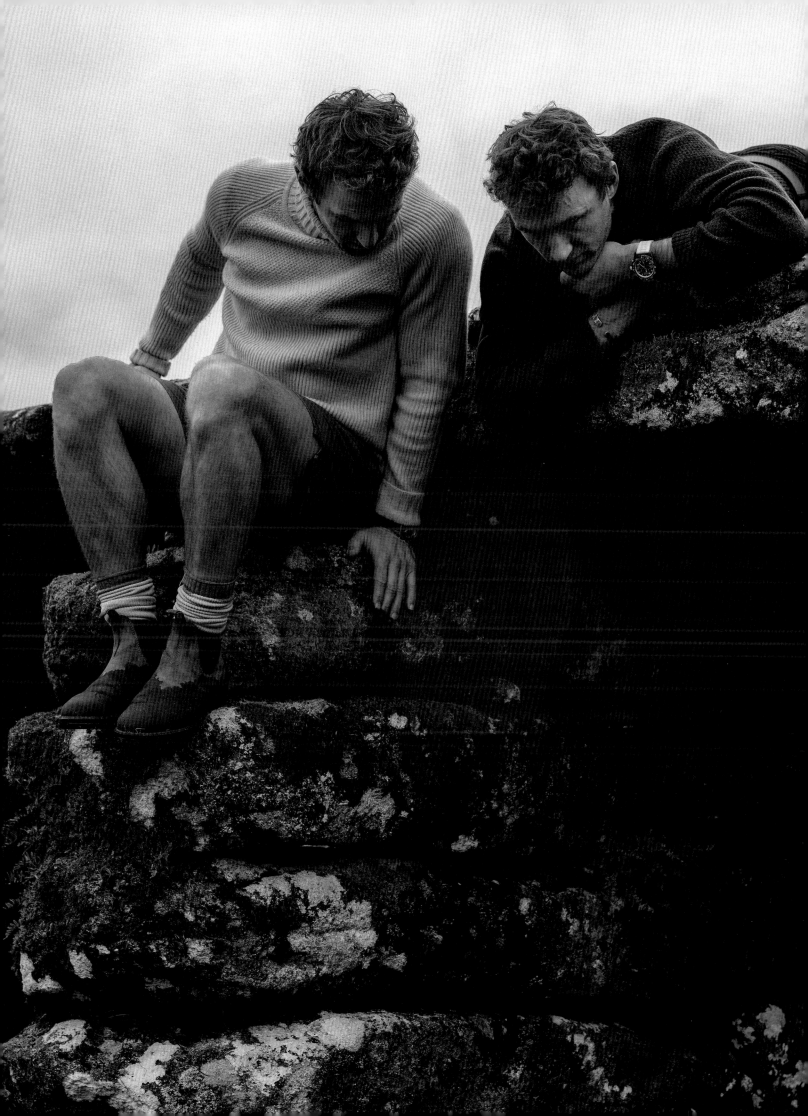

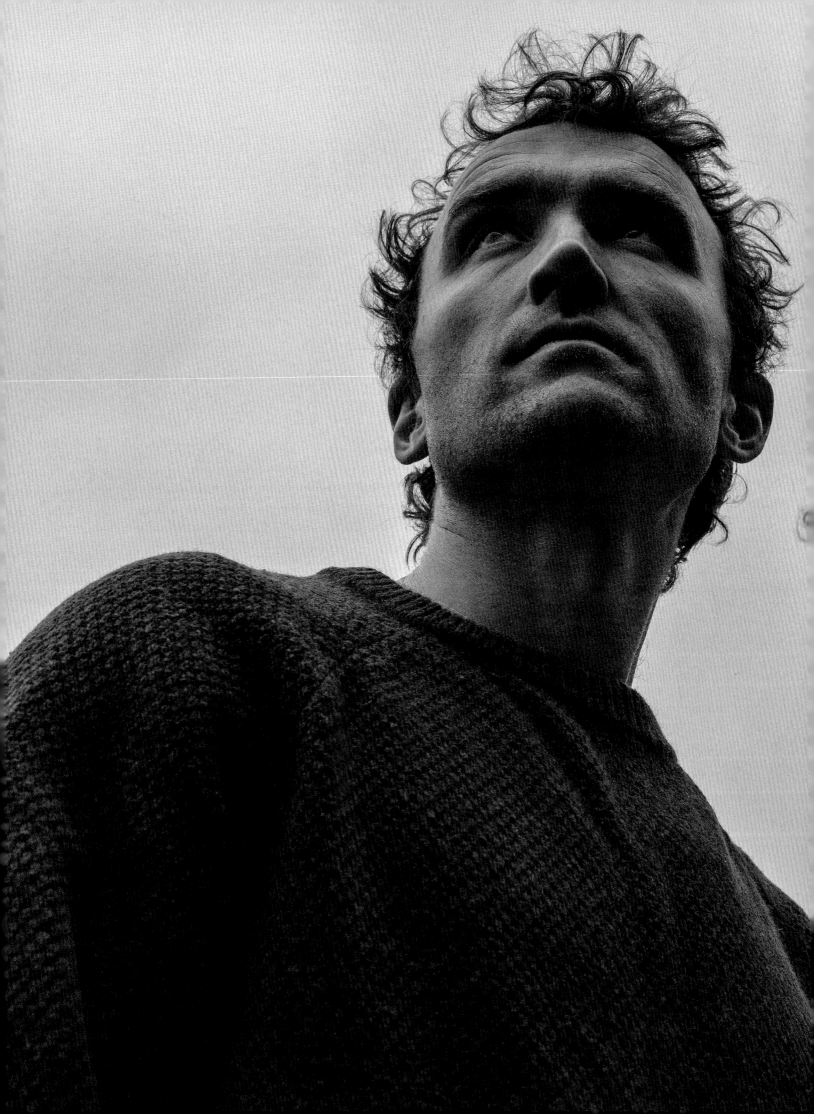

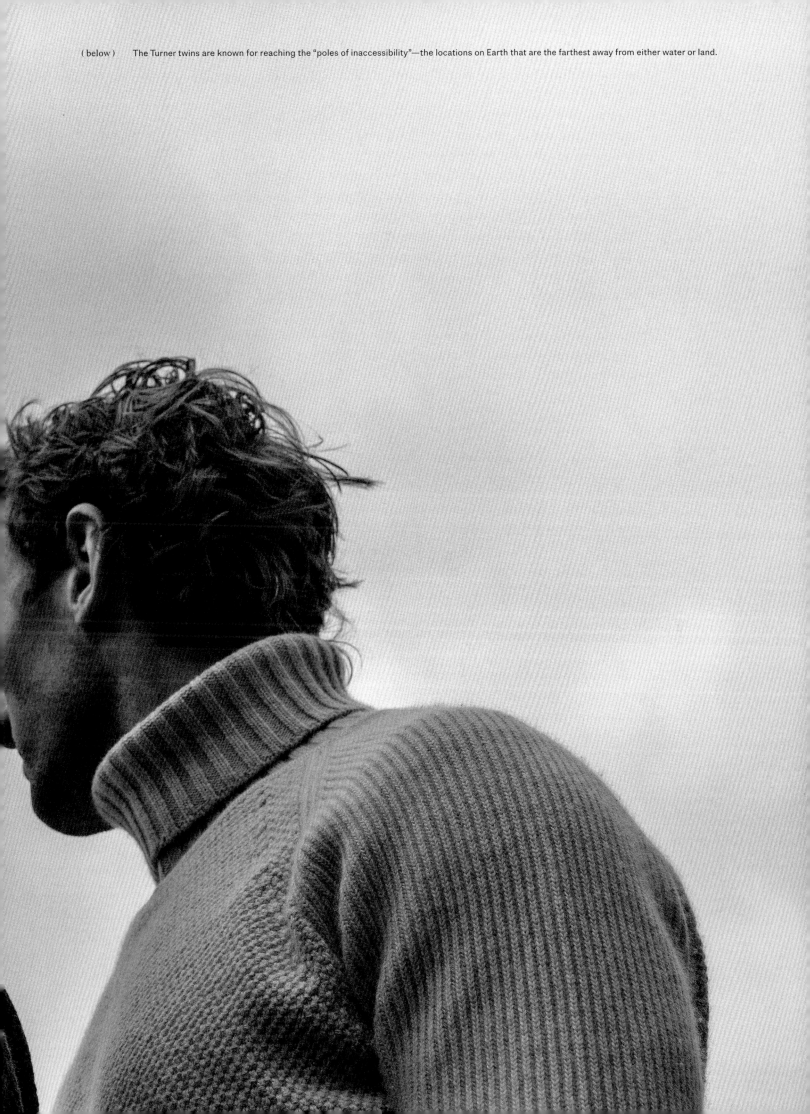

(below) The Turner twins are known for reaching the "poles of inaccessibility"—the locations on Earth that are the farthest away from either water or land.

HT: You're essentially a champagne cork just floating on the ocean: Most waves don't break on you. The top of the crest might, and they do quite regularly. But that's the top five feet.

RT: Ocean swells can be scary and beautiful, though. You'll be slowly rising to the top of what seems like a small hill, and you can see for miles, and then you're dropped down into it, and you really appreciate that drop. Rogue waves are more unpredictable: They can be double the height of a normal wave, and coming from a different direction. You can't really deal with them, you just have to suck it up.

AV: How does survival at sea compare to survival on ice?

RT: You've got to treat them very differently. You can float fairly comfortably in a life raft or on a boat for many days and there's lots of food in the ocean, so you can survive for months. On snow and ice, though, you've only got a finite amount of food. Weirdly, water is also a problem in snow. The worst thing you can do is totally run out of water.

HT: The snow doesn't melt; because it's made of very cold water, heat makes it evaporate immediately into gas.

RT: So you've always got to have water in the bottom of a pan and *then* put snow in, so it'll melt. In a polar environment, whenever we get to the bottom of a water bottle we leave about an inch, two fingers' worth. You can't use gas to start a fire—it'll freeze—so you have to burn white spirit or any sort of flammable liquid that isn't butane or propane. Even if we're not setting up camp, we'll make some water and fill up the thermos and water bottles.

HT: Another challenge is to avoid sweating too quickly, whether that's while trekking, climbing or working. Because as soon as your clothes become saturated with moisture they don't insulate. Merino wool is the best at drawing moisture away from your body. You can get into all sorts of problems if your clothes get too wet.

RT: For me, the biggest surprise with polar environments is that you can use the snow as a survival tool. If you're in a storm and starting to get a lot of snow buildup on the tent, you can dig down below the tent—ideally below the vestibule at the front—where it won't compact and the temperature is only ever just below freezing, even if it's minus 100 above. We made a whole room beneath our tent. You can wait it out there until the wind stops.

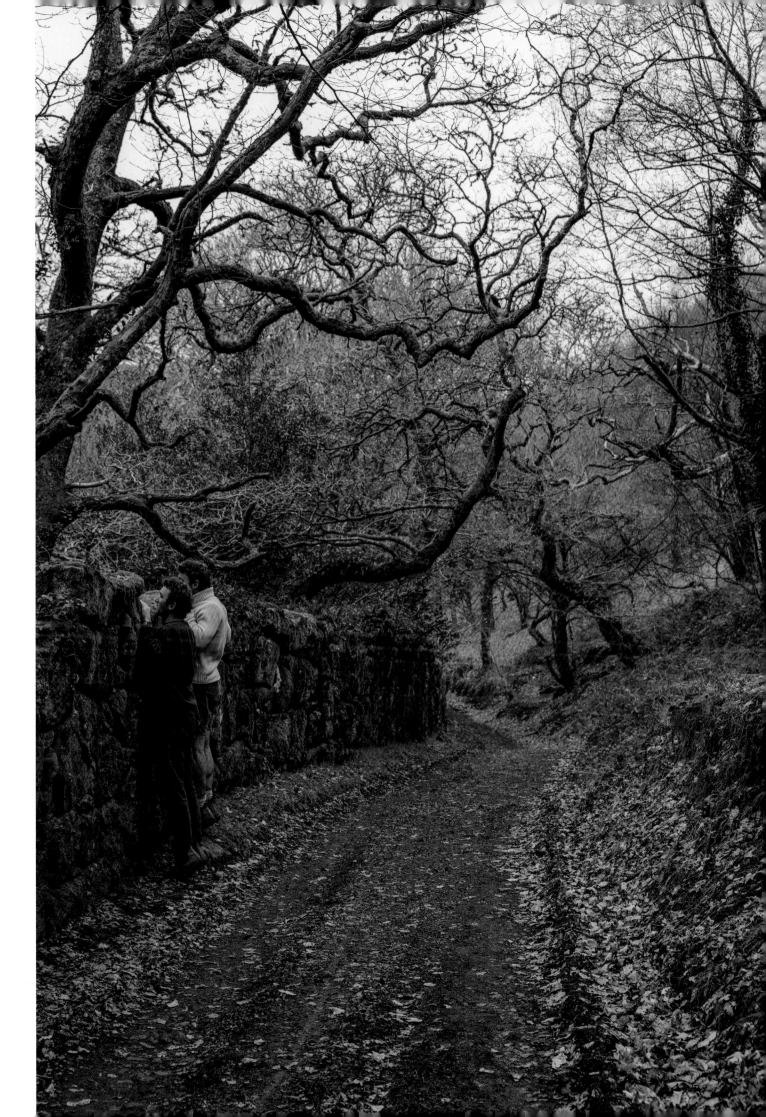

Words ROBERT ITO

Off to Sea *with* CYRILL GUTSCH

Meet the self-appointed design ambassador for the oceans.

Photos EMMA TRIM

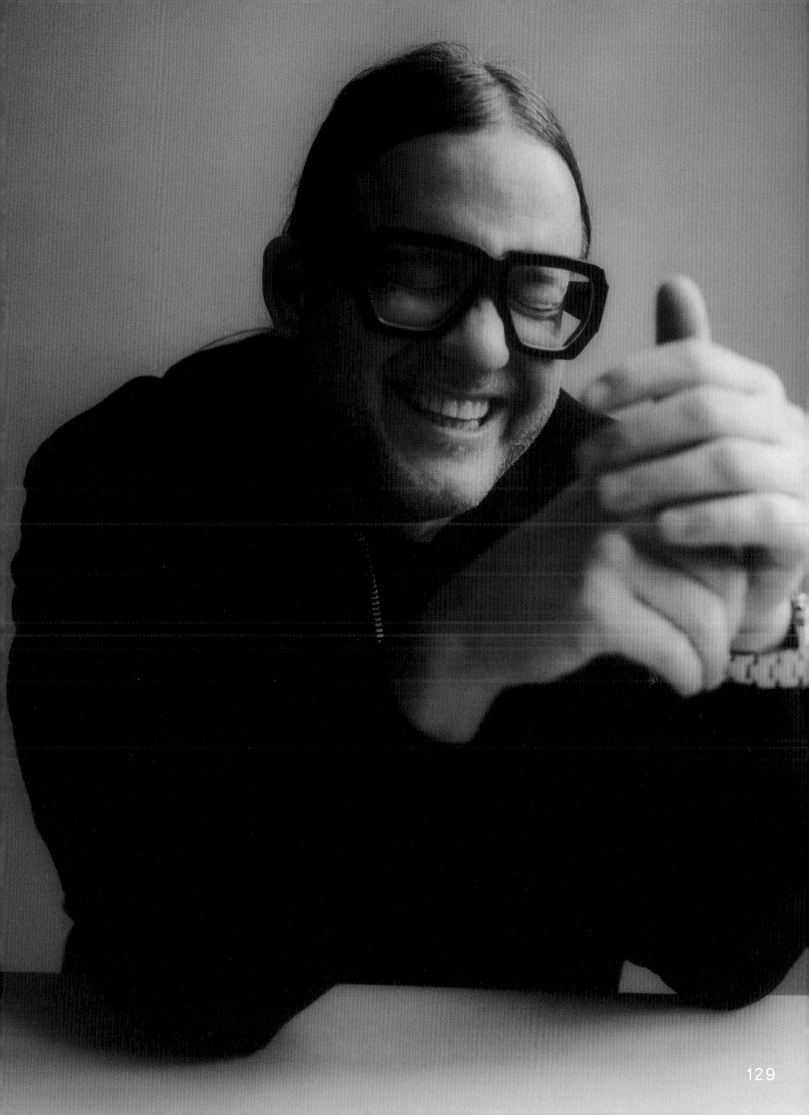

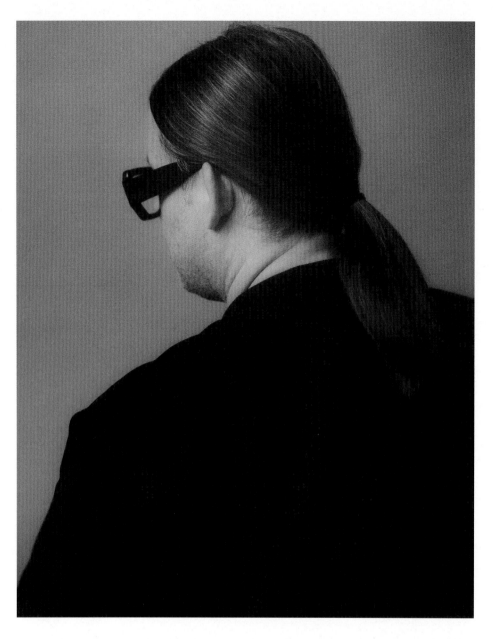

CYRILL GUTSCH built his career as a designer for big-name brands. Then he founded Parley for the Oceans —and set out to change them.

(opposite) Gutsch's projects often seek to demonstrate a point rather than provide scalable solutions. For example, in 2022, he installed the Parley Blueprint Module in London's Selfridges; a 3D-printing machine that turned plastic ocean debris into a range of on-demand objects.

For the past decade, Cyrill Gutsch has spent a sizable chunk of his waking hours trying to convince people, corporations and countries to be kinder to the sea. We all live together on this ocean planet, he says, and our lives and fates are inextricably tied to how we care for it. But rather than protesting in front of the corporate headquarters of oil companies or shaming brands and businesses on social media, Gutsch takes what he sees as a more productive approach to the problem. As CEO and founder of Parley for the Oceans, an environmental nonprofit based in New York City, Gutsch works as a unifier and collaborator, bringing companies and countries together to find ways to create greener products and to increase awareness about everything from climate change to the dangers of ocean plastics.

In many ways, Gutsch is ideally suited for the task. For years, the German-born activist was a designer whose clients included Adidas, Lufthansa and BMW, so he knows how these businesses operate and the sorts of pressures they're under from consumers to clean up their ecological acts. Among his most recognizable design collaborations are Adidas sneakers "reimagined" from plastic waste retrieved from various international coastlines, and Clean Waves eyewear created from reclaimed fishing nets. But Gutsch is also the most persuasive of speakers, a nice thing to be when you're trying to coax companies, many of them governed by decades of tradition and deeply entrenched business practices, to stop befouling our oceans.

> " A good brand is like good real estate. You can always build something else on it."

ROBERT ITO: How can design and designers help the oceans?

CYRILL GUTSCH: I'm a designer. My partner, Lea, is a designer.[1] In our hearts, we like to make stuff. Look at plastic. On one hand, for a designer, it's a dream material, right? It does everything you want, it bends to your will. On the other hand, it's so toxic and creates this avalanche of waste. We felt that we could use the plastic waste that you find at the end of the world, that washes up on beaches, that entangles in the reef, as a catalyst to open up a conversation around materials. We said, *Let's take the stuff that nobody would ever pick up because it's crazy expensive to do, and turn that into a premium material.* Don't get me wrong: Parley Ocean Plastic is not a better material than virgin plastic. But the act of removing it, of retrieving it—that is the difference. The collection alone costs 10 times, 20 times, sometimes 100 times more than virgin material, than virgin plastic. The value is in the story,

the narrative, the impact that removing it has. Every piece of plastic we collect was removed from somewhere, and it didn't end up in the belly of a bird or other animal. This becomes a value differentiator, a luxury.

RI: How do you select who you partner with?

CG: We are very careful in picking the right partners. It's always a process, because you often start from scratch. We work with artists that sometimes don't have any consciousness or knowledge about the topic, so it takes a lot of time. Same with designers. And you work with brands that often also are not very open, because they're scared: scared that it costs more, it changes their supply chain. But if they expose themselves to that, if they allow that, then it becomes this beautiful ping-pong game of exchanging knowledge or challenging each other and asking the questions nobody dares to ask. And the outcome is a better product—better in the sense of the carbon footprint and the materials being used.

RI: What do you do when a company comes to you that you know is a major polluter?

CG: We meet. There are some companies where you know that they can't change, because their business model is simply built on exploitation, and they will not be able to meet the promise they give to their customers—that their product will come out cheap and fast. We couldn't align ourselves with an automotive company that depends on burning fossil fuel, which is the No. 1 driver of climate change. We tell them: We can talk to you, we can work with you, but we can't go out and show our brand next to you, because we would be promising something we know we couldn't deliver. We've had companies that run the big marine parks reach out to us. Those are basically prisons for animals, and we didn't see any indication that they wanted to change that, because the only possible outcome would be that they stopped being a marine park. But I think that every brand has the potential to do something very different with its name, because you don't have to stick with what you have done in the past. A good brand is like good real estate. You can always build something else on it.

RI: Do you get a lot of companies who want to partner with you just to burnish their own corporate image?

CG: Today people want to say, *Oh, we're environmentally friendly, we're green, we're recyclable.* Companies go to great lengths to try to create that appearance now, sponsoring the [climate summit] COP, or inventing new brands in their portfolio, or adding nice logos or even hiring young activists as models

for their campaigns.[2] Greenwashing means that you're pretending to be something that you're not. You didn't change your business practices, you just want to make them look better.

RI: What are some of the bigger ecological issues that you're involved in, and how do you prioritize those? I imagine every issue feels like the most important one.

CG: That's true. We really look at two different forms of impact that we can make as an organization. There's the hard impact: that means something that you can really measure, like saving a whale. The whale is entangled in a fishing net and you save the animal, the animal lives. That's easy to measure. We intercept a certain amount of plastic waste, or we help regenerate an area of underwater forests or we stop poachers, like an illegal fisher, that's also easy to measure. And then there's soft impact: How many people do you educate? How many people do you help change their view on things, or give them the knowledge they need to live a better life, or to change their companies or their countries? That is not so easy to measure.

RI: With Clean Waves glasses, is the idea that people will like the look of them and *then* you can explain that they were actually made out of fishing nets?

CG: That's it: We don't like to preach. We like to create desire for objects. Our narrative, our storytelling and opening people's hearts and brains happens most of the time with a great product. People see a new shoe from Adidas and they say, I couldn't imagine that environmentalism could look that cool.[3] When you look at our partnership with Dior, you don't have the feeling that you're compromising on quality and style. And suddenly these items become the symbols of change, they become a conversational item. People say, Can you imagine that? This was a fishing net before. Or, can you imagine that? This material was grown by a mushroom, or colored by an enzyme.

RI: I probably eat way too much fish and use way too much plastic. How are you doing in terms of living up to your own high ideals? And are there things you could do better?

CG: Oh, yeah. I mean, we're all hypocrites. I don't know any environmentalist who is not a hypocrite. Because we are saying things and we want people to do things, we want ourselves to do things, but it's very hard. I just came back from a trip; I flew in an airplane around the world. So yeah, I'm doing things that are very sinful. But it's not about being dogmatic. It's about being aware that something is bad, and about doing the best you can not to be that bad.

RI: How do you get people who don't care about the ocean to start to care?

CG: I think the best way to care for something is to fall in love with it. And that's easy, if you have the opportunity to bring somebody under water, for example. If you get somebody to travel with you to remote areas and they allow themselves to meet a whale, meet a shark, go diving, that can make a big change. We do a lot of projects, even in very remote areas. We have one project with Doug Aitken—the Underwater Pavilions.[4] We do Parley Ocean School events.[5] We do expeditions. Bringing people into nature, exposing them to the beauty and the magic of the sea is, of course, the ideal way of doing it.

" The best way to care for something is to fall in love with it. That's easy if you bring somebody under water."

(1) Lea Stepken is a film producer and co-founder of Parley for the Oceans.
(2) Conference of the Parties (COP) is the decision-making body of the United Nations Climate Change Conference.
(3) Since 2015, Parley for the Oceans and Adidas have worked together on a variety of sports products and apparel, including a line of running shoes made from recycled plastic waste retrieved from beaches and coastal communities.
(4) In 2015, the artist Doug Aitken installed three underwater sculptures off the coast of California's Catalina Island.
(5) Parley Ocean School provides in-person and virtual programs to educate young people about the ocean and the environment.

How the 32-ounce
water bottle became
a lifestyle prop.

ESSAY:
WATER, WATER
EVERYWHERE

Words
ROBERT ITO

Everybody needs water, and reusable water bottles are as good a way as any to tote a bit of it around. Kids take them, snug in their backpack pockets, to school; grown-ups bring them to yoga classes; adventurers lug them up mountains. But water bottles have moved far beyond their purely practical use as simple hydration devices. Fashion models display designer versions on runways, while the rest of us festoon our Nalgenes and Hydro Flasks with stickers advertising the names of towns we've been to and bands we love. One can find water bottles that look like penguins, or bowling pins, or soccer balls. So how did these relatively simple containers—some with spouts or screw tops, others insulated with double-walled steel—become such powerful signifiers of who we are and what we believe in?

water bottle says 'I don't drink the bottled stuff. I have a conscience.'"

"It's so rare that we can signal what we don't do," he says, "that it has an extra power attached to it." Water bottles also let people know you're someone who embraces an active lifestyle, and maybe even loves the great outdoors, whether or not you ever get out into it. If you're on a walk in your neighborhood with your Hydro Flask, you could theoretically keep walking and walking until you reach some sort of wilderness area, and you'd be set. A direct descendant of the canteen and the goat-skin bag, the modern water bottle was initially created for adventurers to do just that: carry water to distant and exotic places where there might not be any available. That sporty heritage still clings to them today, even for suburban slugs who

> " A reusable water bottle says
> 'I don't drink the bottled stuff.
> I have a conscience.'"

A big reason they say so much about us is because of what they're *not*. They're not disposable water bottles, the sort that litter our shores, or end up in the guts of whales and sea turtles in the form of microplastics.[1] When you take the time to fill your Hydro Flask or Yeti or Nalgene out of a home tap, you're telling others: *I'm not the sort of person who junks up the environment willy-nilly. I'm the sort of person who cares deeply about a whale's guts. I care so much, in fact, that I'm willing to schlep this bulky water bottle everywhere I go.*

"A lot of it has to do with signaling," says Richard Wilk, professor emeritus of anthropology at Indiana University Bloomington, who has written extensively about the history of water bottles. "If I see someone eating a hamburger, I know they eat meat. But if I see someone eating a salad, I don't know if they eat meat or not. It's very hard to show people what you *don't* consume. But a reusable

are using them just to haul water to, say, the mall. Of course, there's adventurous, and then there's adventure-ish. According to Sam Schild, an outdoor adventurer and co-writer of Wirecutter's "8 Best Water Bottles of 2023," not all water bottles have the same rugged cachet.[2] Hydro Flasks, he says, are for people who "like doing outdoorsy stuff, but they probably are urbanites. They spend most of their time in the city, but they're always dressed like they could go on a hike at any moment." Nalgenes, on the other hand, are the bottle

(1) Humans may also be ingesting microplastics through disposable water bottles. In 2018, the State University of New York found microplastics in 93% of the bottled water it tested, roughly twice as many as in tap water.
(2) Wirecutter's research took place over nine years, involved four researchers testing more than a hundred water bottles and included a call to NASA to understand how double-walled insulation works.

of choice for "that traditional outdoorsy person who maybe actually lives in a mountain town, or spends a ton of time outside. They're rock climbers, or backpackers. They're way more concerned with durability than anything else."[3]

As for Yetis, he says, they're for folks who have a "really, really nice Toyota truck, and they drive to a campsite for the weekend. They have all these toys, a mountain bike, a $5,000 rooftop tent, so they have to have a really nice matching Yeti water bottle, too."

Water bottles are also a great way to show that you care about your own health, separate from the general health of the planet. You're a person who hydrates. For decades now, we've been told that we should drink eight glasses of water a day to keep our joints lubricated and our internal organs functioning. Even as questions arose about how that magical eight-glass figure came to be,

" If you had asked me 20 years ago where I thought water bottles were gonna go, I would have said, 'I don't know. Nowhere?'"

the message stuck: Drink lots of water![4] People have bought into this so completely that there are now so-called motivational water bottles—giant, comically unwieldy jugs that hold a gallon of water each. The idea is to drink the contents of the entire jug in a day; line markers at one or two hour increments, along with encouraging messages, tell you if you're hitting your goals ("3 p.m. Feeling Awesome," "5 p.m. Don't Give Up," and so on). "That seems extremely gimmicky to me," says Schild. "But it's clever marketing."

Connie Pechmann, a professor of marketing at the University of California at Irvine, sees the

(3) Most Nalgene bottles are made of a tough plastic called Tritan, which is so durable that the brand offers a lifetime warranty. Inevitably, consumers go out of their way to try to prove the bottles can be broken.

(4) There is no formal recommendation for the amount of water people need day-to-day, and no science behind the idea that you should drink eight glasses. The amount of water required differs by what people eat, where they live, how big they are and what they are doing.

enormous bottles as something of an inevitability, given how long water bottles have been around and how popular they continue to be.[5] "At this point in the life cycle of a product, people are trying different ideas, different segments, trying to keep things interesting," she says. "Water bottles aren't going to grow organically any more, because they're established products. So in order to get any growth, you have to come up with different ideas, most of which will fail."

Among the more dubious ideas are high fashion bottles, including those marketed by style houses like Prada ($160) and Chanel (around $5,000, complete with lambskin holder). Designer bottles by Balenciaga and Givenchy have shown up on runways and in photo shoots, often secured in their own equally stylish holders and shoulder bags. "I don't think that's a core market," says Pechmann. "But it makes sense that if the people who buy your brands are using water bottles, why not make a water bottle that matches your clothes?"

One reason why you might not want to, of course, is that the very idea of water bottles as fashion, something that constantly changes with the seasons, is antithetical to why water bottles were created in the first place. "If you're getting water bottles to match your outfits, and the colors change every year, it kind of defeats the whole purpose of sustainability," Pechmann says. And in terms of functionality or durability, says Schild, you're not getting anything appreciably better once your water bottle goes over, say, $50.[6]

Even if high fashion bottles eventually fade away, however, water bottles themselves aren't going anywhere. Humans are always going to need water, and every year, there are new and different models vying for a fickle public's attention: ones that filter your water or clean themselves or light up to remind you to drink. "If you had asked me 20 years ago where I thought water bottles were gonna go, I would have said, 'I don't know. Nowhere?'" says Schild. " It's just a thing that holds water. It's mind-blowing, actually, how popular they are."

(5) The Stanley Adventure Quencher Travel Tumbler is so popular on TikTok that its hashtag, #stanleytumbler, has 12 million views. Stanley's president reported in 2022 that the product had a 135,000-strong waiting list.

(6) The Acqua di Cristallo Tributo a Modigliani was recognized by the *Guinness World Records* as the world's most expensive bottle of water. Made by Fernando Altamirano from 24-carat solid gold and 6,000 diamonds, the 750-milliliter vessel was valued at $6 million.

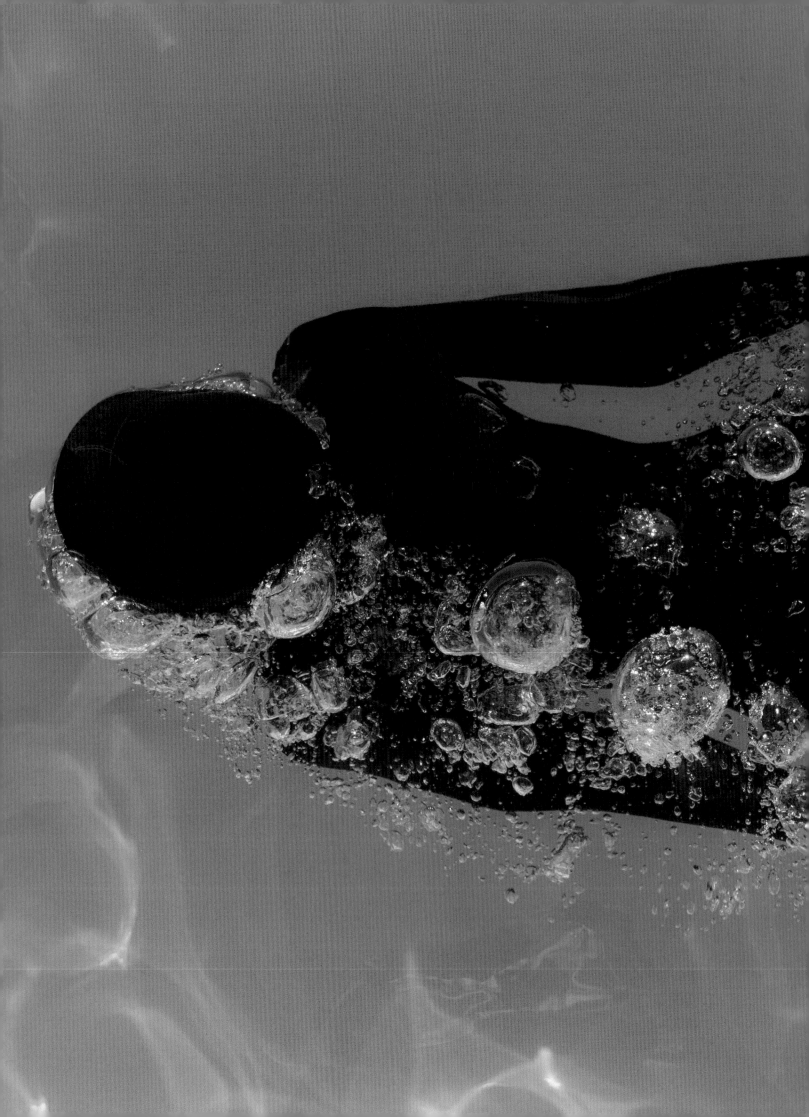

Two friends, one drop
in the ocean.

BODIES OF WATER

Photography
MICHAEL
OLIVER LOVE
Styling
KRISTI VLOK

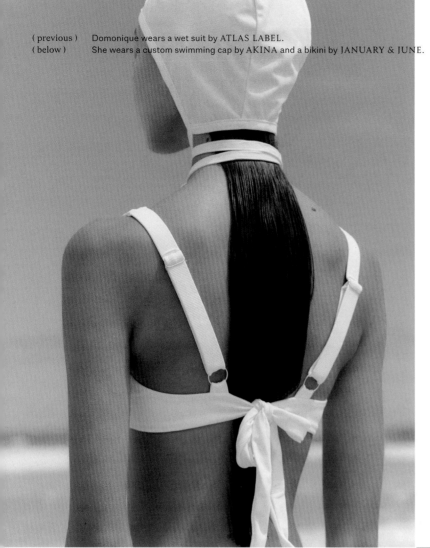

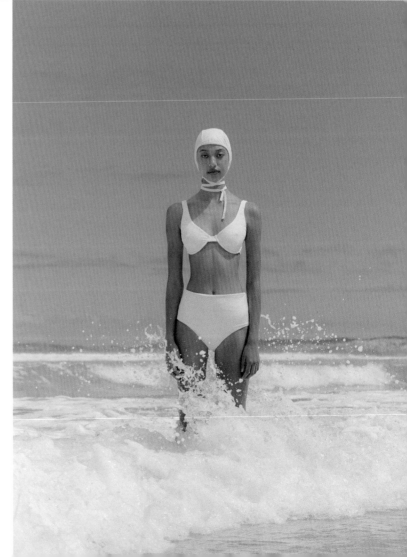

140

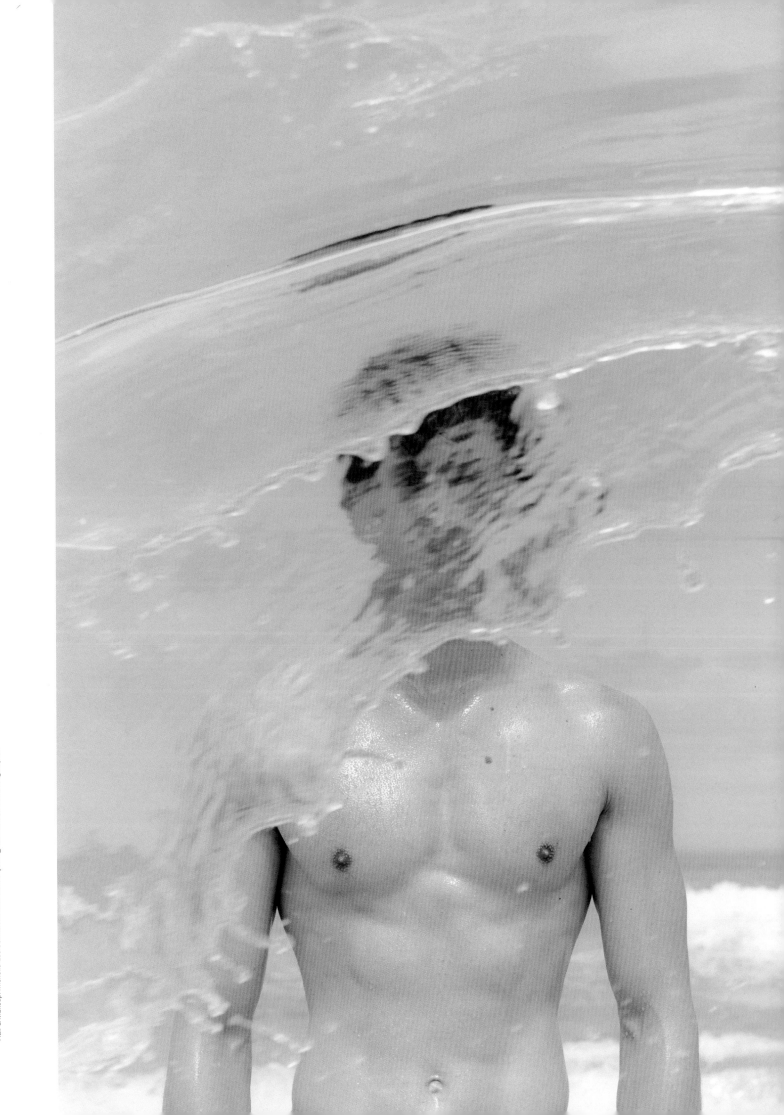

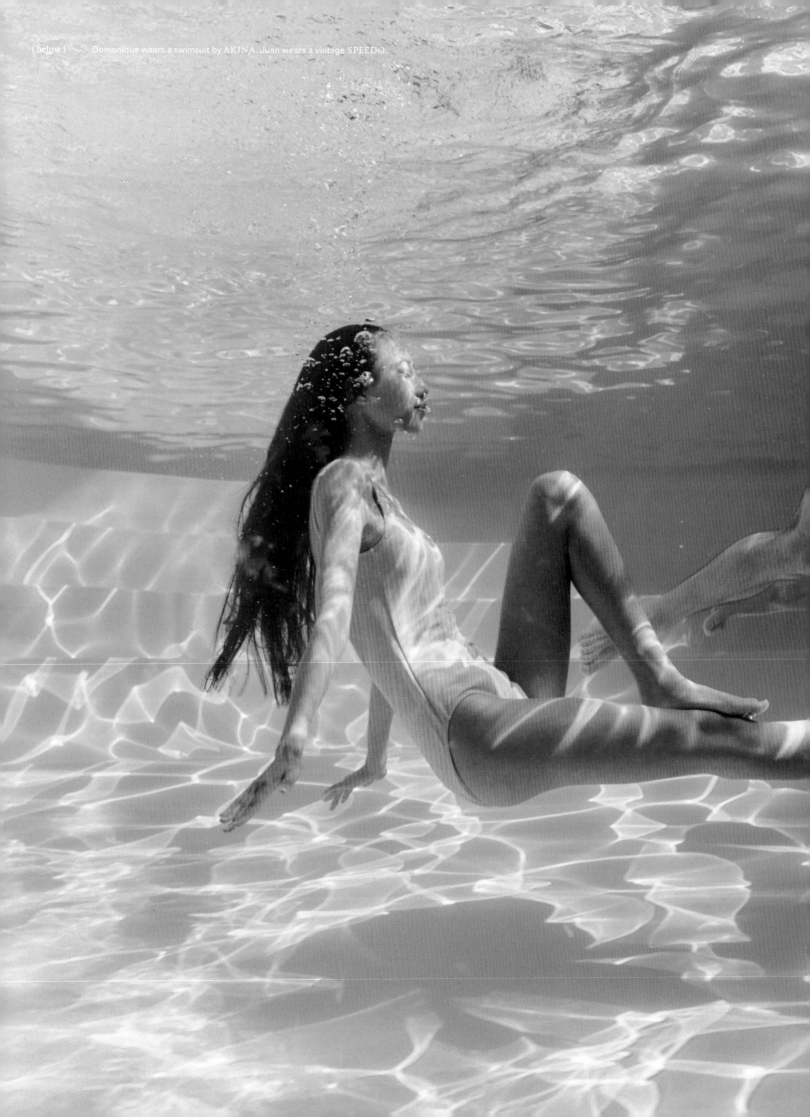

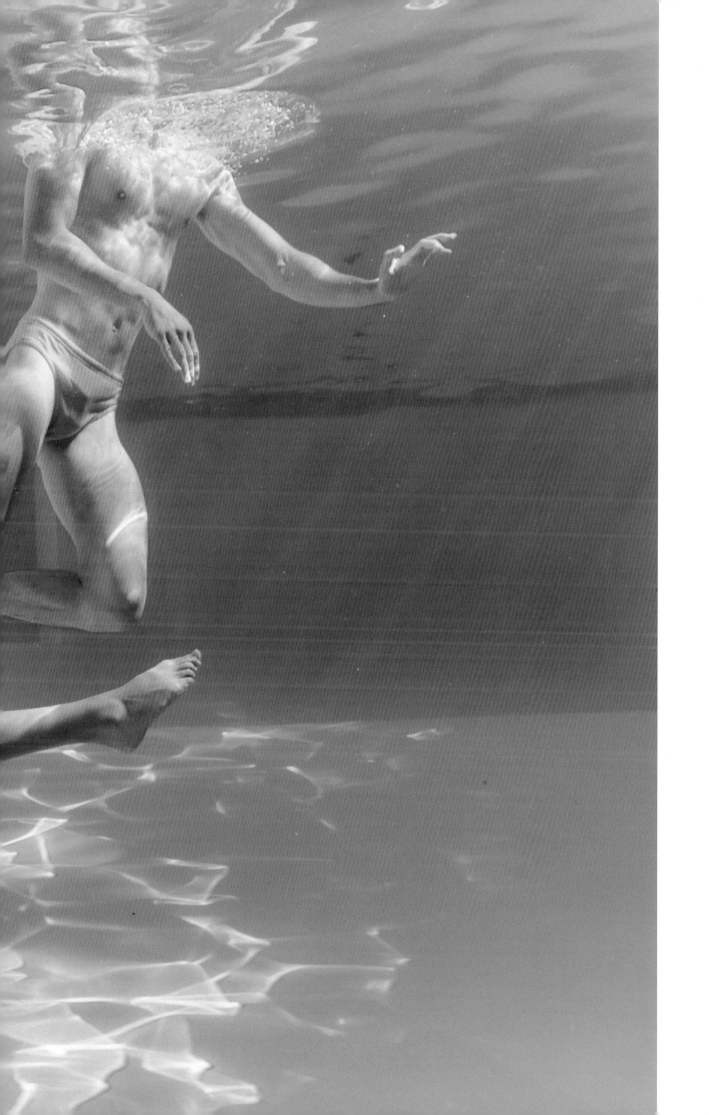

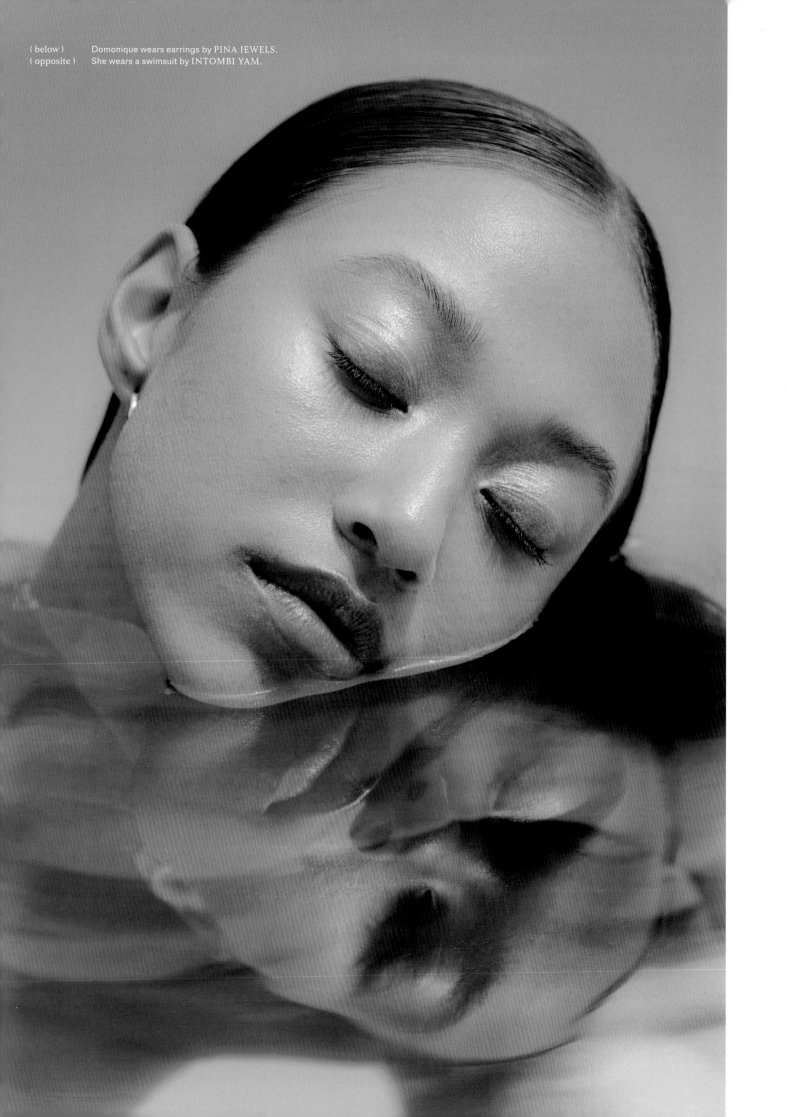

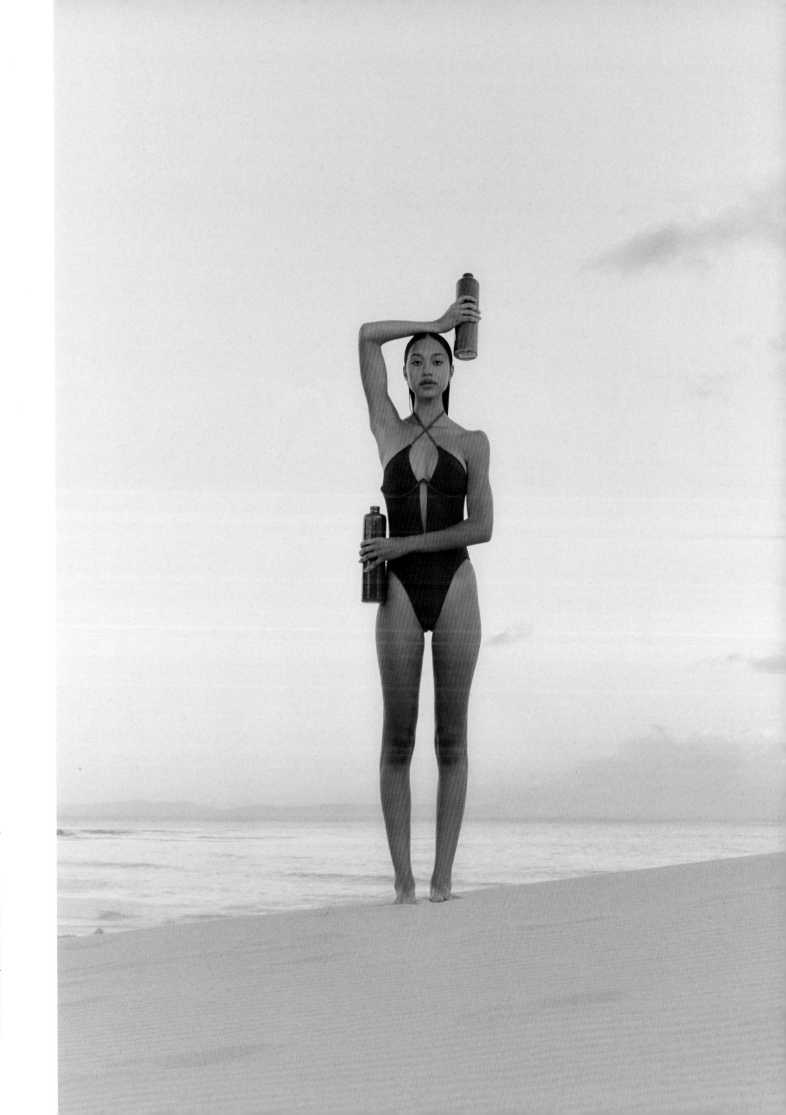

Photo Assistant: Tshepo Rancho. Production: Hero Creative Management

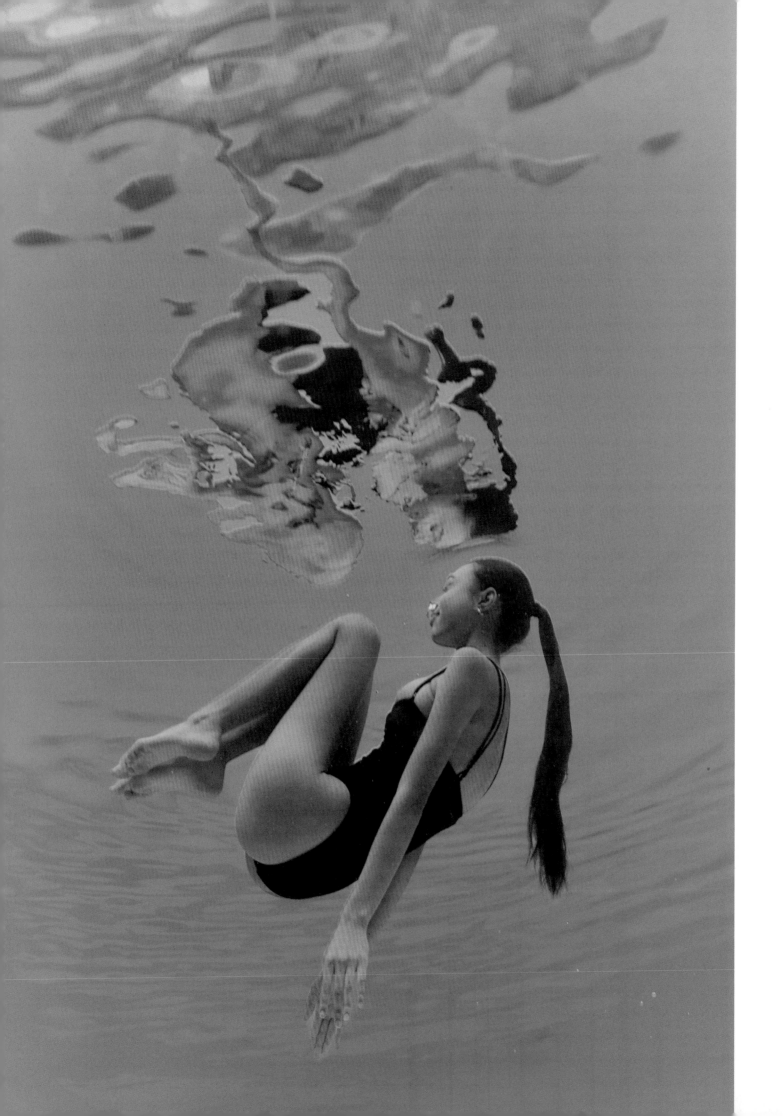

(opposite) Domonique wears a swimsuit by LILY LABEL.
(below) Juan wears a wetsuit by ATLAS LABEL.

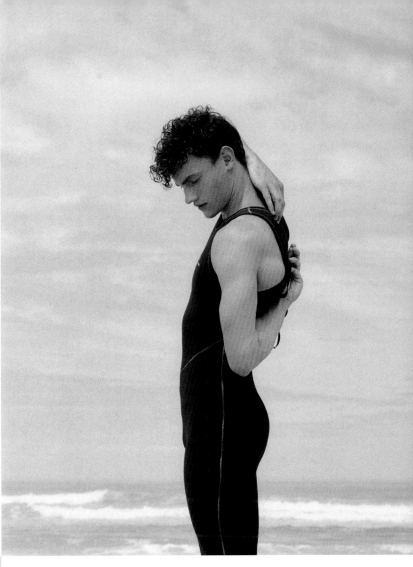

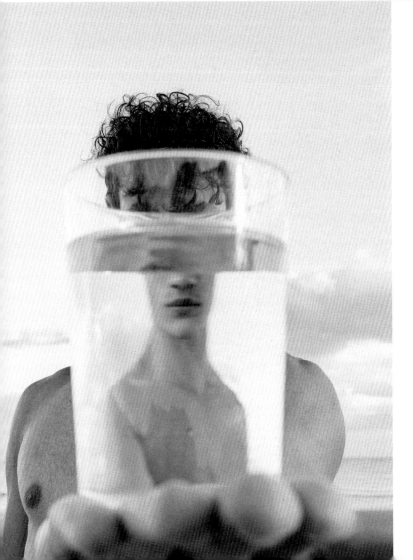

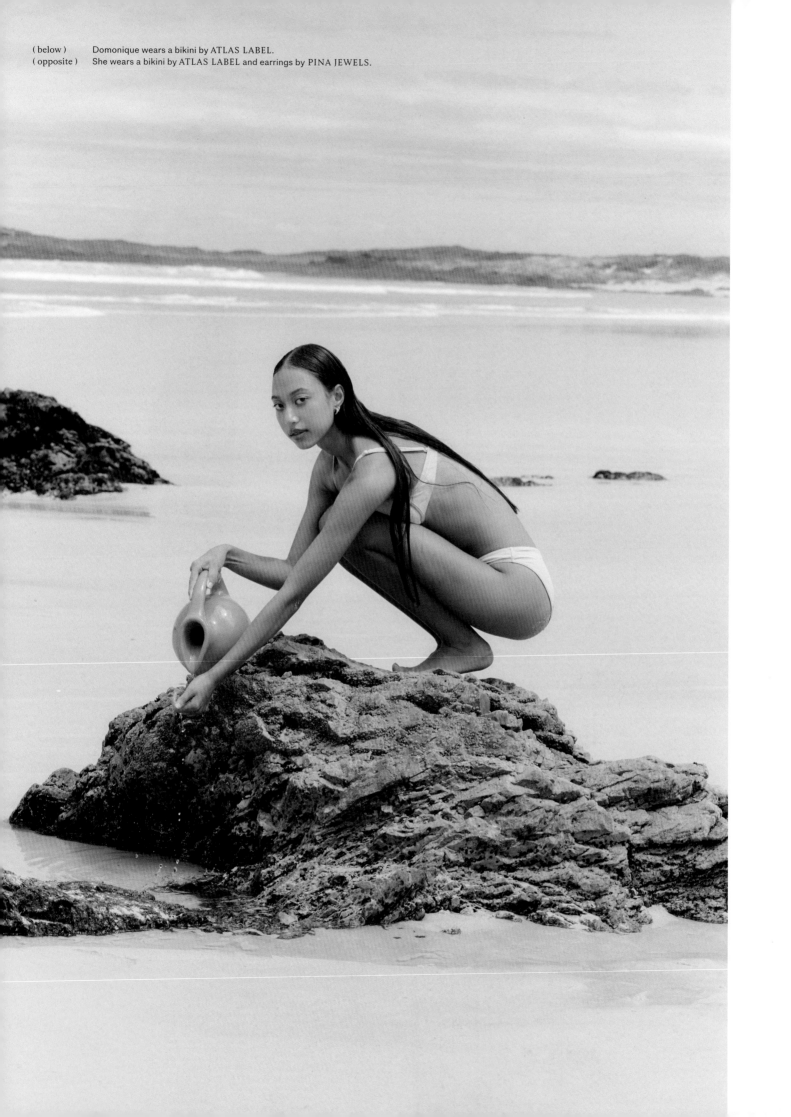

(below) Domonique wears a bikini by ATLAS LABEL.
(opposite) She wears a bikini by ATLAS LABEL and earrings by PINA JEWELS.

The

WORDS Laura Hall

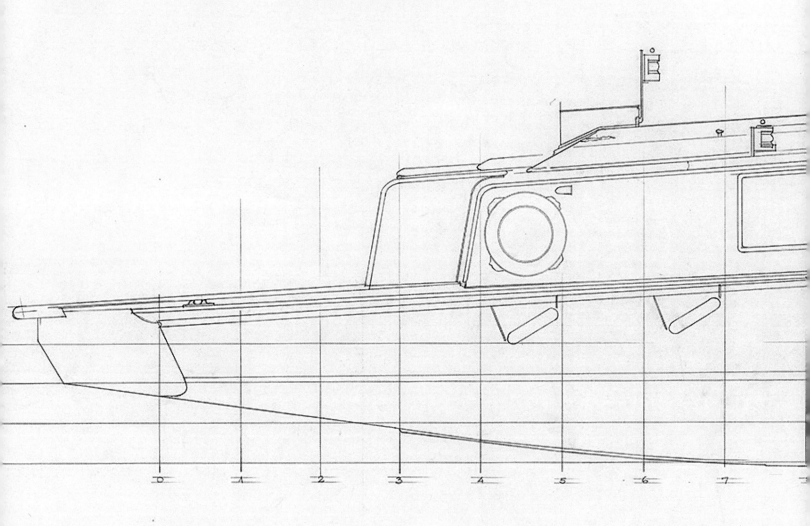

0 1 2 3 4 5 6 7

BOAT

AALTO

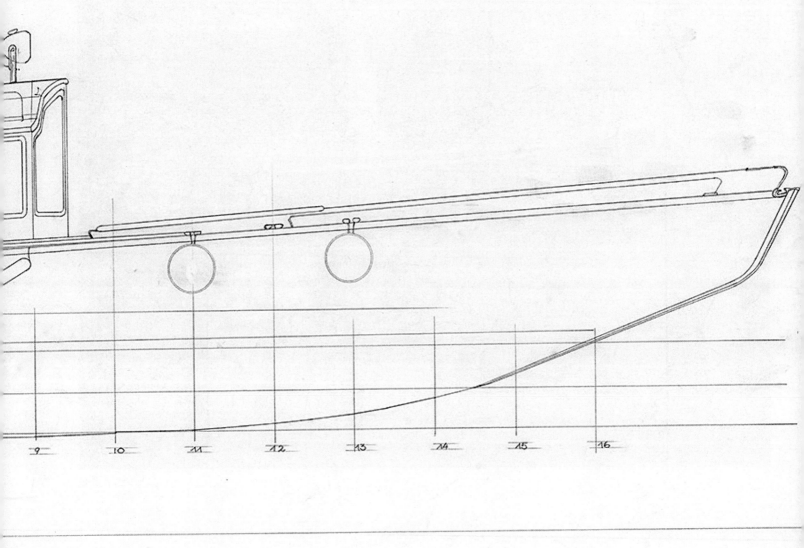

AAA 93-554

The Finnish architect was a visionary completest—and an amateur boatman.

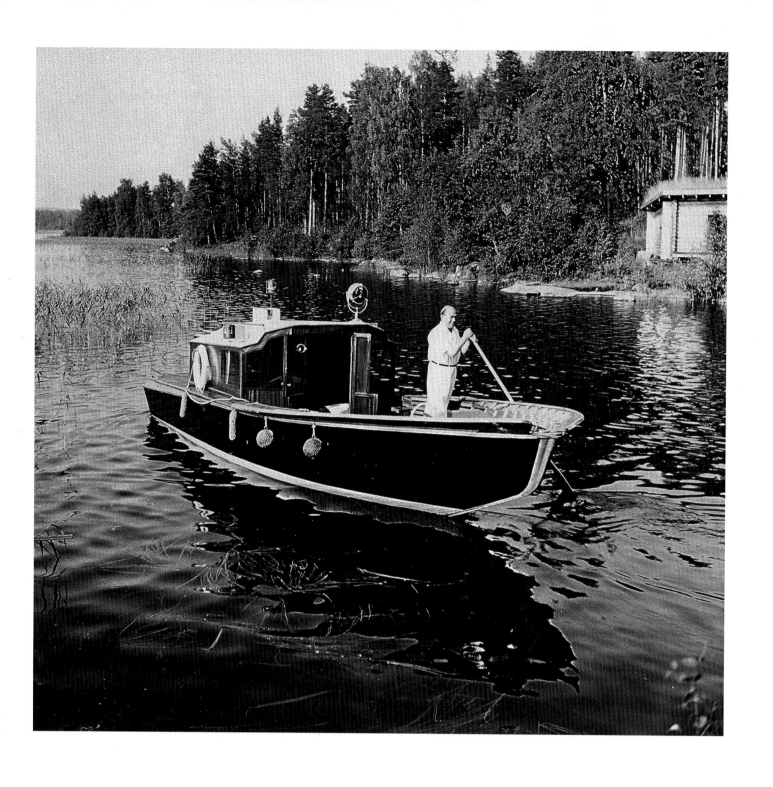

"You would have to look twice to spot it in a lineup."

In the spring of 2023, the only boat ever designed by Alvar Aalto was displayed for the first time in Jyväskylä harbor following extensive renovation. Designed by the Finnish architect in the early 1950s, the black-hulled wooden motorboat was used for shopping, island hopping trips and guest transport to and from his experimental summerhouse on Muuratsalo island in Lake Päijänne, central Finland.

It would be natural to assume that Aalto's boat is a work of genius, a boat that redefines what a floating vessel can be in a humanistic, functional-yet-elegant tradition, like his architecture itself. But what makes it all the more remarkable is how unremarkable it is. In fact, this relatively mundane boat tells the story of an architect who was just as fallible as anyone else.

The idea came to Aalto in the early 1950s, when he was working on Säynätsalo Town Hall, a light-filled redbrick building on an island in Lake Päijänne. Inspired by his experiences working there, he decided to build a house on the neighboring island, Muuratsalo. He intended to use it as a playful architecture lab to which he would bring his office during the warmer months, and a summer residence where he and his second wife, Elissa, could escape the city and relax in nature. Needless to say, he would need his own boat to reach it: "He was used to looking at the whole problem and coming up with a solution," biographer John Stewart, author of *Alvar Aalto: Architect*, tells me. "He liked to design everything in his buildings: not just the architecture but the furniture, the fittings, and right down to the finest details."

This architectural approach is known as gesamtkunstwerk, a completist attitude toward design that suited Aalto's obsessive, detail-driven mind. Like fellow modernist Le Corbusier, he seamlessly integrated the design of his architecture and interiors into a unified whole. The boat was created in the spirit of the house, which took play and experimentation as its fundamental principles. The guest wing, for example, was created as a building without foundations, while the woodshed employed a free-form column structure: The load-bearing columns were positioned in the best places available in the rocky terrain.

(above)
Aalto and his wife, Elissa Aalto, on the western shore of the Finnish island of Muuratsalo, where the two had an experimental summerhouse.

Celebrated for his linear elegance, Aalto also deeply understood natural form and texture and championed the use of local materials and space. His sauna—a Finnish essential rather than a spa-like extravagance—was built on stones on the shore using logs from trees felled on the site.

Aalto is not the only modernist to dip his toe in the water of boat design, or to have his boat on display today. Le Corbusier converted a concrete barge in Paris in 1929, fully fitting it out to create a floating refuge with room to sleep up to 200 people; furniture, cupboards and sliding doors were part of its integrated design. Considered a historic monument, it was in the process of being converted into a cultural center when it sank in storms in 2018. Louis Kahn's musical barge and floating arts center, Point Counterpoint II, has toured the world, and recently found a permanent home at the revamped Delaware Power Station arts complex on the Delaware River in Philadelphia. But while both of these boats were designed for a public purpose, Aalto's was a private endeavor, with one aim in mind: suiting his own exacting needs. His boat, built in 1954 by boatbuilder Väinö Jokinen to Aalto's strict specifications, was perhaps more functional than elegant. At a little over 33 feet long and 8 feet wide, it featured a mahogany deck, a pine cabin in the bow with a white life belt hanging on the side, and engines and fuel tanks in the stern.

The project obsessed Aalto: He did proportionally more sketches for its 275-square-foot space than for any other project he planned. Such was his attention to detail that many parts of the boat were built and taken off and rebuilt, resulting in the whole boat being made twice over.

The boat's bow was custom designed to fit the precise shape of the island's shoreline. Perhaps this is why it was said to "till the surface of the lake like a plow" rather than glide through it. The boat leaked every spring when its pine boards swelled; it even sank a few times. While its gleaming ironwork still drew the odd admiring glance, in its functional design, it seemed a long way from what might have been expected. "[Aalto] was seen then, as he is today in Finland, as a minor god. Whatever he did, he was a genius," Stewart reminds me when we speak. "An Alvar Aalto building at this time was a radical departure from what had gone before. But with this boat, you would have to look twice to spot it in a lineup to see it was an Alvar Aalto boat." Aalto's life on the island was lived out of

(opposite) With a population of about five million, Finland has one lake for every 26 people. Boat ownership is relatively common and Finland is among the countries with the most boats per capita.

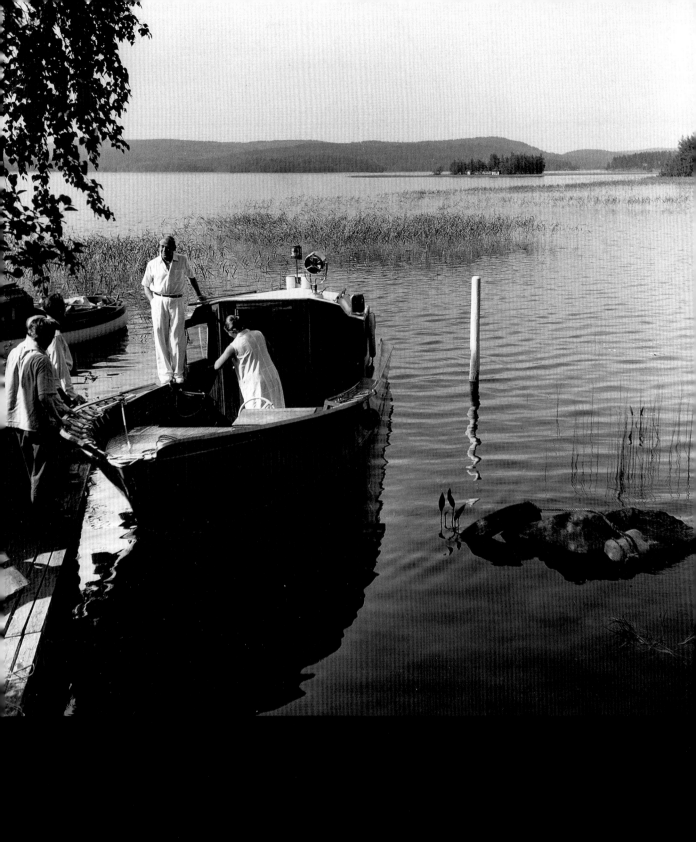

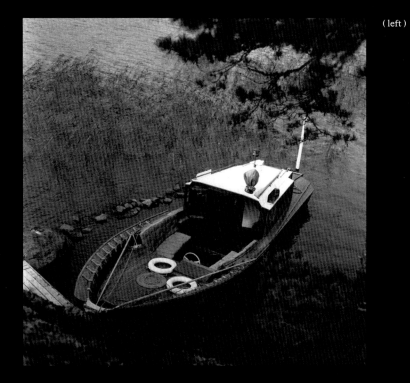

Aalto designed the boat to have an open deck at the front, with padded benches on both sides and a wide gunwale to keep the passengers dry.

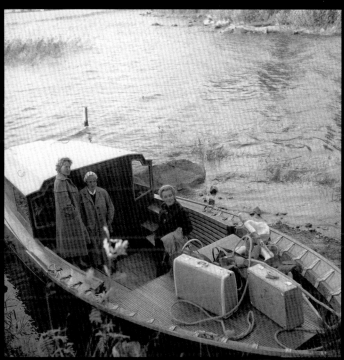

(right) Aalto's friends Mona Schildt, Maija Gullichsen and Maija Heikinheimo on the deck of the boat in 1954.

the glare of the public eye. This is where he would invite friends and family to relax and enjoy nature, sauna and swim.[1] Perhaps the appeal was more about divorcing himself from other influences than about escaping work pressures. Aalto was a noted workaholic who kept long hours in his city studio. On the island, meanwhile, he painted with oils on the house's atelier balcony, worked on experimental projects (including one for generating solar energy) and, along with his wife, dreamed of reshaping the island's rocky spaces and creating a lush garden from its rugged, overgrown state. His work, which owed so much to the Finnish landscape and to his interpretation of how architecture and nature could influence each other, was ever present.

The building of the boat coincided with a period when Aalto himself was struggling to stay afloat. While he had hoped to offset the expense of the experimental house against tax as a research activity, the tax authorities not only disagreed but launched an investigation into Aalto's tax affairs over the previous six years. It caused chaos in the architect's studio: His business affairs were messy and he was profligate with money. He once ran up such a large bill with his long-term taxi driver that he opted to design a house for him to clear his debt. At the same time, Aalto's application to join the elite Finnish Academy was under review and he felt the Finnish government was working against him. As a result, he named the boat Nemo Propheta in Patria (meaning "no one is a prophet in their own land").

Aalto went on to create his greatest works in architecture in the following years, including Finlandia Hall, completed in 1971, widely considered a masterpiece. He was admitted to the Finnish Academy the year after the boat was built, and served as its president from 1963 to 1968. His future as one of Finland's greats was secured.

On the side of Jyväskylä harbor, Nemo Propheta in Patria sits now in a stylish, custom-designed weather shelter.

"Aalto was experimenting all of his life. Some of the time it worked, sometimes it didn't."

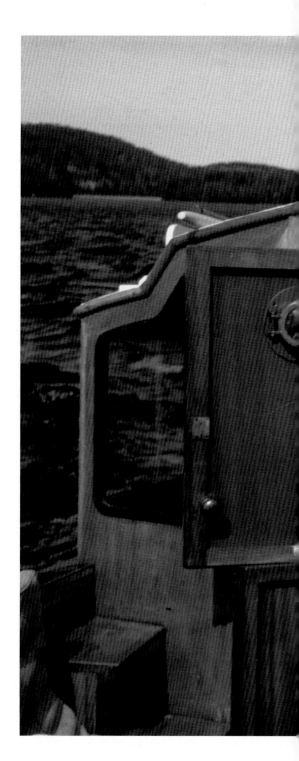

Floor-to-ceiling windows along two of its three sides simultaneously protect the boat from the elements and reveal it to the public. Designed by architect Tapani Tommila and coordinated by Tommi Lindh, CEO of the Alvar Aalto Foundation, the shelter functions as a mini museum.

Does the celebration of Aalto's boat reflect an unquestioning belief that everything the architect touched turned to gold—and that greatness attaches itself to even the smallest of projects, if created by the right person? Or is it celebrating an essential building block of great success: failure? It may well serve to remind us that all our heroes have feet of clay—and that sometimes even the most talented teams can get things wrong.

As Stewart puts it: "Aalto was experimenting all of his life. Some of the time it worked, sometimes it didn't. That's the price you pay to work at the leading edge of architecture."

(1) Aalto built a traditional smoke sauna on the shore of the lake. Unlike modern saunas, a smoke sauna does not have a chimney. As wood is burned in the stove, smoke fills the room. Only when the sauna reaches the appropriate temperature is the fire extinguished and the room ventilated briefly before sauna-goers enter.

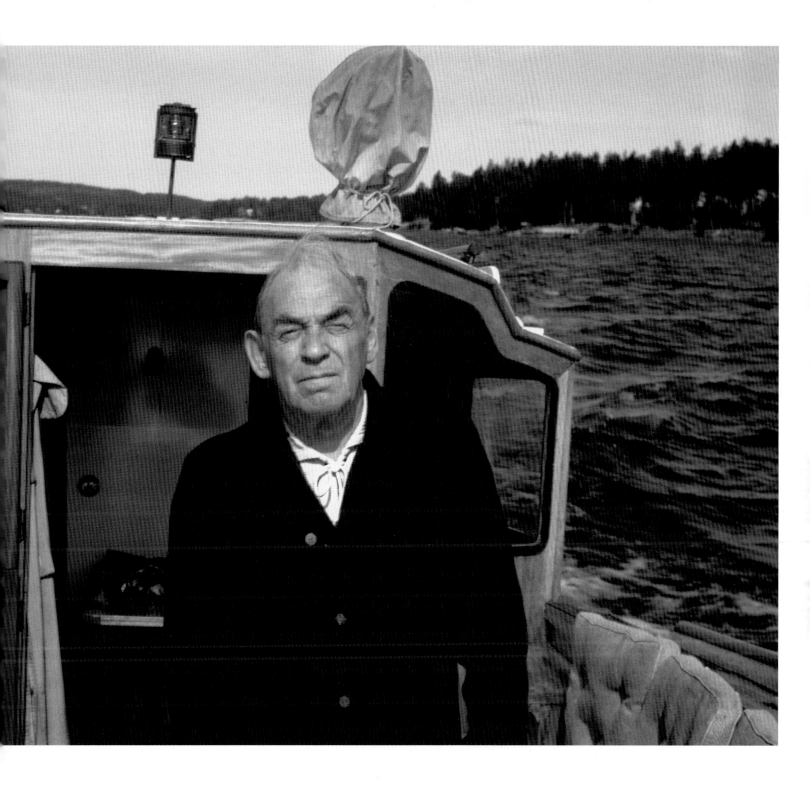

(above) Aalto apparently smuggled the boat's engine, a 96-horsepower Scripps Marine Engine, from the United States. It was so heavy that it forced the boat's prow to rise, making steering difficult.

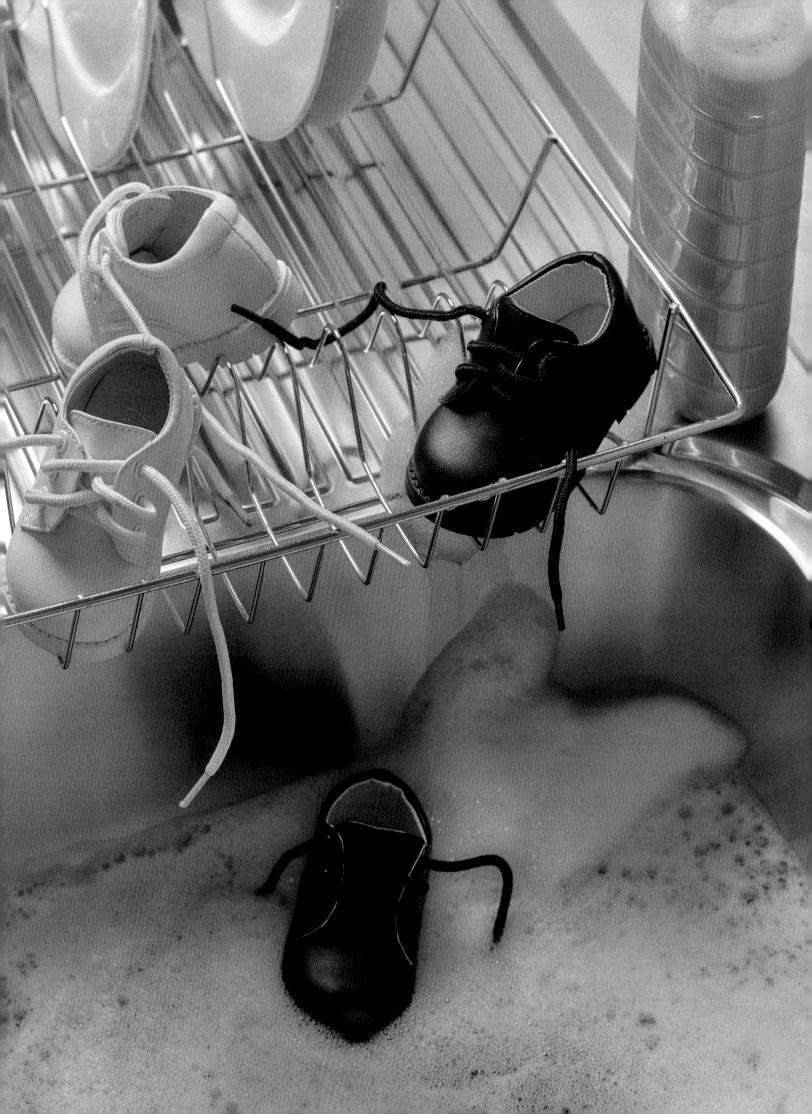

An ode to the fount
of domestic life.

159 THE KITCHEN SINK

Photography
LAUREN BAMFORD
Styling & Set Design
SARAH PRITCHARD

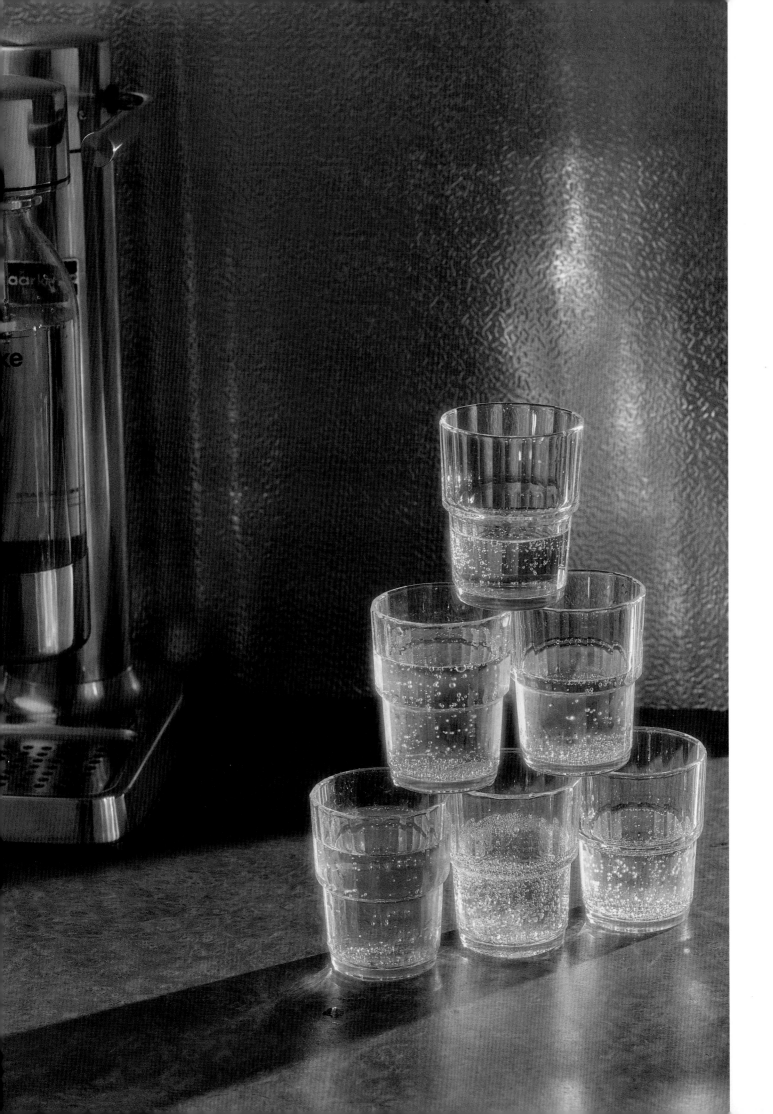

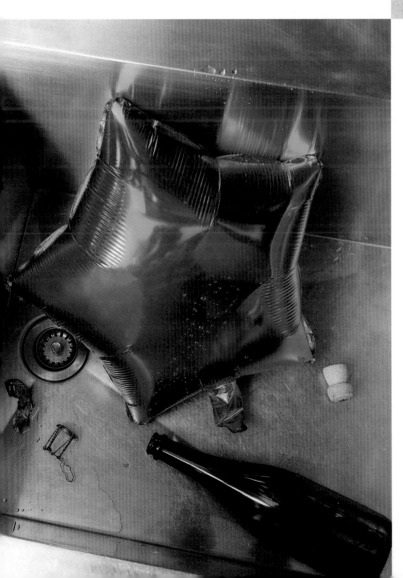

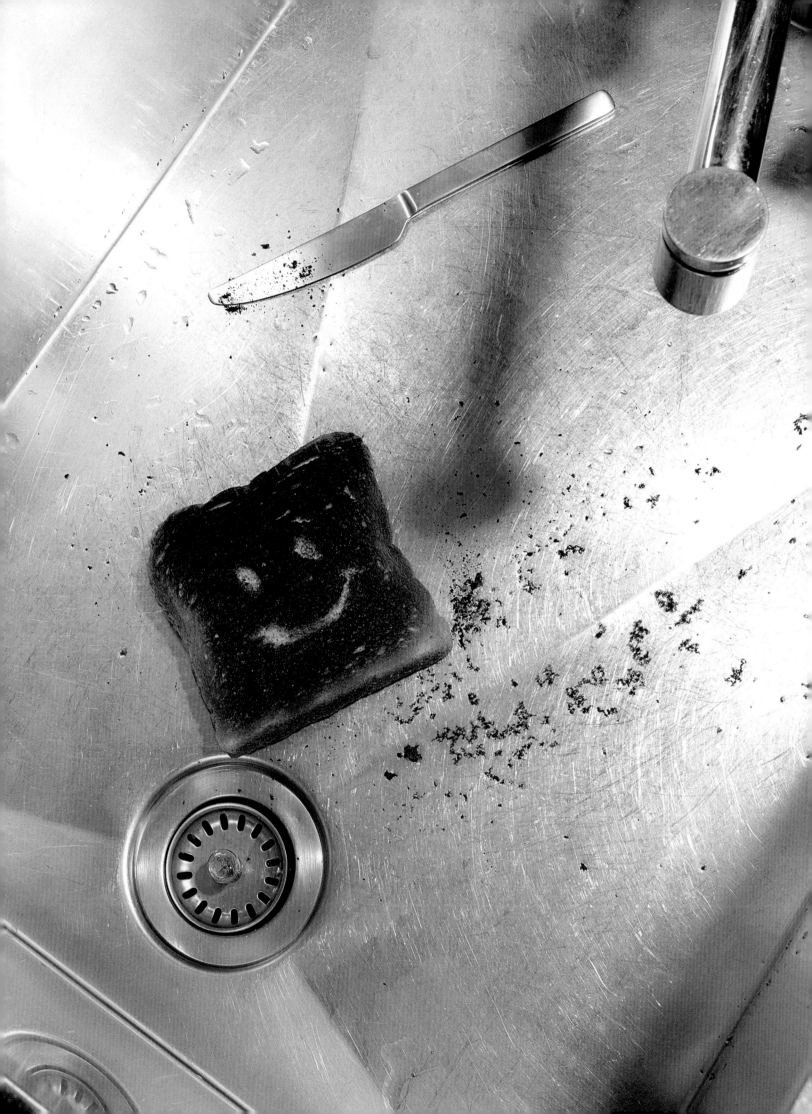

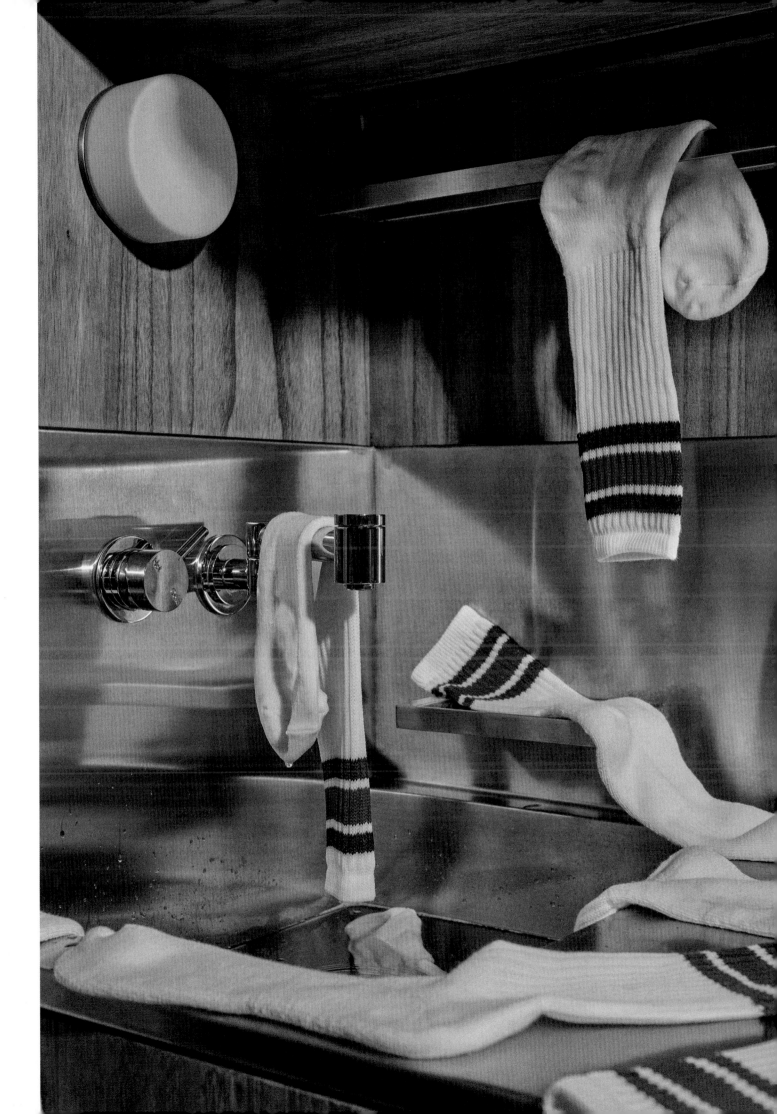

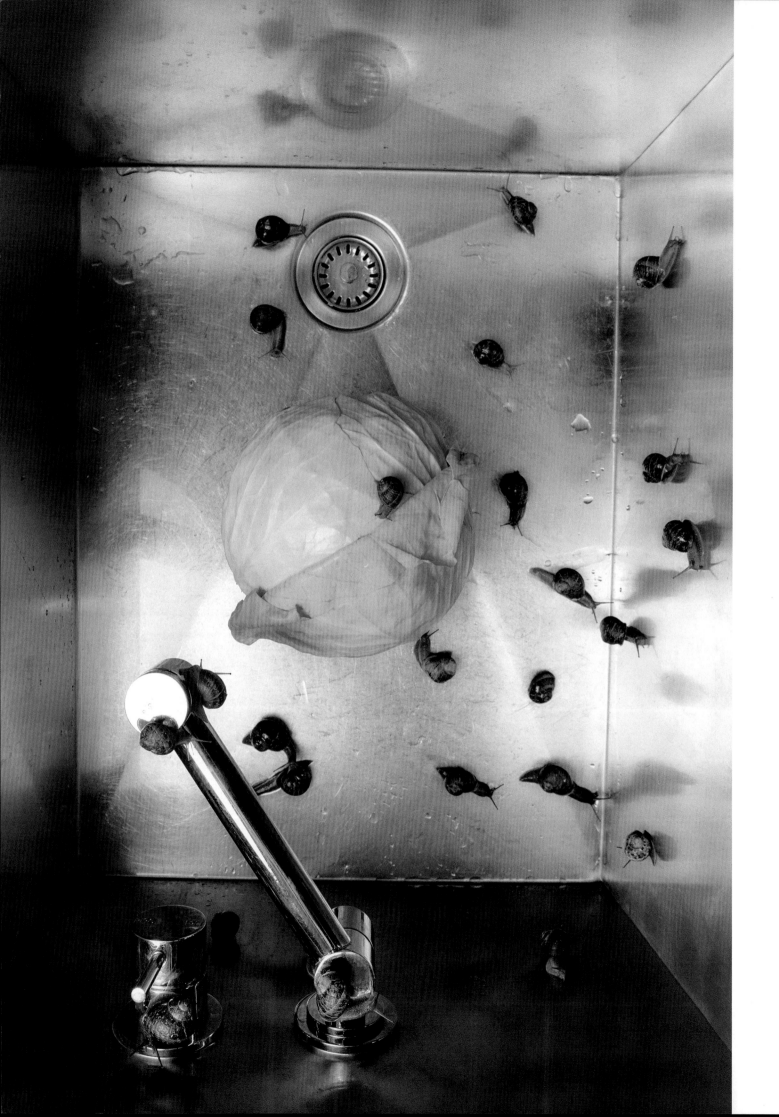

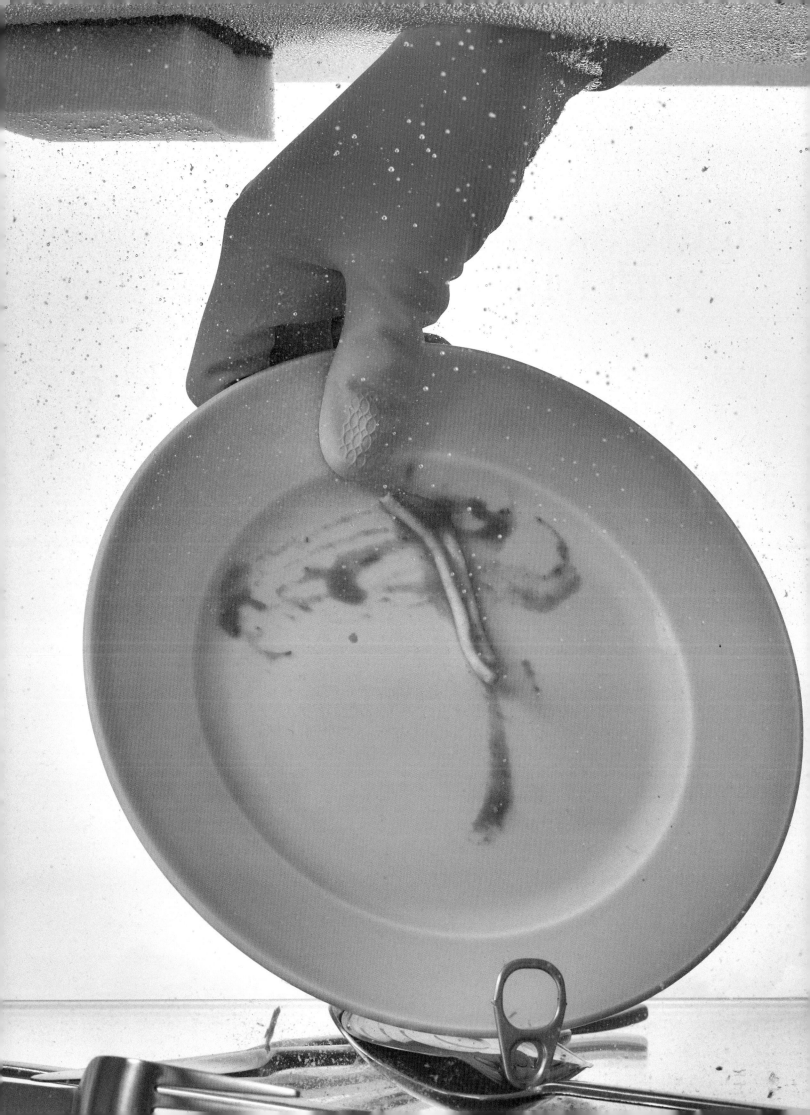

Words REBECCA LIU

Figure Skating
with MIRAI NAGASU

The Olympic athlete has known glory, pain and transcendence on the ice.

Photos TED BELTON

Styling NADIA PIZZIMENTI

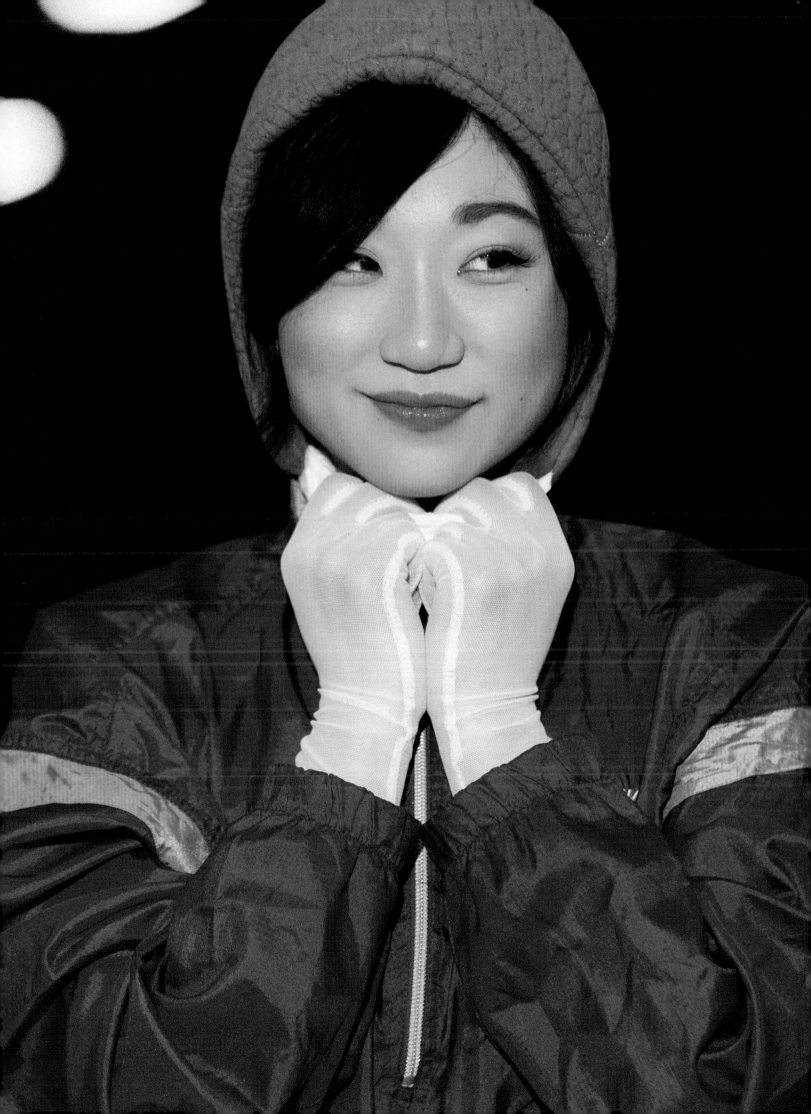

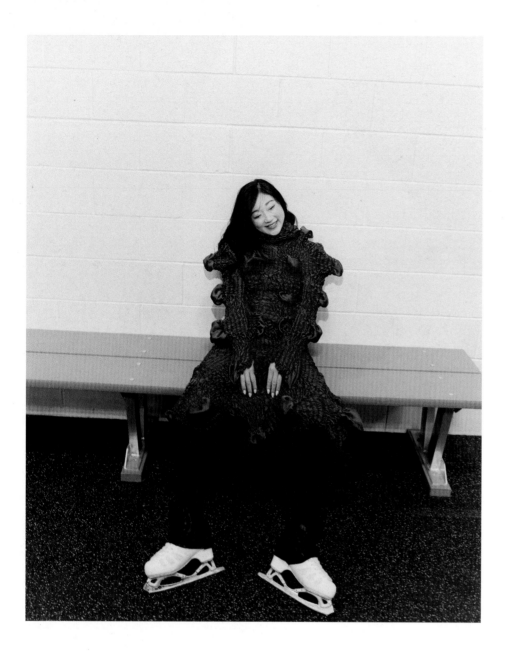

An afternoon on the ice with the first American woman to land a triple axel at the Olympic Games.

Competitive figure skating is an exercise in smoothing over contradictions. An athlete privately takes in all the bodily toil and injury, the gossip and rivalries, while publicly embodying the image of a graceful and transcendent vision gliding, spinning, leaping and forever smiling on the ice.

Few know this better than the 30-year-old American skater Mirai Nagasu, whose career has included two Olympics, one Olympic bronze medal, seven national championship medals and countless others. As she speaks about figure skating, she is initially a little weary—it is 6:30 a.m. in Portland, Oregon, and she has traveled here from Boston to teach some private skating lessons. "I've been skating for so long that I don't even remember a time period where I wasn't skating," she says.

Like many professional skaters, she started young. She was a five-year-old growing up in Arcadia, Los Angeles County. Her parents, Japanese immigrants chasing the American dream, set up a local sushi restaurant and were "adamant that I found my passion from a very young age." Her father had hoped it would be golf, but a rainy day in California saw her ask to go to the ice rink instead of a driving range.

Figure skating is as much an art as a sport, with athletes judged both on their athleticism—the difficulty of their jumps, spins and footwork, and how cleanly they have been performed—as well as their creativity, which includes their interpretation of the music, the quality of the skating and transitions between moves. Nagasu is a powerful skater: Watching her on ice, you are struck by the speed at which she glides, the explosiveness of the jumps and the effortlessness of her spins. The artistic side of the sport came less naturally: She began learning piano "because I was told I had no rhythmic abilities and needed to learn how to count music. And then I was taking ballet classes because I was told I needed to be graceful on the ice."

Her talent wasn't immediately clear. "I wasn't winning everything. I was getting fourth place a lot." That changed in 2007, when a 13-year-old Nagasu won the USA Junior National Championships; the following year, she became the second youngest senior national champion ever. A year later, she competed in the 2010 Winter Olympics and placed fourth. "It was like going to Disneyland," she says. "Everything was so new."

In figure skating, countless hours of training are condensed into two performances: a 2-minute-40-second short program alongside a 4-minute long program, with routines composed of elements including jumps and spins. The routines change

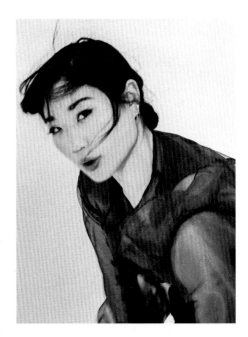

with each competitive year, and music, choreography and costume choices are a way for skaters to distinguish their personalities.

"Most skaters are very young," Nagasu says, "and they don't really know what they want. I felt like a lot of times I was like a racehorse and the packaging was being put together for me." She became more involved as she got older, working together with choreographers and costume designers. In 2014, the rules were changed to allow songs with lyrics, and Nagasu's 2015 long program was a *Great Gatsby*–themed medley with songs by Beyoncé and Lana Del Rey. Programs for all skaters during Olympic years tend to be more conservative, filled with classics like *Swan Lake*, *Phantom of the Opera* and *Romeo and Juliet*. "In Olympic years I would often pick things that represented me," Nagasu says, "but something that the judges would like as well." Yes—the judging. Figure skating fans often find themselves becoming quasi-judges of judges. Score sheets are shared, dissected and disputed online. There are complaints about over-scoring skaters from countries with powerful skating federations and underscoring those from countries with less influential organizations. The artistic side of the sport can be especially fuzzy to determine, and thus easily invites disagreements. At the 2002 Winter Olympics, allegations around vote fixing led to the entire judging system being overhauled.

How did Nagasu cope with competing in a sport in which the decisions of the judges are often and increasingly—through the power of social media—disputed? She takes a deep breath. "That's a tough question that I asked myself every day," she says. She would sometimes feel that there was "something

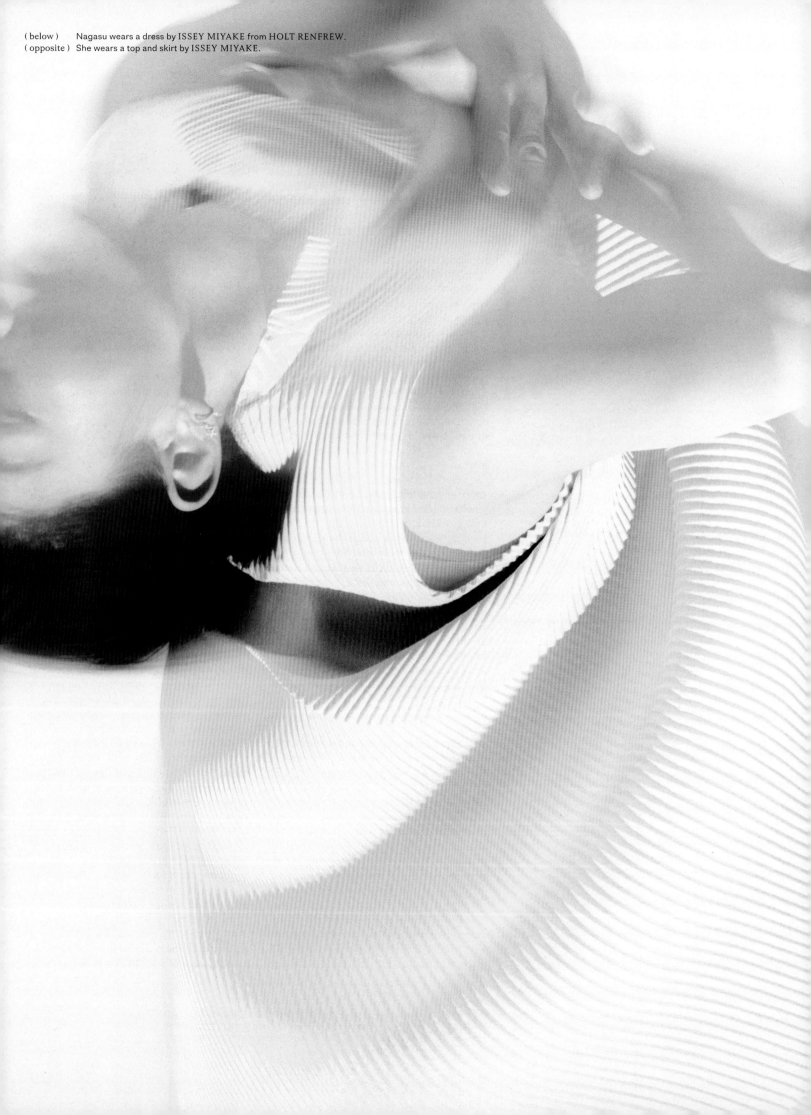

(below) Nagasu wears a dress by ISSEY MIYAKE from HOLT RENFREW.
(opposite) She wears a top and skirt by ISSEY MIYAKE.

fishy going on" but tried to focus on what she could control. Yet her unease about the fairness of the sport has been recently triggered by the doping scandal that rocked last year's Olympics, when it was revealed that the women's skating frontrunner, Kamila Valieva, tested positive for a banned substance in December the previous year. To the consternation of many skaters, Valieva was allowed to compete, and the case is still going through the courts. It "really puts a lot of things into question. I question a lot of things about my own career," Nagasu says. "If it's happening now, how long has it been happening before?"

Last year's Olympics also highlighted a startling pattern: Valieva, who ended up placing fourth, was 15, while the champion and runner-up were both 18 (the men's skating champion, by comparison, was 23). Women's skating has always had young prodigies, but the trend has accelerated in recent years as athletes have begun to do high-scoring jumps with quadruple rotations ("quads"). The current quad jumping technique favors smaller, lighter bodies that can snap back after back strains—only one woman over the age of 18 has ever landed a validated quad in competition.[1] Beyond the controversial quad revolution, all skaters have spoken about the need to relearn skills after growth spurts, and it's common for star junior athletes to struggle as adults. Nagasu remembers feeling like a "has-been"

at 21, when she was left off the 2014 Olympic team in favor of a 15-year-old newcomer. Winning the US championship at 14 had thrust her in the public eye and there was constant speculation in the years that followed whether she was past her prime.

The disappointment would, however, also lead to Nagasu's greatest triumph. She began to look to the 2018 Olympics, and decided to learn a new jump: the famously difficult, and rarely attempted, triple axel. Her coaches used contraptions like a fish pole—an overhead harness that lifts the skater upward—so Nagasu could attempt the jump while minimizing the danger of a potential fall. On February 12 that year, at South Korea's Gangneung Ice Arena, Nagasu became the third woman in history to land a triple axel at the Olympics, and the first American woman to do so, also winning a bronze medal for the team event.

" I felt a lot of times I was like a racehorse."

The jump itself comprises a few exhilarating moments in the air, sandwiched in between the tense lead-up as Nagasu skates into it—you can feel the stadium quiver with anticipation—and the ecstatic roar as she lands it. Behind those seconds of triumph were thousands of attempts made every day over four years. And it had taken its toll. Nagasu had injured her hip socket and parts of her pelvis while training for the axel, and needed two surgeries. (Skaters tend to land their jumps on the same leg, putting them at great risk of hip injuries.)

Today, having now retired from competitive skating, Nagasu coaches skaters, mainly in Boston, where she lives, studies at Harvard Extension School and performs in shows. What does she hope for the next generation of figure skaters? "The message of inclusivity," she says. "Going from a teeny tot to my body developing in the public eye—that was really hard for me, and people are really brutal. . . . Skating is not just for one certain body type. I think that I learned that much too late, and I listened to the people around me way too much." There's a new joy in being able to skate on her own terms and perform in shows; to dance on the ice without the pressure of pleasing the judges or being caught up in the media circus. "It's been a long journey for me to fall back in love with my sport," she says. "Now I'm able to enjoy skating without the grueling demands of it."

(1) Last year, the International Skating Union (ISU) made a historic decision to raise the minimum age for competitors in figure skating to 16 for the 2023—24 season, rising to 17 for the 2024—25 season. The ISU's medical commission cited concerns over "burnout, disordered eating and long-term consequences of injury."

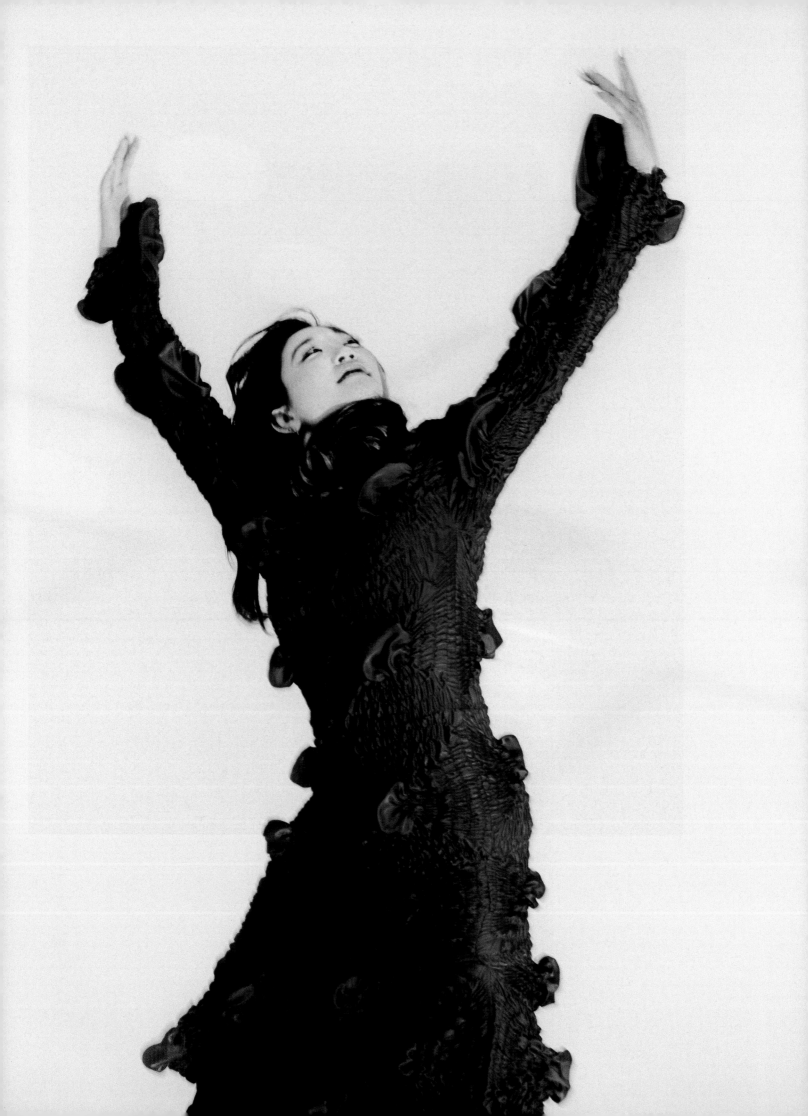

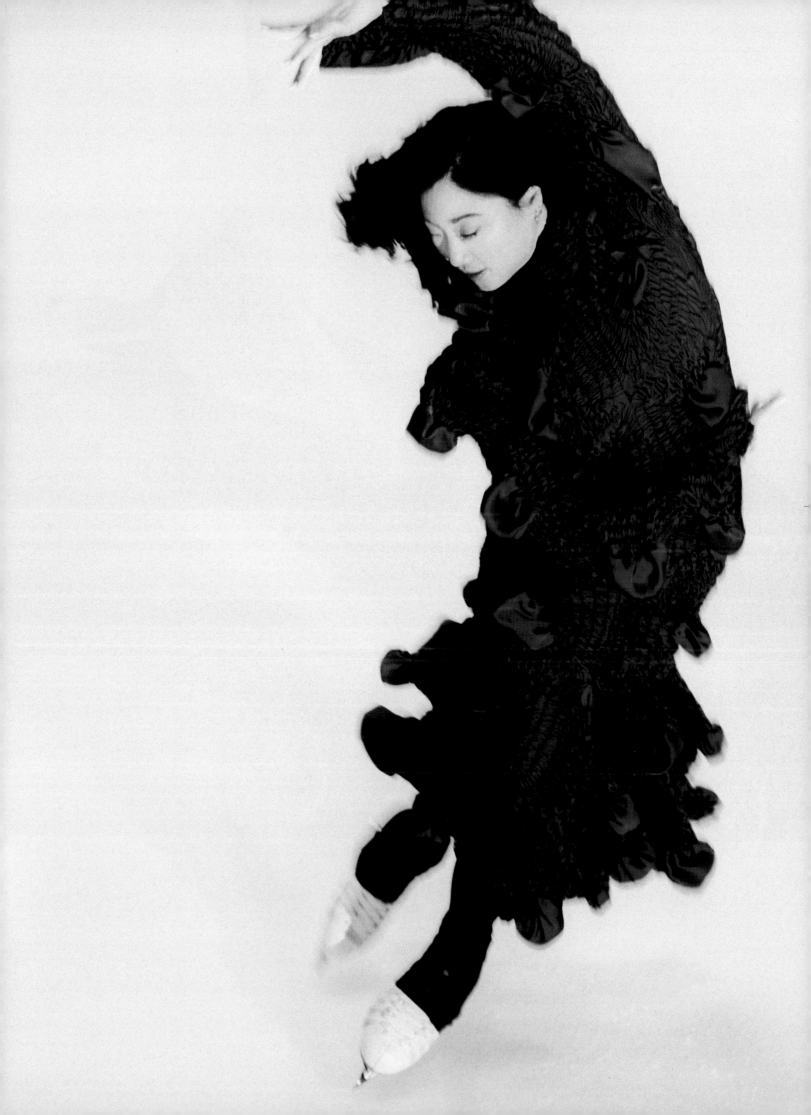

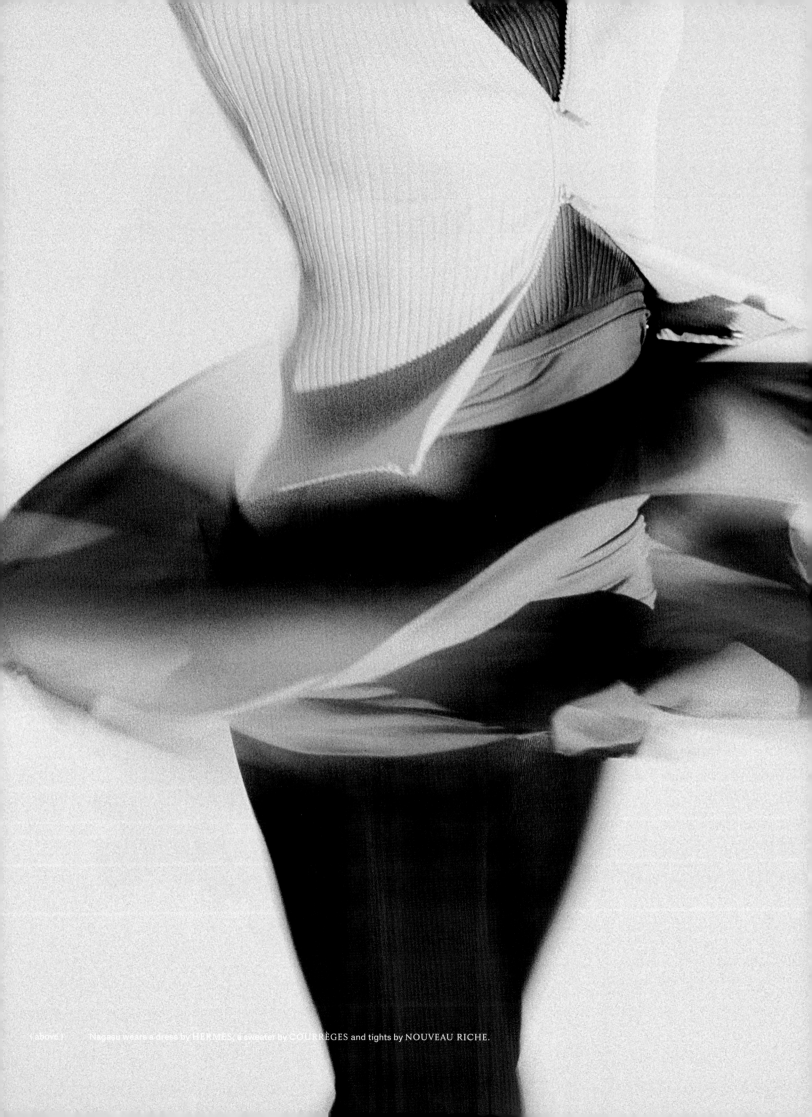

(above) Nagasu wears a dress by HERMÈS, a sweater by COURRÈGES and tights by NOUVEAU RICHE.

PEER REVIEW

Words: William Cobbing

Artist WILLIAM COBBING on painter, publisher —and family friend—FRANCISZKA THEMERSON.

I first came across the beguiling drawings of Polish-British artist Franciszka Themerson (1907–1988) when archiving the collection of my grandfather, the poet and publisher Bob Cobbing.[1]

To help give context to the collection of drawings and photographs, I contacted her niece, the esteemed writer and curator Jasia Reichardt, who had completed archiving Themerson's works. Over conversations at her house, I grew more familiar with Themerson—not least through the paintings on the walls. *Untitled—Multi figure* (1972/3), hung above the staircase, is typical of the artist's work: a compound figure, a body sprouting from the head, a smaller figure superimposed on the torso, sparsely painted with a visceral energy.

Similarly composed figures, albeit drawn in a more lyrical, linear way, populate many of the illustrations she made for Gaberbocchus Press, which she co-founded in 1948 with her husband, Stefan. The press was part of a milieu of small-scale artist-run presses at that time, and the Gaberbocchus Common Room—situated in the basement of their office—provided a meeting place for fellow artists and writers. My grandfather had long been friends with the Themersons, who lived down the road from him in West London. He also published Themerson's drawings in his Writers Forum imprint and included her works in exhibitions at Drian Galleries.

The Gaberbocchus publication which stood out to me was the shocking, absurdist play *Ubu Roi*, written by Alfred Jarry and translated from French by Barbara Wright. Themerson had added her puckish drawings in lithium crayon directly onto the printing plate, responding to Wright's handwritten text. The story follows the grotesque and barbaric Père Ubu, rendered by Themerson with childlike glee. It was a continuation of the absurdist drawings she'd been making in response to the brutality of World War II; the Themersons had moved from Poland to Paris in 1938, then volunteered for the Polish Army at the outbreak of war before fleeing to London.

Themerson's drawings for *Ubu Roi* became a leitmotif for her practice for decades afterward, and the initial book illustrations led to stage and costume design for live adaptions of the play at the Institute of Contemporary Arts in London in 1954, and the Marionetteatern in Stockholm in 1964. At Reichardt's house I had previously seen a collection of papier-mâché masks designed for the ICA production, which managed to retain much of the spontaneously contorted lines of Themerson's drawings. They complement my grandfather's photographs from the Stockholm performances, documenting the towering cutouts of her lyrical drawings on the stage.

It is no surprise that Themerson, who began as a painter, ended up applying her talents in such varied ways. As art critic Edward Lucie-Smith observed, "She enters into collaboration—or should I say a conspiracy— with the line, and awaits to see what the result will be."

(1) Cobbing, an experimental poet, was a leading force in Britain's postwar cultural scene. He was a founding member of the Association of Little Presses, convenor of the Poets Conference and founder of the Writers Forum press. William, his grandson, is a performance artist best known for making sculptures.

Words:
Ed Cumming

A material history of the tote bag.

The downstream consequences of new laws can be difficult to predict. Legislation around the world to limit plastic shopping bag use has been triumphant in its stated aim. In Britain, which introduced a charge on plastic bags in 2015, there has been a 97% reduction in their use. But there has been another, less predictable consequence of these new laws: the Great Tote Bag Explosion.

These are canvas or cotton bags, stronger than plastic and ripe for re-use. The history is somewhat murky. While bags made from natural fibers have been in use since medieval times, the tote got its name in the US in the 1940s, after L.L. Bean released a range of "Boat" and "Tote" bags, with the latter in the now-familiar boxy shape.

Spotting the opportunity for a cheap bit of reusable marketing, brands began pumping totes out in extraordinary numbers. Some acquired cult status, like *The New Yorker*'s version which is emblazoned with large lettering; carrying it signals that you are both environmentally conscious and a subscriber. Win-win. If you use this to transport a shiny Apple laptop, for which it is perfectly sized, so much the better.

The novelty of the tote bag has worn off—they have become a menace. Like the USB stick, the tote has become a default branded item. No publicity executive ever got fired for suggesting a tote. Our homes are awash in the things, which have bred like an invasive species that finds itself with no predators. The other day I counted them before a cull: There were 27. Totes from festivals and shops and conferences. Three from the *Financial Times* alone. Thanks to their aura of environmentalism, there is a taboo around throwing totes away. But research has found that they need to be used over 100 times before they match plastic bags for carbon waste. After selecting the best ones—the biggest, the strongest, the most comfortable handles—we donated the rest. It felt like letting go of baggage.

Photo: Elena Khrupina

Photo: Jae-An Lee. Location: Kinfolk Dosan, Seoul.

ANTON HUR on the intricacy— and inequality —of literary translation.

Without translators, global readers would have missed out on wildly successful contemporary works like *The Girl with the Dragon Tattoo* and the Neapolitan Novels, as well as classics by writers such as Frantz Fanon and Gabriel García Márquez. Despite this, translators are often unrecognized, sometimes barely credited. Anton Hur, who translates between Korean and English, is one of the most respected literary translators working today. In 2022, two of his translations were longlisted for the International Booker Prize: *Love in the Big City* by Sang Young Park and *Cursed Bunny* by Bora Chung. But he is unusual in more ways than this: He is a successful literary translator of color.

OKECHUKWU NZELU: How did you get started as a translator?

ANTON HUR: My first job was interpreting for my mother. We would go to the market together and I would interpret for her. It's a very typical experience for people like me who are "third-culture kids."[1] I went to college in Korea and I had a full scholarship, but I still wanted to make some money. The easiest way was either tutoring, which I did a lot of, or interpreting and translation. Eventually, I realized I just wanted to be a freelance translator.

ON: What has been your experience of the world of literary translation?

AH: Publishing, especially Anglophone publishing, is notoriously insular. To this day, no translator of color has won the International Booker Prize. Translators of color are expected to be much less artistic, and we're supposed to need a lot of hand-holding from a white co-translator. There was actually a publisher in the UK that made it a policy to pair every translator with a monolingual poet, in order to create an artistic translation. One publication reviewed my first book, and they called me "a little too fluent," as in, *How dare he be so good at English?* So not only is my English often judged as being not fluent enough, now I'm a little *too* fluent. The day I got double-longlisted [for the 2022 International Booker Prize] was the day I finally stopped wishing I could quit!

ON: What's your approach to deciding which projects to take on?

AH: I have to respond at a visceral level. I have to immediately hear the English in my head. Also, I have a rule I call the Miuccia Prada Rule, because she always incorporates an element of something that she hates. For example, she hates nylon, so her response is, "I hate nylon. I'm going to use nylon in my collection." And everyone is like, "But Miuccia, why are you using something that you hate to use?" And she'll be like, "I don't know, I'm eccentric like that." I'm doing a fantasy book right now, and it's not that I hate fantasy, but it's not a genre that I personally am familiar with. And so when I got this fantasy book, I embraced the challenge because I think if I struggle with it a little and I workshop it a bit I know that it will be interesting. I want to do work that's unexpected. I want to change the face of Korean literature. That's why I went into science fiction, and why I wanted to do queer translation. And that's how I try to choose works—that and the money.

(1) "Third-culture kid" is a phrase used to describe the fact of someone growing up influenced both by their parents' culture and the (different) culture in which they are raised. Hur was born in Stockholm, Sweden, and raised in Hong Kong, Ethiopia and Thailand. He has lived in South Korea for over 30 years.

A RIVER PUNS THROUGH IT

Crossword: Mark Halpin

ACROSS

1. Carries or tows
6. Become mature
9. Like some things you might buy cheap
13. Prenatal test, for short
14. Golf bag supplies
15. Apply asphalt, perhaps
16. Honey badger, by another name
17. Becomes putrid
18. Sign of things to come
19. Made crazy by being forced into a river?
22. Culmination
23. Clean a floor, in a way
24. Taylor of fashion
25. Trendy
28. Sunbeam or laser
29. Assurance that a river has got your back?
32. Daisy Ridley's "Star Wars" role
33. Aired a program again
34. Part of the Bible concerning a river?
41. Less confined
42. Nebraska tribe with a palindromic name
43. Endless nourishment provided by a river?
47. Existed
50. The sun
51. Sue Grafton's "___ for Innocent"
52. Strand in a cell
53. Mont Blanc, e.g.
54. An American's quick sketch of a river?

58. Newborn
60. ___ gobi (curry dish)
61. Low-budget film, often
62. At ease
63. Cameraman's choice
64. Rocinante, to Don Quixote
65. They make a girl go crazy, per Lizzo
66. Wrath
67. Hot, spicy drink

DOWN
1. Less of a breeze
2. Where cuneiform was discovered
3. Like a slob
4. Actor Schreiber
5. Grave
6. A very long time
7. Does well in a class, but no more
8. Dead Sea Scrolls writer
9. Atop
10. "Likewise!"
11. Night before a holiday
12. Animal's lair
14. A rare sort of child
20. Private eye film genre

21. Prefix with mural or venous
26. Exporter of saffron and pistachios
27. Confined
30. Keep an ___ (look after or monitor)
31. Tailor's task
34. Advanced degrees for sculptors, painters, etc.
35. Folksinger Guthrie
36. Stephen Foster song that inspired a journalistic pen name
37. 180° turn, slangily
38. Yogi or Paddington Bear, e.g.
39. Sound systems
40. ___ fro
44. Rwanda's capital
45. Horse handler
46. Lao-tzu follower
47. Made a paper into a ball, perhaps
48. On the same side
49. Brisk
55. Responses to the captain
56. Region
57. No longer fooled by
58. Lobster-eating convenience
59. Kerfuffle

CORRECTION: GRATITUDE JOURNALS

Words:
Precious Adesina

On the downside of only seeing the good side.

For those who live on the internet, it has been difficult to avoid the recent onslaught of hyper-positivity. In early 2023, this came in the form of "lucky girl syndrome" on Tik-Tok—the idea that if you repeatedly tell the universe how fortunate you are, you will be.

Adopting various techniques to have a more optimistic outlook is nothing new. Perhaps the best-known analogue equivalent is the gratitude journal, in which a practitioner dedicates a certain amount of time each day or week to listing how they are fortunate. The premise is that by regularly thinking about the ways in which your life is good, the

reasons why it is not quite ideal will feel less potent. Studies have shown a range of benefits to the habit, including better sleep, stronger resilience, a reduction in the symptoms of PTSD and improved life satisfaction.[1]

But constant gratitude is not always healthy. Some people may find that by focusing heavily on what is great about their life, that they end up feeling guilty about their negative emotions during tough times. This is known by professionals as "toxic positivity," which is a dysfunctional form of emotional management where we make ourselves ignore negative feelings even when things get difficult. "Toxic positivity denies emotion and forces us to suppress it," psychotherapist Whitney Goodman explained to *Women's Health* magazine. "It tells us that this emotion shouldn't exist, that it's wrong, and if we just try a little bit harder, we can eliminate it entirely."

Only focusing on gratitude can also result in people ignoring dangerous circumstances, Alex Wood, a psychologist and visiting professor at the London School of Economics, told *The Guardian*. "Many people might feel a lack of gratitude because they're in objectively bad situations. For people in abusive relationships, for example, the answer is to get the hell out, rather than feel more gratitude," he says.

"It's important when practicing gratitude not to invalidate your feelings of stress," Florida-based psychologist Dr. Nekeshia Hammond told Healthline. "You can have both: a strong sense of gratitude along with feelings of sadness, confusion, or anxiety."

(1) According to Australian social psychologist Lisa A. Williams, research also shows that expressions of gratitude are more beneficial when you share them with other people rather than with an inanimate object. "If we keep gratitude to ourselves, we're curtailing the potential benefits of it," she told Australian broadcaster SBS.

LAST NIGHT

Words:
Annick Weber

What did interior designer BEATA HEUMAN do with her evening?

Swedish-born, London-based interior designer Beata Heuman founded her eponymous firm in 2013 and has since won accolades for her joyful, maximalist aesthetic. Though her practice focuses on residences for private clients, she has also designed restaurants and is currently working on her first boutique hotel project in Paris.

ANNICK WEBER: What time do you get home from work?

BEATA HEUMAN: I try to leave work a bit after 6 p.m. It takes under 10 minutes to walk home, so I get to spend some time with my daughters before they go to bed at 7. Running my own business means having the luxury of deciding where our office is. We're currently moving to a bigger workspace, but staying in Hammersmith [West London] was a must.

AW: What do you do once the kids are asleep?

BH: Because of my busy work life it's nice to have that time to relax. Last night we FaceTimed my nephew in Sweden for his birthday and my husband cooked me orzo pasta with crab and chili. We also watched an episode of *South Park* and I managed to read a few pages before bed.

AW: Do you struggle to find the time to read?

BH: My friend does this thing where she sets herself the goal of reading at least 10 pages a day. I do the same now. It takes a bit of self-discipline, but it makes me so much happier than spending that time on Instagram.

AW: How much sleep do you need?

BH: At least eight or nine hours; if it were up to me I'd probably go to bed at 7:30.

AW: Did you design your bedroom with sleep in mind?

BH: My bedroom is painted in a calming blue. I made sure that everything is as comfortable as can be: not just the bed and linens, but also the bedside tables, which come with a pull-out shelf for a water glass, and the lighting, which can be dimmed or boosted for reading.

AW: What don't you want to see in a bedroom?

BH: A TV, although we currently have one opposite our bed. It's such an indulgence, but I don't turn it on unless there's something I really want to watch.
—

CULT ROOMS

Words:
Tom Whyman

After "completing" philosophy, LUDWIG WITTGENSTEIN tried —and failed—at architecture.

"Philosophy," the early German Romantic writer Novalis remarked, "is homesickness": the desire to be at home everywhere in the world. If that's right, then surely philosophers should also want to be architects—or at any rate, to build houses for themselves.

And yet, as far as I know, no great philosopher has ever successfully made the transition from the armchair to the drafting table. In fact, the only one who even attempted anything remotely like it was Ludwig Wittgenstein, who in the middle of the 1920s helped supervise the construction of a modernist townhouse in Vienna for his sister Margrethe. Technically, the architect on the project was Paul Engelmann, a friend of Wittgenstein's who had been a student of the pioneering modernist Adolf Loos. But so particular was Wittgenstein—and so demanding—that Engelmann eventually came to see the philosopher as the real author of the final product.

This was very much a reflection of Wittgenstein's personality: neurotic, perfectionist and overbearing. Born in Vienna into one of the wealthiest families in Europe, Wittgenstein had studied aeronautical engineering before becoming obsessed with the foundations of mathematics, notoriously turning up unannounced to Bertrand Russell's rooms at Cambridge, before rapidly convincing everyone there that he was a genius. His first book, the *Tractatus Logico-Philosophicus* (1921) was gnomic and austere, comprising 525 numbered declarative statements.

Wittgenstein believed that with the *Tractatus*, he had solved all the important problems in philosophy—which left him with the rest of his life to live, doing real stuff in the real world. Before attempting to become an architect, Wittgenstein had trained as a village schoolteacher, which went disastrously. He also worked as a gardener and considered becoming a monk.[1]

Wittgenstein's plans for his sister's house were perfectionist to the point of megalomania: He spent two years making sure that every detail fit his specifications exactly. Everything was ultra-modernist: straight lines, white walls, stone floors, no carpets,

Photo: Atelier Leitner

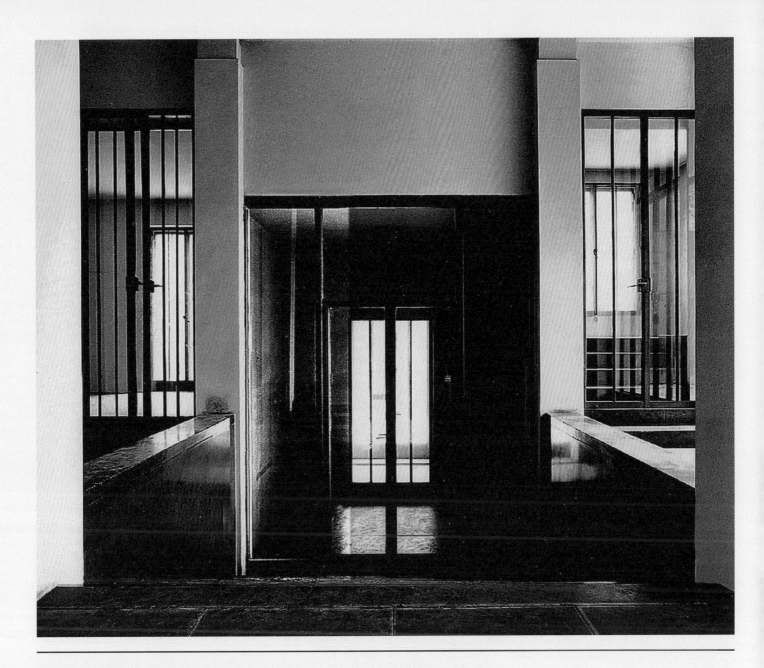

bare light bulbs. Just as the project was almost completed, he insisted that one of the ceilings be raised 30 millimeters, so that the room would have the exact proportions that he wanted.

But it was probably always going to be impossible for Wittgenstein, or anyone, to be satisfied with the result. When experienced in person, the house, which now forms part of the Bulgarian Embassy, is manifestly a failure—an empty maze of light and glass. Wittgenstein himself came to believe that the building was too austere, with "good manners" but no "primordial health." His sister Hermine remarked politely that while she admired the house, it seemed "to be much more a dwelling for the gods than for a small mortal like me."

In the end, the house did leave a major legacy—in its impact on the development of Wittgenstein's thought. Shortly after completing it, Wittgenstein returned to Cambridge, and philosophy. He had grown dissatisfied with his thought as expressed in the *Tractatus*, realizing, in part through the

example of the awful perfection of the house he had built, that its icy purity was too detached from reality to ever be relevant to life as lived.

In a famous remark from his second great work, *Philosophical Investigations*, Wittgenstein compares thinking to walking. "We want to walk," he says, "so we need friction." Philosophy desires to feel at home in the world. But to do this, it must take in all the rough and tumble of the mess and chaos that Wittgenstein sought, impossibly, to eliminate from the home *he* built. "Back to the rough ground!"

(1) After his time as a teacher, Wittgenstein worked as a gardener's assistant at a Benedictine monastery near Vienna. In the 1930s, while teaching at Cambridge, he sent a letter of complaint to Trinity College regarding their plans for the Fellows' Garden. "The kidney-shaped bed with the dahlias in it looks very bad," he wrote, demonstrating himself to still be a fan of more austere design. "This fringe makes it look like a gaudy birthday cake."

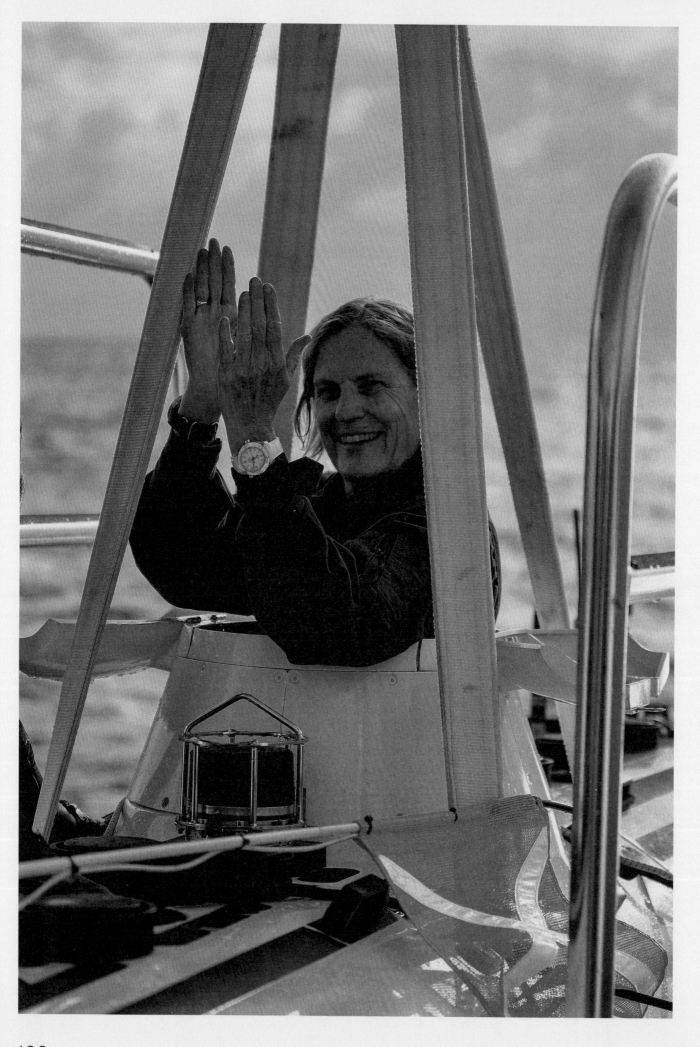

DIRECTORY

KATHRYN SULLIVAN

Words:
George Upton

The astronaut turned deep-sea explorer on the highest highs and lowest lows.

In 2020, Dr. Kathryn Sullivan became the first woman to descend to the Challenger Deep, the deepest point in any ocean, approximately 36,000 feet beneath the surface of the Pacific. Sullivan, who was 68 at the time, had already been a trailblazer in her career, including flying on three space shuttle missions as part of NASA's first group of female astronauts. Yet, as Sullivan explains here, she has always been far more motivated by being able to experience these inaccessible, inhospitable places firsthand than by setting new records.

GEORGE UPTON: What drives you to explore such challenging places?

KATHRYN SULLIVAN: It's really just an endless curiosity. The fundamental thing that motivated me to fill out the long application to join NASA was that, if I somehow succeeded in getting through, I would be able to look back at the planet from space. I think a quintessential part of being human is the profound experience of being in a particular place, conscious of the journey that it took to get there. Setting those records is just a nice consequence.

GU: How did the experience of going into space compare with your dive to the Challenger Deep?

KS: For both environments you need a craft that allows you to create the very specific kind of space that humans need to survive; a protective bubble that is within a fairly narrow range of pressures and temperatures, and which contains the right mixture of gases for us to be able to breathe. And then it needs to be strong enough to withstand the environment that you're in. I have always marveled at how I can feel completely safe in my little craft when I know that just outside the window is an environment that would be lethal.

GU: You're an ambassador for Omega. Why did that particular partnership make sense?

KS: It is always vital to keep track of time. I had an Omega on my spacesuit and I had one when I did the dive in the submersible—the same model that many astronauts now wear on the International Space Station. You need a watch that can keep both Earth time and mission elapsed time, and you need the minutes to be different in those two time zones. There are very few watches that can do that.

GU: Very little of the ocean has been explored and what we do know comes from sonar readings and limited imagery of the seafloor. Did it feel like going into the unknown?[1]

KS: I certainly had no idea what it was going to be like on my scale, seeing it with my own eyes. We have stunning images of the moon—it's possible to visualize what it would be like up there—but because light does not pass through the ocean, you can't take pictures of vast expanses of the seafloor. No matter how many scientific papers you've read, or how much imagery of the seafloor you've seen, it's ultimately only snippets of the real experience. After we landed, we rose around two meters off the bottom to explore. I could see a radius of maybe 15 meters—just as far as our little circle of light would reach. The word that kept coming to my mind was "moonscape." There were no large rocks like on the moon, but it had a fairly uniform grayish tone and the surface undulated slightly. As an oceanographer, you would call that an active bottom—it's a sign that there are animals, chiefly worms of different kinds, rootling around in the upper levels of the sediment.

GU: Why is it important to explore the ocean?

KS: The sea is our life-support system—half of the oxygen we're breathing is produced in the ocean. It's important to know whether it's still functioning as it should. The oceans are getting warmer, which can affect the currents and the climate, and they're also becoming more acidic because CO_2 is being absorbed in the water as carbonic acid, threatening marine life like coral reefs. Recently, deposits of precious metals have been discovered on the seafloor. Mining these would involve dredging the seafloor, extracting the metals and letting vast plumes of sediment drift back down through the ocean. It's only by studying life on the seabed and the role it plays in our ecosystem that we will know whether this kind of mining would have some horrendous side effect.

GU: Has the experience of going into space and descending to the bottom of the Challenger Deep changed the way you look at the world?

KS: It gives me an ever-sharpening realization of how interconnected everything is on this planet. If you go to the deepest part of the ocean and take one of the invertebrates that live down there back to the surface, odds are you will find microplastics in its intestines. It would be impossible to trace exactly how it got there but that is far less important than the fact that it has, hundreds of miles from any large landmass and 11 kilometers beneath the surface.

(1) According to Sullivan, light only penetrates the water for the first 100 meters during the descent: "It's a beautiful turquoise blue that gets darker and darker until you realize that it's actually just black."

CREDITS

COVER:	PHOTOGRAPHER	Michael Oliver Love
	STYLIST	Kristi Vlok
	HAIR & MAKEUP	Michelle-Collins
	PHOTO ASSISTANT	Tshepo Rancho
	MODEL	Domonique E @ Kult Models
		Domonique wears a swimsuit by Akina and a vintage swimming cap.

JORDAN CASTEEL:	PHOTO ASSISTANT	EJ Muniz
	STYLING ASSISTANT	Alba Tiell

MINERAL CONTENT:	PHOTO ASSISTANT	Joe Conway

THE AALTO BOAT:		All images courtesy of the Alvar Aalto Foundation

SPECIAL THANKS:		Josephine Akvama Hoffmeyer
		Rachel Sené Todd

STOCKISTS:
A — Z

MY FAVORITE THING

Words:
Harriet Fitch Little

CLIFF TAN, interviewed on page 45, tells the story behind his favorite golden cat.

This little golden beckoning cat was given to me by my partner. It's probably the most kitsch item I own and I cringed when I first received it because it was a cheap, shiny plastic thing, a far cry from the exquisitely crafted design pieces that I preferred. To make matters worse, it required AAA batteries to make it "work," essentially waving its paws all day long.

In feng shui, a cat like this would sit in the money corner to beckon wealth. I reluctantly had it on my table, allowing it to do its waving thing. But as the cat waved relentlessly—day in, day out—its unfaltering efforts became a part of the energy of the home. When the batteries ran out you could somehow feel that something was amiss, like a part of the home's energy had left. Its dedication to its duty to continuously wave its paws, to beckon for wealth, was rather moving, and for as long as I kept my side of the promise—to feed it energy in the form of batteries—it would not fail me. And so I did. I made it a point to greet it every morning, to be sure it was still doing its thing. For as long as it is waving, it gives me a sense of assurance that all is well. An unexpected, yet very real relationship had been unwittingly established, and it taught me that value of things is not determined by price, but through time and meaning.

——